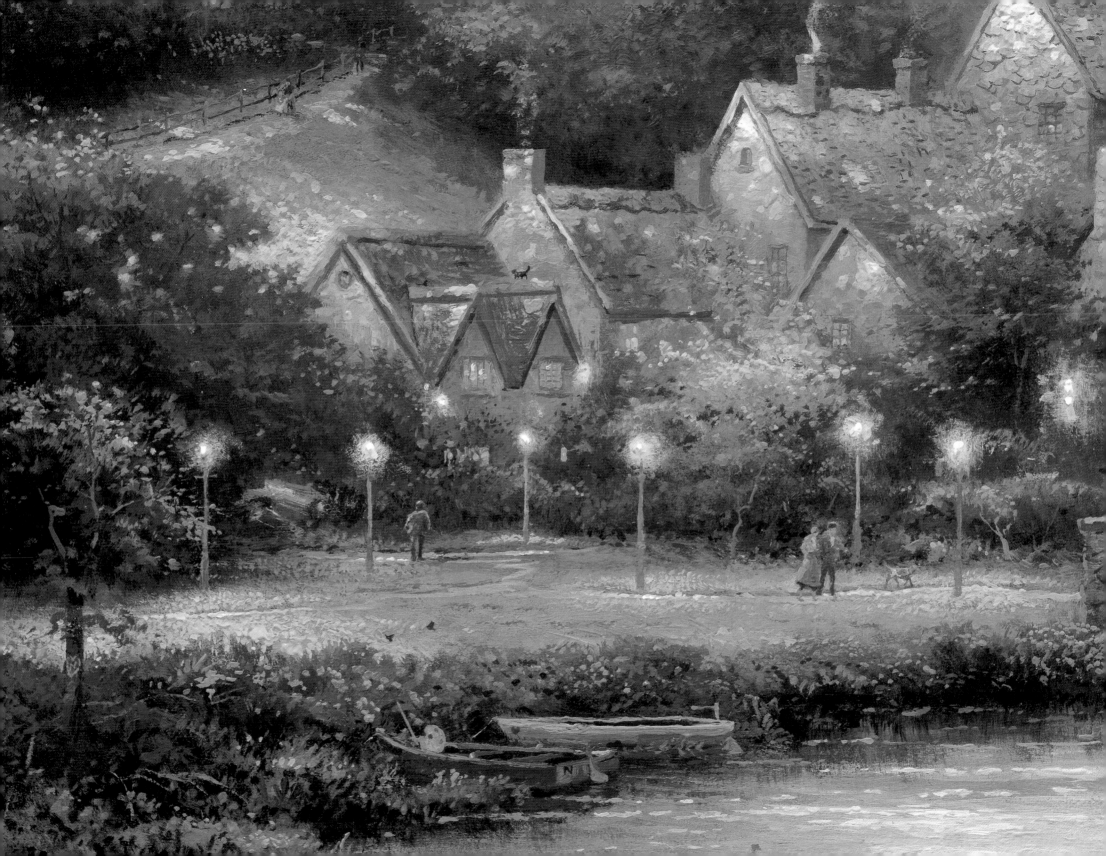

THOMAS KINKADE

Paintings of Radiant Light

BY THOMAS KINKADE AND PHILIPPA REED

ABBEVILLE PRESS PUBLISHERS

NEW YORK · LONDON · PARIS

Designer: Barbara Balch
Production Editor: Owen Dugan
Production Manager: Lou Bilka

Printed and bound in Korea.

First edition
2 4 6 8 10 9 7 5 3 1

Library of Congress Cataloging-in-Publication Data
Kinkade, Thomas, 1958–
 Thomas Kinkade: paintings of radiant light / by Thomas Kinkade and
Philippa Reed.
 p. cm.
 Includes index.
 ISBN 0-7892-0082-1
 1. Kinkade, Thomas, 1958– . 2. Painters—California—Biography.
I. Reed, Philippa, 1954– . II. Title.
ND237.K535A2 1995
759. 13—dc20
[B] 95-34334
 CIP

CONTENTS

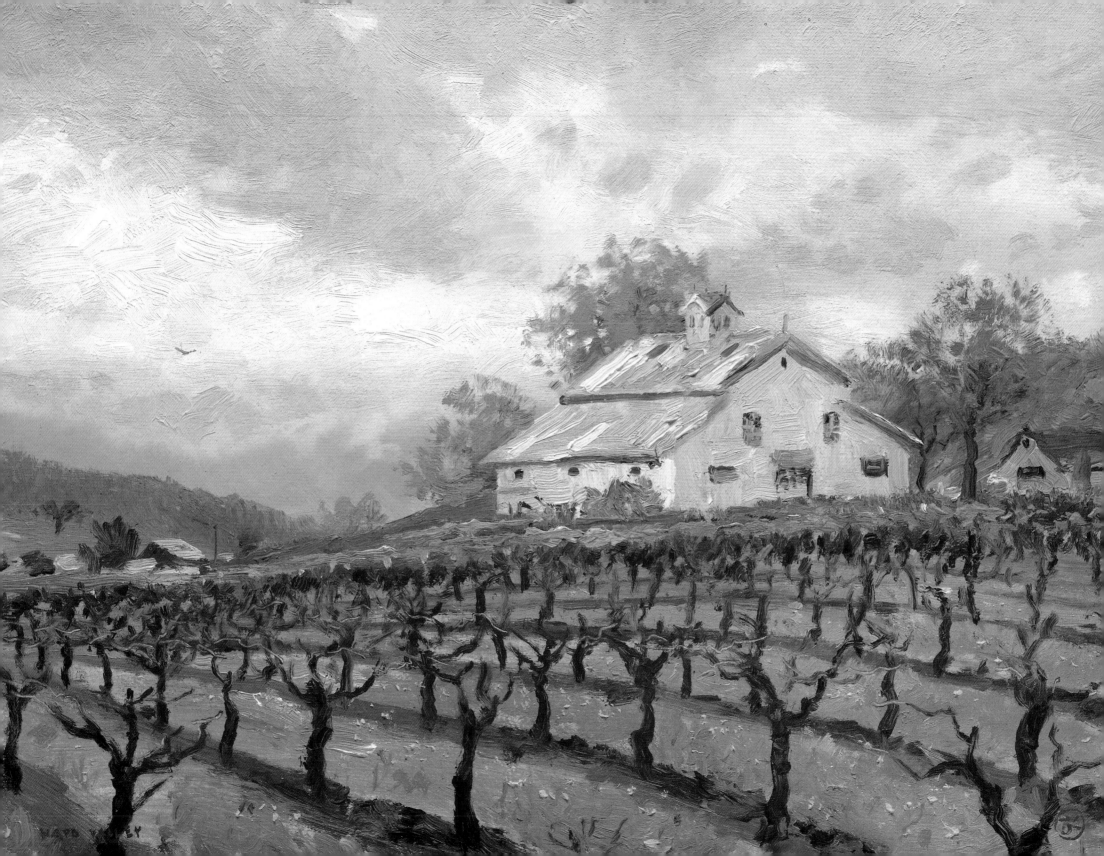

The Artist and His World

by THOMAS KINKADE

Recently, I went with my father and my brother Pat to Omaha Beach in France, where the Americans landed on D-Day in 1944. It was a pivotal experience for both my dad, who fought in the war, and for me. I grew up hearing my dad's amazing adventures and war stories. So it was an awesome feeling to drive up to Omaha Beach and know that this was a real place. The day we arrived no one was there. Just a silent beach with low waves lapping in, and an elderly man on the beach with his memories. Dad stood with the sun at his back, casting a long shadow, and I knew that all those ghosts—the memories he had from those years—were

Thomas Kinkade's studio, IvyGate Cottage

coming in like waves off the ocean. For fifty years he dreamed about going back to Omaha Beach. Now here he was. And there I was, an artist whose goal is to share memories and traditions with people. That day is a part of the heritage I will pass on to my own children—the day that Grandpa and I stood on Omaha Beach. The feeling of sharing something so powerful with my dad and brother, watching the light on this quiet beach, knowing that we were standing on a spot with such a rich history, was an unforgettable moment that I could share with others—my wife, three children, and perhaps even with the people who collect my work. After all, I suppose sharing memories and special moments with others is what my art is all about.

Opposite: Spring at Napa Valley, *oil on canvas, 9 x 12 in.*

Life and Art

I don't see my art as something distinct and different from my life. My art is nothing more than a reflection of who I am as a person—what I value, believe, and experience. You do things as a painter for private, artistic reasons. You paint because you have to inside. And then it turns out that something public is happening—lives are being touched by your art. In a way, you have to ignore that. As an artist you must continue to reach deep inside yourself to experience life and to discover and bring to life on canvas the private inner daydreams we all share. And right from my earliest years, I got a lot of happiness from my art and from the fact that what I created brought joy to others.

Early Years

It's funny how, as a child, you're shaped by seemingly random events. The first time it dawned on me what it meant to be an artist was when I was sitting with one of my sisters—I have three sisters who are much older than I. I couldn't have been more than three-and-a-half or four, and one of my sisters was drawing a picture of a road going back to some hills. She drew the road as two parallel lines, and she asked me, "What do you think of this, Tommy?" I remember erasing the road and redrawing it as lines converging at the horizon. When my sister said, "That looks better," something clicked inside me. All at once I realized that this two-dimensional piece of paper could look like a world of space. And it became my obsession, from then on, to draw the world in space. And throughout my school years, I became known for my talent in art.

I grew up in Placerville, a small town in the foothills of Northern California. My family didn't have a lot of money, but together with my younger brother, Pat, I had a kind of Tom Sawyer childhood. There was no dare Pat and I wouldn't take, no adventure we wouldn't embrace. Our tree house was a makeshift palace in the air. We had secret hideouts and homemade go-carts—and of course, an entire cast of imaginary characters in our nightly skits. I grew up in a place and time when six- and seven-year-olds could ride their bikes to town by themselves without their parents having to worry. It was a very innocent era.

Thomas Kinkade at two years of age

My mother was absolutely full of unconditional love. We grew up knowing that no matter what happened, she was always there for us and that she loved us. Mom was the first "collector" of my art. She was the one I wanted to show my drawings to first. She would ask me questions about what I was doing, and when it was done she would frame it and hang it in the house right beside her prints by famous artists. The two pieces of art in our house that I really remember were a Rembrandt print and a print by one of the Parisian street scene painters, a boulevard with the lights aglow. To this day, I'm sure that's why I love the effect of wet streets with lights. And seeing my drawings hanging on the wall next to reproductions of great masterpieces encouraged me to think that I might become an artist someday.

My sister Katey was another source of inspiration when I was young. She worked at the town library, and she would bring home stacks of art books for me to read. I also pored over back issues of *American Artist* magazine, because they seemed full of the best in traditional American art. At the time, I kept a journal, and in it I wrote about this dream I had that some-day I would have my own studio and be an artist just like those I had

Kinkade at art school

read about. It's amazing how influential all that reading was on my young mind. From the age of eleven or twelve on, all I ever read were art books.

From junior high onward my whole life was my painting and drawing. I would walk, sketchbook in hand, through the fields and lanes of Placerville. I was fortunate to live in a very beautiful place— we lived on a hill that was all forest. There were barns, and there were deer and squirrels—a lot of wildlife. By about age eleven, I had become fascinated with the landscape and with drawing from nature. And at about this time, some miraculous influences dropped into my life.

The Apprentice Finds His Masters

I think that a person is truly blessed if he finds one mentor in a lifetime. I've had two. The first was a man named Charles Bell, a painter from Los Angeles who had moved to Placerville. He was sixty-five years old when I met him, and I was eleven. I had applied for a job at a sign shop in town, the Western Sign Shop. This was when sign painters were true craftsmen. To be a sign painter was still

a big thing back then, before computers did it all. Charlie was considered one of the best sign painters in America, but he had so many other interests. He was a master shipbuilder, and he wrote two books about ship design that became minor classics. He designed and built his own house by hand. He was also an artist—he did beautiful watercolors and sketches on location. It was because of Charlie that I got into the habit of carrying my sketchbook with me everywhere, something I still do today.

Charlie took me under his wing and nurtured me. One day I noticed that Charlie changed the scene he was sketching—he took out a telephone pole, and added an extra boat. When I commented on this, he said, "Artists have the freedom to change the world any way they want. Never be afraid to change a scene if it makes the picture better." I didn't know you could do that! It was something that I would remember years later, because Charlie had unknowingly unlocked for me one of the basic keys to my career as a romantic landscape painter.

After Charlie, another incredible mentor entered my life. I'm a Christian man, and I can see God's hand in my daily life, but this was definitely an extraordinary miracle from God. Glenn Wessels was an artist who had been a big behind-the-scenes influence in the 1940s and '50s. He taught at the California College of Arts and Crafts, and then for many years in the art department at the University of California. Glenn had done incredible things. He had been in Paris between the wars, and he knew people like Hemingway, Picasso, and Gertrude Stein. He also wrote art criticism, and he was a photographer and a close friend of Ansel Adams's.

Kinkade in his studio

When I met met Glenn, he was nearly eighty and I was a sophomore in high school. He had just moved to Placerville from Berkeley after the death of his beloved wife, and had set up a studio in a converted barn near our house. He had broken his hip in a jeeping accident with Ansel Adams and was having a hard time getting around. I offered to help out in the studio in exchange for being allowed to watch over his shoulder and learn what I could do. I remember the anticipation as I went to Glenn's studio each day. I would crack open the door and see him at work on a new canvas. I can still smell the intoxicating scent of the studio—a mixture of turpentine and brewing coffee!

As it happened, Glenn, like Charlie Bell, took me under his wing and began teaching me, sitting down with me every day and

pouring into me all the wisdom he had stored up during his long life. He was a great philosopher on the subject of art. He talked about what he called the spatial box—the spatial dynamics of picture-making. Today, people look at my paintings, and the universal comment I hear is, "I feel like I can step into that painting." I attribute that to Glenn's influence, but that isn't all I got from him. I always say that Glenn didn't teach me *how* to paint, he taught me *why* to paint. He saw fine art as a high calling, worthy of a person's utmost dedication. Art was, to Glenn, more than a profession: it was a mission.

Shaping a Credo

I started to formulate my own personal credo at this time, which was that art is first and foremost a very deep form of communication. I liken it to the experience of nature. You cannot go to Inspiration Point in Yosemite and look out over that valley and not have your life changed a little bit. Something about it is overwhelming; you're in awe of God's creation. And to a large degree, that's my mission as an artist—to create little glimpses of a world that is tranquil, peaceful, and full of the beauty of God's creation. People who see my work often tell me they feel peace when they enter the world I paint. Others who have had terrible problems in their lives write and tell me that experiencing my work helps them rebuild a sense that there is joy in the world—that there is beauty, something good awaiting them somewhere.

I began to see that the populist definition of art had completely gone from our culture. Art had become something that existed on the fringes of society—a subculture that had little bearing on the average

person's life. This struck me as such a shame, because there were popular forms of other arts—music, architecture, dance, and theater. But art had not really found an equivalent, at least in terms of a fine art expression—that is, art from the artist's soul, direct from his or her own vision and heart. While thinking about such questions as a young man, I became introduced to the art of Norman Rockwell.

I view Rockwell as an important artist because he helped define so many traditions of American popular culture that we take for granted now—the small town, people returning to their roots, a sense of hometown America. You go to the Norman Rockwell Museum in Stockbridge, Massachusetts, and there are hundreds of people there on any given day—far more than you'd find at your average museum. That says something about the enduring value of his work. Another American artist I discovered about this time was Maxfield Parrish. At the peak of his career, one out of four homes in America had a Parrish of some form on a wall—further evidence of the impact an artist can have on his or her culture.

In high school, I began to study Rockwell's work and technique. For a while I toyed with going in the same figural direction he did, but I began to see so much more power in the landscape as a universal expression. A house, a village, a landscape—almost anyone can identify with these. By my mid-teens I became even more heavily involved in the study of landscape and landscape artists. I was captivated by the work of Thomas Hill, who struck me as one of the greatest landscape painters in California during the nineteenth century. I'll never forget the first time I saw one of his paintings of Yosemite. It was at the Oakland Museum, and that experience is one of the reasons why I

paint landscape. No painting has ever taken my breath away like this one did. The piece is about six feet by ten feet, and its illusion of three-dimensional depth is staggering. I felt like I was going to fall off the edge of the precipice, it was so impressive. After seeing Hill's painting I became totally dedicated to the idea of doing what I call romantic landscape painting—works like those by Thomas Hill, Albert Bierstadt, Thomas Moran, or Frederick Church, who each painted a very idealized world. Recalling what Charlie Bell had told me, I started to make paintings that were based on my observation of nature, yet which were enhanced by my artistic vision. By changing certain aspects of a scene, I could greatly increase the painting's dramatic impact, creating something that was both of this world and also a world unto itself.

Taking the Boy from the Country

At Glenn's suggestion, I applied to Berkeley. Thankfully, I was admitted and received several scholarships. I took my life savings, which I remember was about 1800 dollars—earned from various jobs, my paper route, and my work at the sign shop—plus my scholarships, and went straight out of high school to Berkeley. Talk about culture shock! You couldn't imagine two places more completely opposite than Placerville and Berkeley. I got a studio, a basement room in an old apartment building on Dwight Avenue, and I would retreat there and work late hours on my paintings. I began to get a real sense of a work habit—a pattern in my life where art began to be a disciplined part of my day. I knew I was going to be an artist, even if I had to sell my work on the street somewhere; no matter what, I was going to make my living doing what I love to do. I started to do a comic strip and editorial illustrations for a newspaper called the *Daily Californian*. I did hundreds of drawings for them. I remember getting paid five dollars per illustration and three dollars per comic strip—but at least I was making money through my art.

It was also at Berkeley that I met fellow artist James Gurney. In another amazing coincidence, we were assigned to the same dorm room freshman year. The day we met, we stayed up half the night talking about our art. He became my closest artist friend, and my colleague in many adventures. Jim later achieved great success with his "Dinotopia" creations, and to this day our friendship continues to be an inspiration for each of us. We were each other's best man at our weddings and our kids are about the same ages. Our adventures on the road continue, but now we take our families with us.

At Berkeley, I had studied a wide variety of subjects—rhetoric, English literature, music. I wanted to get a broad humanities education, as Glenn Wessels had advised me to do. But having grown up in a small town—which was a lot like living in a Norman Rockwell painting—the anything-goes environment of Berkeley made me hunger for more structure in my environment. I remembered a man I met when I was fourteen. My dad had taken me to see an artist for the *Sacramento Bee*. He recommended getting a general education, and then going to the Art Center College of Design in Pasadena. "Don't go anywhere else to refine your skills as an artist," he had said. At the time it was the best illustration and applied arts school in the country, and it was legendary among artists.

I applied to the Art Center and was accepted. My time there was the most intense period of focused dedication that I had known. The workload was grueling—"all nighters" were common—and the stress level was intense. The competition with other students forced you to work at a very high level. I suppose I was a bit of a rebel at the Art Center. Most students were doing hard-edged photo-derived work, but I wanted to paint soft, romantic things with a heavy dose of imagination. A few of my teachers, especially Ted Youngkin and Jack Leynwood, encouraged my traditional approach.

During my art school years I lived at the Golden Palms Apartments, which was another one of those major experiences—I've heard it has become something of a legend among Art Center students and up-and-coming artists. James Gurney, who had also transferred to Art Center, lived there, as did Paul Chadwick, Bryn Barnard, Ron Harris, and many other well-known artists. We were all really poor, but we had dreams of making our living as artists one day. It was a bit like the Pre-Raphaelite brotherhood. I believe that an artist's most important education comes not from school, but from the stimulating company of fellow artists. My relationship with other artists

Kinkade and TV crew at IvyGate Cottage

at the Golden Palms set the tone for my career. We challenged each other to dream big dreams and encouraged each other to accomplish them. And in the process, we had a lot of fun.

An Artist Comes of Age

The Art Center was a marvelous phase, and as a result, a part of me awakened again. After two years of working at a very dedicated level—often at the studio twenty hours a day or more—I wanted to get out into open air, to work from nature again. About this time Jim Gurney and I began taking sketching adventures together—we called these expeditions "hoists." I don't know where the word came from, but to us it meant simply packing our sketchbooks and hitting the road.

Once we went to sketch at the Los Angeles freight yards and we had an experience that changed our lives. It came in the form of a man named Bud, a professional hobo we met in the shade of a boxcar. We stopped and began asking him questions about his life. Soon we began sketching him, and as we worked he proceeded to tell us about his life on the rails. He believed

in something called the music of the rails, and that if you had the music in you, you were a hobo. It was kind of a mystical view of being a hobo, but being the romantics we are, Jim and I ate this up. We decided to do a hobo trip of our own that summer—the summer of 1980. This was to be the hoist to end all hoists.

We left the Los Angeles freight yards in June, our backpacks filled with odds and ends of clothing, a few peanut butter sandwiches, and numerous sketchbooks. By the time we arrived in Yuma, Arizona, we were black with soot and rust. We met a sweet older woman who said we could come to her house and use her garden hose to clean up. Afterward she graciously offered to introduce us to her friend at the local newspaper who might be interested in our story of sketching and traveling. Sure enough, the paper did a big article on the two young "hobo artists" traveling across America. By that time, we had done some sketches, and they featured them in the article. That article set a trend, and everywhere we went we started to get publicity. The biggest article we had was in the *Nashville Tennessean*. Then a radio station did a one-hour interview with us. This made us think that what we were doing—this combina-

Thomas and Nanette Kinkade on their wedding day

tion of sketching and adventuring—was of interest to people. We had an idea for a travel sketcher's handbook. The more we discussed it, the more excited we got.

We finally ended up in New York. We rented a typewriter, and would sketch all day and type all night at a cafe. After a week or so, we took all our sketches and our manuscript to Watson-Guptill Publications—one of the largest publishers of art books. We walked in and told the receptionist we had a book idea we wanted to present. "You can't just walk in here," she said. "You have to send something in first. We get fifteen manuscripts a day." So we asked who the person in charge was, but we were told that she was too busy to see us. Then, by an amazing miracle, she just happened to walk by at that moment. We introduced ourselves, and she agreed to meet with us for five minutes at 3:30 the next afternoon.

Our funds had run out, so that night we went to an abandoned pier on the Hudson River to sleep. We put our manuscript and sketches under the pier for safekeeping, but we didn't realize that rivers had tides. When we awoke the next morning, all our materials were floating in the water. But we weren't willing to give up. We spent the

day photocopying our manuscript to clean it up and running around New York making new sketches—I think we each did a dozen or so sketches that day! By 3:30 the next day we were ready. The five-minute meeting turned into two hours: it turned out that they had been looking for a book on sketching for years. A few weeks later, we had a contract, and a year or two later, *The Artist's Guide to Sketching* came out, and it was one of their best-sellers that year.

After Jim Gurney and I left Art Center, we both, through another one of those miraculous coincidences, landed jobs as background painters on an animated feature film called *Fire and Ice*, which was directed by Ralph Bakshi. Frank Frazetta, one of the great fantasy painters, was the movie's art director. Jim Gurney and I did all the background paintings—about six hundred each over the course of two years. Also during this time we were working on our book, and I was doing paintings for galleries. It was surely the most energetic phase of productivity of my life to that point. But Jim and I had a great time. We got paid to paint all day, every day, and as we worked we'd talk about the masters of academic and naturalistic realism. Our work on *Fire and Ice* became a training ground for these masters' techniques. We'd paint a Frederick Church scene, then an Albert Bierstadt scene. It was incredible experience for exploring the effects of light.

Finding Love and God

I first met my wife, Nanette, when I was thirteen years old. I was a paper boy for the *Sacramento Bee*, and Nanette's family moved into a neighborhood on my route. She was a beautiful twelve-year-old blond girl who seemed very mature for her age. We got to know each other, and became childhood sweethearts. When I went off to high school, I suppose I thought I was too big to have a girlfriend in junior high, so we broke up. But we kept in touch, and I always knew in my heart that we were meant to be married. Even when I was in college, and dating different girls, Nanette and I would still get together once a year and go out on these wonderful dates. But the way we got back together was another miracle.

When we were in college, Nanette and I each had other sweethearts. While I was still an art student, I started to show my work in galleries and I would send Nanette clippings about my shows. I guess this attention didn't sit very well with Nanette's boyfriend, so she asked me to stop writing, and for a year or more I didn't send her anything. But then one night I had a dream that I had called Nanette and that we had gotten back together. I woke up the next day and thought: I have to call Nanette! And when I did, I learned she no longer had a boyfriend and had moved back to Placerville to be with her parents for the summer. After talking a bit, I asked her on a date. "I'll pick you up in my new car, and we'll go to Lake Tahoe," I said. So I hung up the phone and suddenly I realized the only vehicle I owned was a broken-down motorcycle. That week, I went out and bought a nice used car and drove up there. Nanette really loved the car. Thinking back, buying a car for a date was pretty extravagant, but in the process I got back with my true love, so I suppose it was worth it! During our trip to Tahoe I professed my love to her, and on our second date, I proposed. We were married in 1982, and I would describe our relationship as truly a love affair. For me, marriage is such

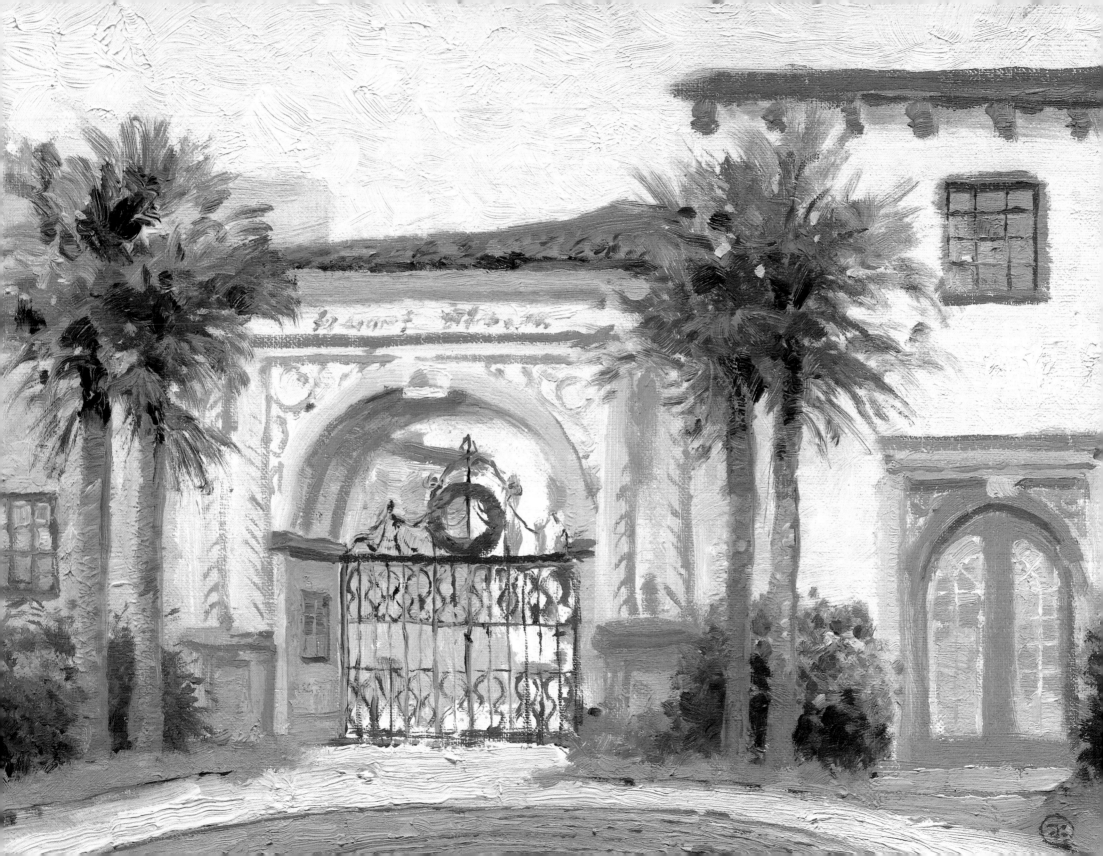

a liberating and exciting experience. Nanette is my best friend for life. It has gotten to the point where if something interesting happens to me and Nanette's not there, I feel like I have to go home and tell her about it, or else I haven't really experienced it.

Some time before Nanette and I got married, in 1980, I had what turned out to be the most important experience of my life. I had reached a state of disillusionment and skepticism, and I needed a vision and purpose. About this time I met God in a real way and I became a Christian. After my salvation I began to discover that my faith was a highly personal walk with God, and that God would reveal Himself every day through experiences. Every one of these—from the book, to the way Nanette came back into my life—I would put into the category of miracles. I believe each life is filled with God's miracles; you only need to look around a bit and see them.

The Birth of a Company

After *Fire and Ice*, I had the opportunity to keep working in the movies, but I decided that I wanted to pursue my own art on a full-time basis. And at that point, in 1984, Nanette and I also decided to leave Los Angeles and return to Placerville. In the meantime, my paintings were selling quite well through a number of galleries. I realized there was a very large, enthusiastic market for the kind of traditional paintings I did. But I also knew I couldn't keep up with the demand—there must be a way of providing artworks for people without having to paint every

Opposite: The Gate*, oil on canvas, 9 x 12 in.*

single one. I began to understand why illustrators such as Norman Rockwell wanted their work to go onto the covers of such magazines as *Saturday Evening Post* rather than into galleries. How few people see paintings in a gallery, but as Rockwell said, "The *Saturday Evening Post* is a gallery that goes into millions of people's homes." When I begin thinking about ways to get my work into the homes of people everywhere, my life changed again—Nanette and I made our first foray into art publishing. I knew we were on the right track, because my first limited-edition print, a scene of an Alaskan gold-rush town called *Dawson*, was extremely successful. It was followed by another historical scene, called *Placerville, 1916*, which sold out a month or two after we launched it. These humble beginnings grew into one of the biggest companies in the field of art publishing, art licensing, and collectibles.

At first, the company was just Nanette and me—I suppose she was the boss and I was the employee! She packaged prints, ran the books, and answered the phone. My job was easy by comparison—I did the paintings. Pretty soon, we had ten dealers selling our prints. There was definitely something viable there—the company quickly grew to the point where it was too much for Nanette and me to operate on our own. Meanwhile, I had become friends with a very talented businessman named Ken Raasch. I told him about my vision of a publishing company that produces art that uplifts people—art that carries a vision and a testimony of our Christianity, which provides a bit of hope for people of all faiths. This idea really appealed to Ken, and we started a company. We called it Lightpost Publishing, because through our products we hoped to share light with people, and because the underlying theme of all my work is light.

Miracles began to happen the second we started that company. God gave us wonderful employees—people who have become almost like family. Ken has a wonderful ability to inspire a vision in the individual while maintaining a great feeling of unity in the group. We always say that Lightpost is not a company; it's a cause. It's inspiring to visit the offices of Lightpost, to see the highly talented and dedicated people who are so committed to what we do. It's also humbling, because I realize more than ever that God surely had His hand on Lightpost. I feel that God has put a special warmth into everything we produce, and when people see that warmth, they are drawn to it.

Painter of Light

In the past people looked upon fine art in a spiritual way. People would often make pilgrimages to see Michelangelo's *Pietà*—they really thought his sculpture was divinely inspired. People need that spiritual connection with art. I sense this all the time as I meet with people in the nationwide conventions that Lightpost Publishing sponsors for collectors of my work and they share with me how that spirituality affects their lives. There's one show that we do at 5 o'clock

Kinkade painting The Gate

in the evening. People start lining up for it the day before, because they want to be the first one to get their print signed and to meet with me. This kind of experience is both flattering and humbling—it makes me want to work even harder to create art that will bless people.

Light generates so much hope in the individual. People who are deprived of sunlight for an extended period often become very depressed. And although effects of sunlight are a big part of my sense of light, I'm also drawn to the different forms of manmade light. I suppose you could say I'm a student of lampposts, after all lamplight plays a big role in my work. I even named my home in Northern California Lamplight Lane. I've often thought of light as a spiritual dimension, and it is interesting to me as a Christian that light is one of the most consistent metaphors throughout Scripture. Christ himself said He was the light of the world, and the first thing God created was light. It's also a great symbol for the life of the believer—we are told to let our light shine before others. The truth is represented as light. It's something that goes out and opens up people's darkness.

For me as an artist, light has so many planes of meaning, not the least of which is that it's so emotionally warm. If you've ever taken a

walk through the woods as dusk starts to fall, you know just how dark it can be under the canopy of trees. You can look up and see what amounts to the last radiance in the sky, and often you can barely find your way. But if you walk through that, and you come to a campsite where a lantern is hanging, or, better yet, see a lit cabin, the light has a warm radiance that's entrancing. I've often thought that light elicits one of the great urges in all human-kind. We are drawn to light. Many of my paintings are an attempt to get at that feeling. Since in my art, I can "leave the lights on" perma-nently, it's a way that people can, figuratively speaking, hang a light in their own homes, even in broad daylight. I even like to think people will be warmed by that light. I have so often heard that analogy in peo-ple's descriptions of what my paint-ings mean to them. I'm told that people feel as if they wanted to step into the light, and that no matter what was going on in the day, they could just feel at peace by going into the light of the painting.

Nanette Kinkade and the children in England

My discovery and use of light began early. As a child, I was fas-cinated with the play of light and how that translated into color. A big insight came when I recognized that light has color, and that simply by choosing colors, you can create an intense effect of light. It really amounts to the fact that shadows are generally cool, although at their deepest they get warm again. Light is generally warm, though at its brightest, it gets cool again. Because of that simple formula, you can play with color in a subtle way that creates radiance on the canvas. I began formally studying the visual effects of light as a teenager, and in the movie business I did a really intensive study into the effects of light, since I was given complete freedom to invent the lighting qualities of the scenes I worked on.

When I started doing paintings for galleries, I was fascinated by this idea of capturing light on canvas. I began to be known as "the guy who paints light." I found that oil paint allowed me the freedom to develop textural effects that would catch the light. When a painting was lit in a gallery setting, with the light raking over it, it would just explode with light. As my work developed, I began to want to create an effect that is not readily under-standable. I experimented with the hundreds of colors available to the oil painter. Some of these pigments are quite radiant, I found, and I began to use many layers of paint, carving and shaping the many pig-ments much as a sculptor would carve marble. Some layers are thick, some are thin. Through carefully modulated color, a lot of glazing, and

the working of those interrelated layers, I'm able to give the illusion that the painting is glowing. When the painting is completed, all the layers have been woven together like a tapestry. All you see is the painting—not the way it was painted. My efforts early on have truly paid off. As my work reached maturity in my late twenties I became known for the very efforts I had worked so hard to master—the creation of light and mood on canvas. I don't paint emotionally neutral paintings. My greatest interest as an artist is in subtly shaping the world through my own romantic vision. After all, my favorite artists are the ones who did just that—created their own worlds of hope and joy.

Family Values

I'm very open, when giving a talk or doing a show, about my love for my family. Even my paintings are full of little "love notes" to them—initials, birthdates, hearts, holiday wreaths, and of course the hidden "N" that appears throughout my work as a tribute to my wife Nanette. I even include a small number beside my signature on a painting to indicate how many "N"s are concealed in the painting. My father was often not around when I was growing up, and I became determined that when I had my own family I was going to be a dedicated father and husband. I knew that I wanted to lead a balanced life and be committed to my values. Nanette and I are very thankful to God for our successes, and humbled by how fortunate we are to have the opportunities that we do.

I grew up in very modest circumstances, with a family that worked hard for the basics of life. Little thought was given to such extras as travel; when I became a father one of the gifts I wanted to give my family was the gift of experiencing different people and places. I knew that I wanted to mesh my desire to travel, and my love of experience for its own sake, with my love for my family. When our daughters Merritt, Chandler, and Winsor came along, people were amazed at how we took them with us everywhere we went. Merritt was three days old the first time she traveled with us, and our kids have joined us on some outrageous adventures. I'm thankful they will grow up with a breadth of experience I didn't have.

Many of our family trips focus on my sketching activity for studio paintings. When visiting an area, I often create small plein-air paintings done directly from nature. Painting on location is a pursuit that adds meaning to every trip we take. One of our most memorable trips was the time we stayed in Rockwell's studio—a dream come true for me. As a kid, I was always really intrigued by Norman Rockwell's studio in Arlington, Vermont. Arlington is the place Rockwell was most closely associated with during the height of his career, since he didn't move to Stockbridge, Massachusetts, until he was much older. I believe he did his best work in Arlington. The studio I wanted to visit was one that he moved to after his first Arlington studio burned down. We were on a trip back East, and on a whim, Nanette and I detoured to Vermont to see Rockwell's studio. I didn't even know if it existed anymore, but I wanted to make a pilgrimage to it. We found the property, and saw the old red carriage house that had been the studio. I was so overwhelmed. After all, this was where *The Four Freedoms* was

Opposite: Maui Beach, *oil on canvas, 8 x 10 in.*

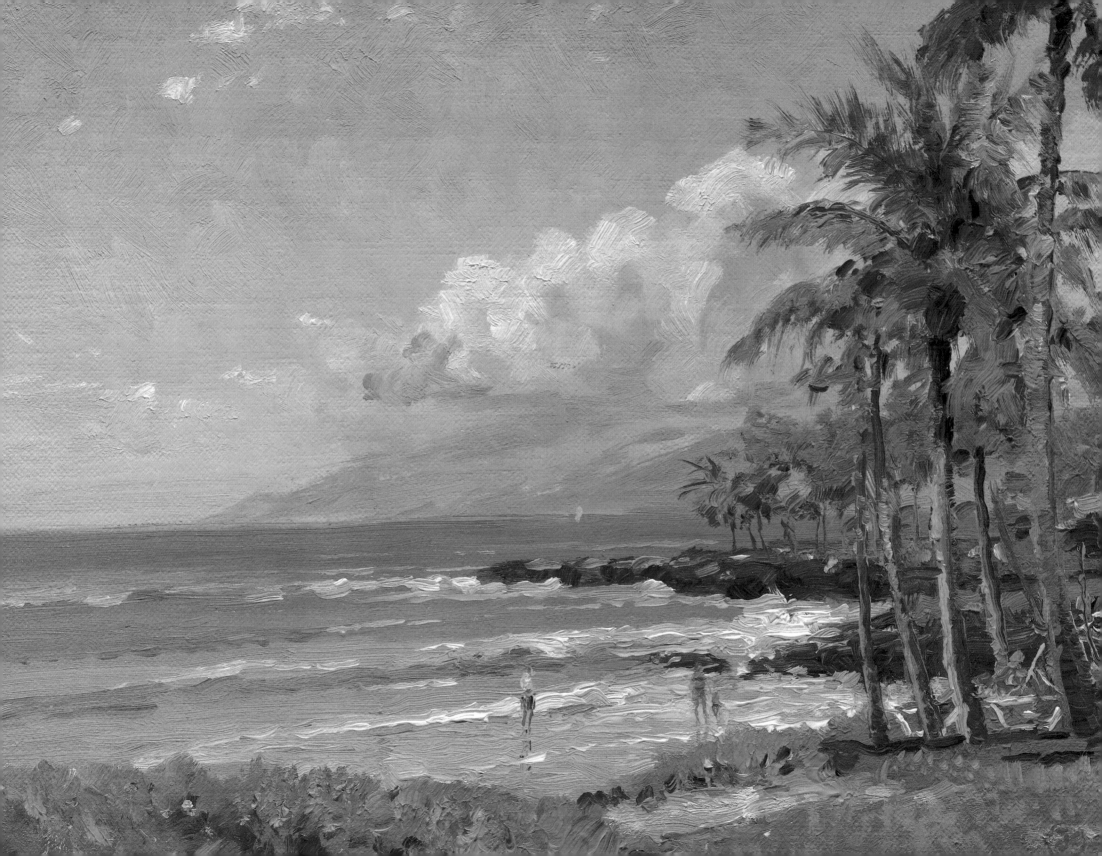

painted, not to mention some of Rockwell's famous wartime *Post* covers, such as *The Homecoming Marine* and *Saying Grace*. This was the haven for Rockwell's most creative phase, and there it was in front of us. It turned out that the current owner was operating a country inn there. So I asked if there were any chance of renting the studio—it wasn't one of the usual guest rooms. I told her who I was, and she knew a bit of my work, so we were allowed to spend the night in the studio. Then I concocted a plan to return in the fall, when the foliage colors were at their peak, and paint the landscape for a couple of weeks while living in Rockwell's studio. When I returned, she gave me special permission to paint in the studio. It was my dream to paint where Rockwell painted, with the memories of all those pictures in the air. Here I was, working on paintings in the studio of one of my great mentors. We had the kids there, and they loved the working farm near the property. We even went on a canoe trip down the Batten Kill, the famous trout river that was a favorite haunt of Rockwell's. It was a perfect rural adventure for our family.

But Nanette and I also love to have adventures on our own. Because we have this very strong love relationship, we've always felt it was important to maintain our romantic bond. I believe a marriage is a living organism that requires a lot of care. We make a priority of getting out and experiencing things together. It doesn't have to be a big thing—often a simple walk together enriches us. I believe being a romantic is really a way of life. A lot of my collectors—in particular, women—ask, "How can I get my spouse to be more romantic?" That question has come up so often that I feel almost like a counselor for the romantic way of life. Whenever I show my paintings of Carmel during slide shows, I will say to the group, "Now, doesn't that get you in the mood to take your wife for a drive down the coast and have a getaway together?" And inevitably, the women are nodding in agreement and elbowing their husbands. Couples often seem to get in a rut and feel they don't have any options. But we are the only ones who can get ourselves out of those ruts. For example, my dad has been an adventurer from day one. He will, at a moment's notice, drop everything and go on a trip. He was 77 years old, and he hadn't been to Europe in fifty years, but he just got on a plane and went with me.

Another big part of my family life is my studio, IvyGate Cottage. I now have the kind of studio I used to dream about as a

Kinkade at his easel with daughter Merritt

child. I think I identify more closely with a studio than do most artists. So many artists work just anywhere—an old garage or a crumbling warehouse. I like having a studio that's organized and has some charm to it—that's something that inspires me as an artist. Thinking back, my love of interesting studios probably started in high school, from reading all those books that my sister Katey would bring home. A great art critic once told me that he felt artists had an innate need to dominate their studio environments through clutter. In my case, clutter is just a natural outgrowth of the long hours I put in at my studio. As I work, the painting is my only focus. I don't even notice the space around me—my only goal is making the painting. It's as though I'm living inside the painting and not the studio.

As an artist, day-to-day interaction with my family is critical to me. But the fact that I work just a few steps away from home means that my relationship with my kids is a little different that of the average father. I have an open-door policy in the studio—the kids can come and go as they please. This is such an advantage for all of us. The kids are around the studio throughout the day, though my time from six to eight each evening is family time. Under almost no conditions do I violate that. I would describe my lifestyle as somewhat old-fashioned, in that my real interest is to lead as simple a life as possible. I like living within walking distance of our town—evening walks are a big tradition in our family. I like the idea that a week could go by and I wouldn't touch my car. We're also avid bicyclists. Recently my daughter Merritt achieved a major milestone: being able to ride her bike into town. This was a big triumph for her, and it's the kind of experience our small-town life offers us; it's as though we've turned back the clock a bit on the fast pace of contemporary life. Since we don't have commercial television in the house, we spend our evenings doing old-fashioned things—playing games, roughhousing, even singing. One night a week or so we have "family chapel"—a time to get together to thank God for our many blessings. Through God's grace, my relationship with my family is very much like the world I paint—full of peace and joy.

Kinkade with Merritt and Chandler

To me the keys to life are simple—a walk with God and a committed, loving relationship with your family. Those two things put everything else in perspective.

Gardens of Light

The original garden of light was, of course, Eden, which I imagine to be a perfect expression of the divine plan in its abundant fertility, its delightful profusion of colors and shapes, its fragrance, its chorus of bird song, its gentle breezes, its grace and harmony, and its tranquil moods.

Natural vistas and tended gardens are imperfect memories of Eden. In the wild places, I find a joyous exuberance in the bursts of color of a blooming field in springtime, or in autumn's flaming leaves. Gardens charm me with their sense of order, their artful arrangement of nature's colors and textures, their planned variety.

I greatly admire the gardener's patient faith that nature can be tamed, controlled, even improved by the imposition of human judgment and design. The gardens that I love to paint strike a balance between man and nature. They are luxuriant, brilliantly colored, spontaneous—trees, flowers, shrubs grow in splendid profusion. But they also betray subtle human touches, even such expressions of sentiment as hearts or initials wrought into iron fences or carved into the trunks of trees.

As a painter, I am in a sense a gardener myself, but with this important difference; it doesn't take me years to train a rose bush to climb a trellis. I can create that effect with a few brush strokes. So, of course, I have the freedom to create more romantic, more imaginative gardens than real gardeners can!

Nature's lovely vistas can provide a wonderful atmosphere of peace and serenity—even when their beauty exists only on canvas. I hope that my Gardens of Light will provide that serenity for you.

Gardens Beyond Autumn Gate

*T*here are places that touch you so profoundly that they become a part of your imaginative geography.

The Autumn Gate—a simple, evocative limestone and iron gate I discovered in the English Cotswold—has become such a place for me. When I came upon it, I knew I must paint it. While I painted from memory in my California studio, I became obsessed with knowing what lay beyond. I actually traveled to England to walk its path, and discovered the regal manor house that became the subject of *Beyond Autumn Gate.*

In my daydreams, I often return to this tranquil spot. My painting *Gardens Beyond Autumn Gate* portrays the fabulous classical grounds that would provide its ideal setting. A graceful Greek urn rises out of a reflecting pool dotted with water lilies, just as a manor house looms above its manicured grounds, with their green lawns sloping gracefully down to meandering paths. In the distance, a bench offers a quiet spot for contemplation. Brilliantly colored flowers abound along the walks and cascade over low brick walls.

A radiant light permeates the misty air in *Gardens Beyond Autumn Gate.* This is the perfection that exists only in places that touch our imaginations and our hearts.

Oil on canvas, 25½ x 24 in.

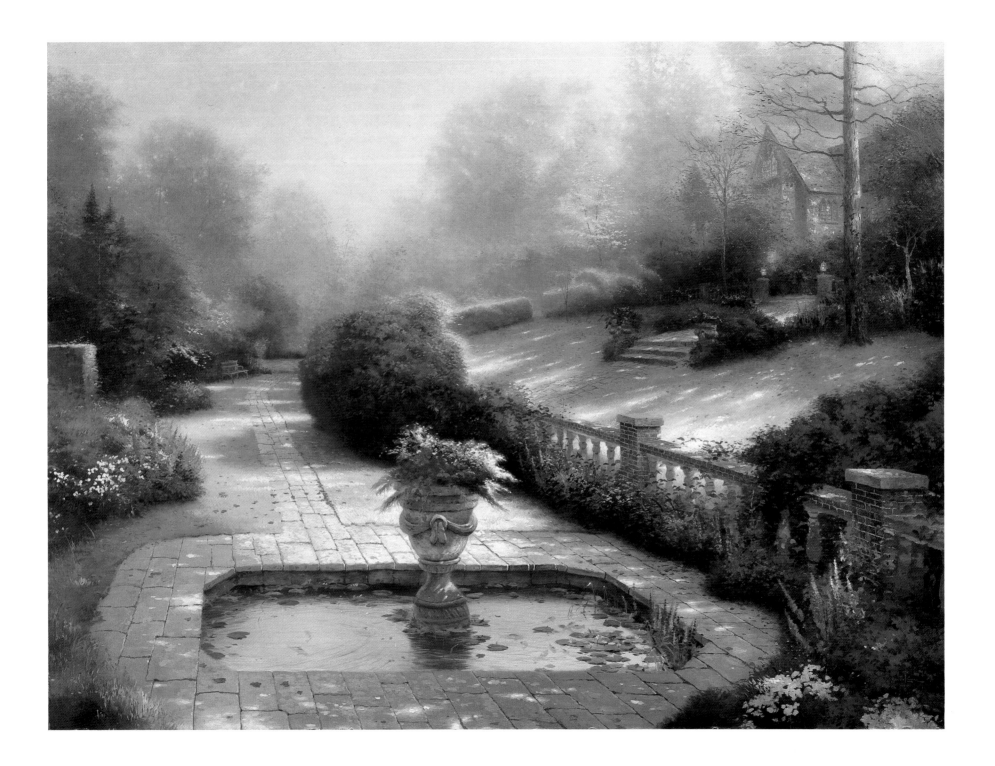

The Hidden Gazebo

If you and I were to walk together along the old plantation road north of New Orleans, I could take you to the very spot that inspired this first issue in my new Secret Garden Places collection. It's a delightful hideaway in a blooming garden—a lovely place to stop and smell the roses.

But as often happens in my work, I decided that as wonderful as the real setting was, it just lacked the charm and mystery that I so much enjoy creating on canvas. One of my childhood mentors told me that an artist must never be afraid to alter a scene if it makes the picture better. So I added the graceful sweep of the worn brick walkway and changed the Gothic roof of the gazebo to something gentler and less imposing. Hence, *The Hidden Gazebo* exists in that special realm midway between imagination and reality.

For those of us fortunate enough to find it, there exists a half-hidden path that winds its way toward a destination of great tranquility and beauty. Perhaps the stairs that lead to the hidden gazebo will carry us to a quiet place of prayer and inspiration.

Oil on canvas, 16 x 20 in.

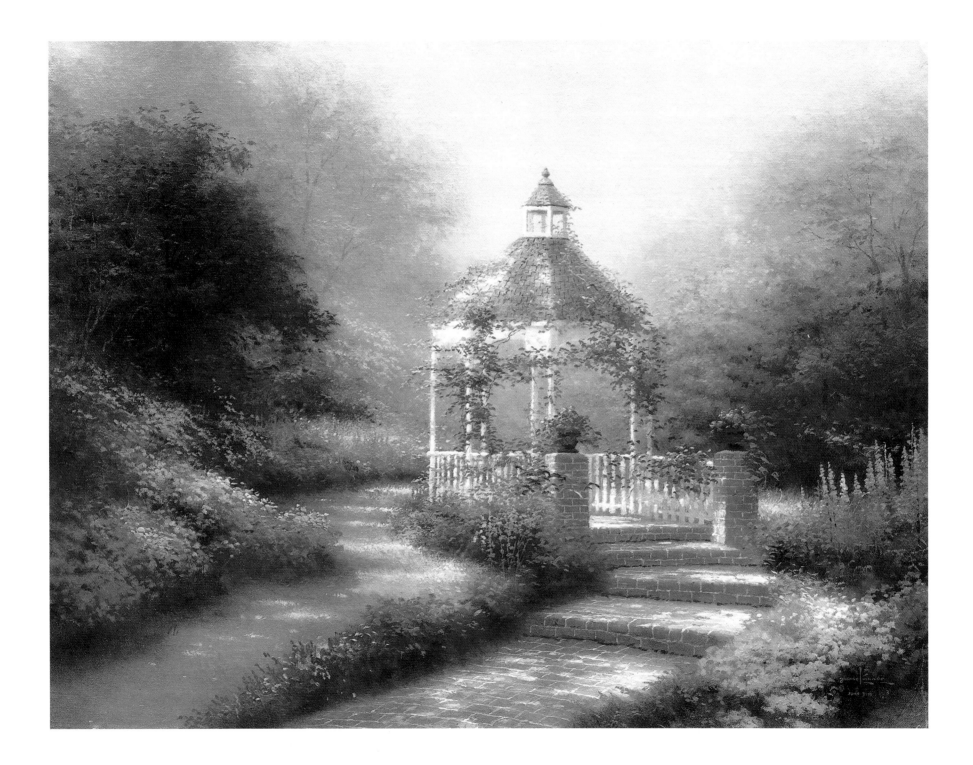

Hidden Arbor

I often seek out a quiet place to meditate and pray: a special retreat like *Hidden Arbor*, the second in my Secret Garden Places collection. This marvelous waterfall, with its myriad rivulets and streams, is based on an actual place—a little touch of heaven that my family and I discovered on a recent trip to the island paradise of Hawaii, where the wonders of nature never cease to amaze me. All I've added is the romantic arbor with its massive bronze scrollwork. (And of course, the radiant effects of light have become my hallmark!) The tropical luxuriance of the climbing flowers is a gift of the warm sun and of the mist, a perpetual veil of cooling moisture created by the dancing waters. The sound of the waterfall provides the perfect accompaniment to the tranquility and beauty of the scene.

My prayer is that this painting, and each piece of the Secret Garden Places collection, can provide a lovely promise of peace for my collectors. Perhaps each of us, if only in our hearts, can journey to these hidden places for moments of quiet refreshment.

Our first stop was at the *Hidden Gazebo*, and now the *Hidden Arbor* beckons us. What "hidden" treasure will we visit next? Perhaps we can meet there sometime soon!

Oil on canvas, 16 x 20 in.

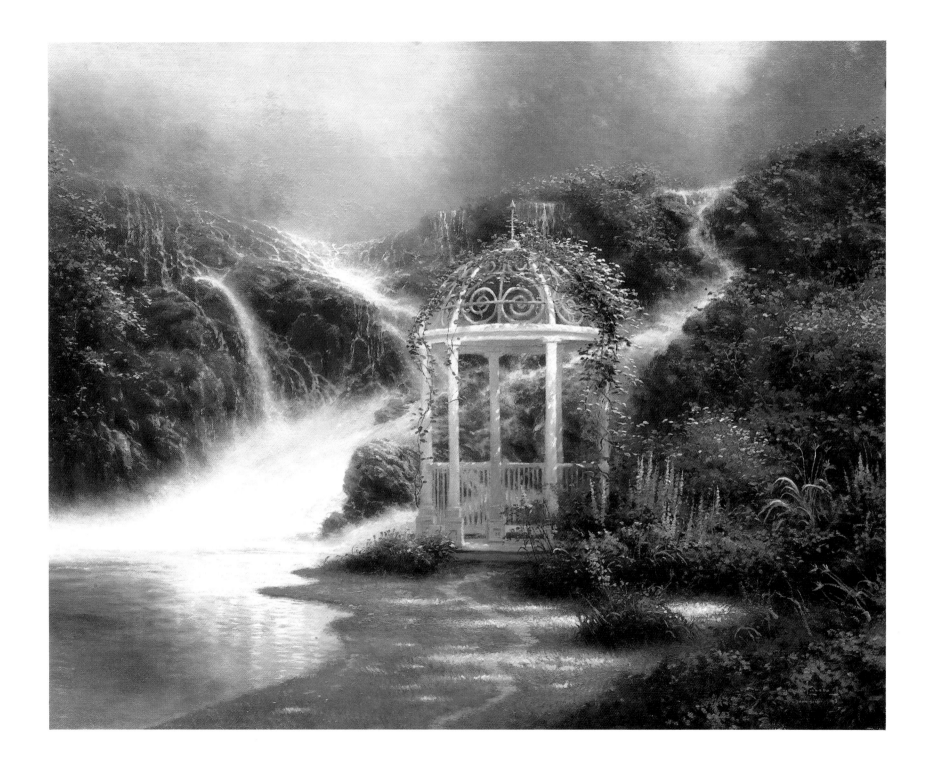

Studio in the Garden

An artist's studio is his most important self-portrait. Studios, after all, are the places we artists do our work; more important, they're the sanctuaries where we go to seek our inspiration. They have to be functional, comfortable, and above all, stimulating.

Studio in the Garden is all that and more for me. This is my second studio—a romantic hideaway in the charming California village of Carmel-by-the-Sea. I've long dreamed of a second studio—a place where I could retreat for a change of scene, but still do the work I love. And my studio in Carmel is really more than that dream come true.

On lovely days I paint under the sky, with the sound of the Blue Pacific in the distance—and nothing can be more romantic than that as far as I'm concerned! Huge windows satisfy my passion for light and allow me to stay in touch with the sun's many moods. The flowers that I love surround me in a charming English garden. And, as my collectors may have noticed, in the windows of my garden studio hang paintings that are my personal favorites.

Oil on canvas, 12 x 16 in.

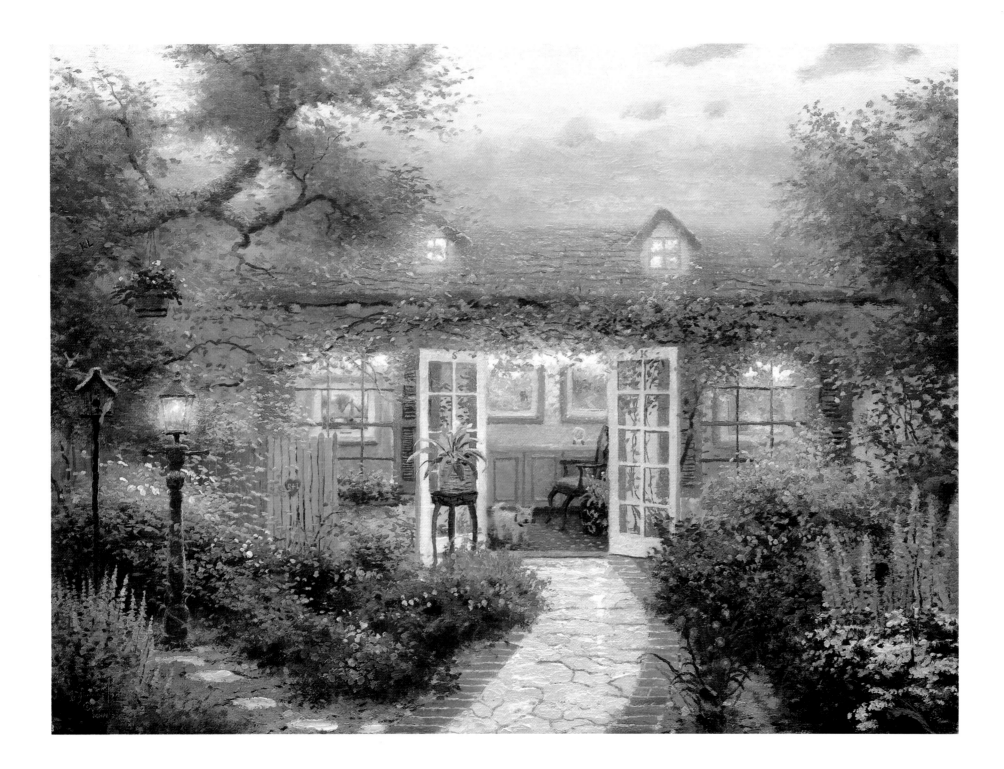

The Garden of Promise

When a close friend recently lost loved ones, I was amazed to see the serenity and peace that filled his heart. It was almost as if, despite the hardship of parting, he was already anticipating the joyful reunion that lay ahead. He reminded us that he would see them again soon.

I was so touched with the grace and hope God had given this man that I decided to do a painting as a tribute to the hope many of us share of the better life that lies ahead. I chose a garden with a rambling stone walkway climbing up through flower hedges to illustrate my theme. In my painting, as we make our way up the stony path, we seek to reach the top, where the brilliant purity of a white dogwood in the sunlight greets us with the hope of what lies beyond the gate.

There is a garden, a place of peace promised to each of us, and the gate lies open to those who wish to come in. My prayer is that my portrayal of *The Garden of Promise* will remind many of this hope that lies ahead. As one anonymous chorus puts it:

> *Beyond the gate will peace await*
> *And joy to fill each heart—*
> *A fragrant bower every hour*
> *And love that never parts.*

Oil on canvas, 20 x 16 in.

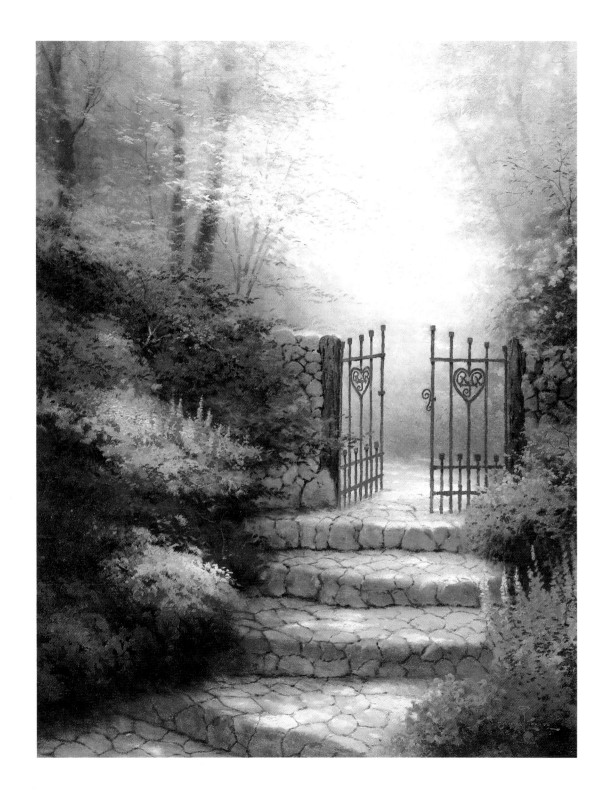

The Victorian Garden

To me, a painting of a garden is a chance to celebrate the joy of pure color. The subject for this painting is loosely based on a beautiful garden that was part of one of England's grandest country estates. The morning we were there, flowers and trees, vines and hedges, were all bathed in the glow of a moist but sunny morning and the effect was wonderfully luminous. We began wandering around the extensive grounds, which included meadows and a series of interlocking lakes, when we came upon a secret garden, overgrown and almost hidden. I was intrigued by the way the garden seemed so natural, as though it were cultivated yet still allowed to flourish on its own. The dappled light of flowering trees overhead made it almost irresistible as a subject.

As I explore the garden, trying to lock my first impressions firmly in my mind, I was struck by another sensation, the overwhelming fragrance of the many blooms. It was as though I had stepped into a huge expanse of fresh flowers and was utterly surrounded by blossoms. Back home in California, as I worked on the final painting, I was reminded of the delightful floral scent of that garden. Though painters usually deal with qualities of light and color, I must say, I hope this painting captures some of that fragrant bouquet on canvas.

Oil on canvas, 24 x 30 in.

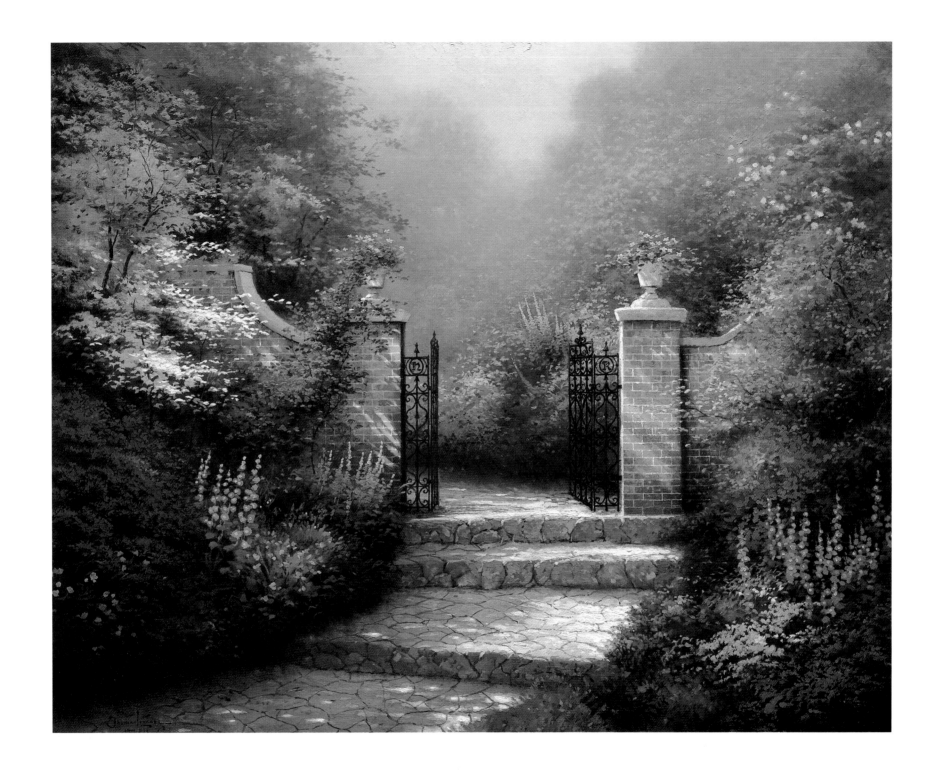

The Broadwater Bridge, Thomashire

Perhaps my pleasant memories of this beautiful Victorian-era stone bridge are not entirely based on the subject itself, but also on the wonderful ambience of its location. Broadwater Bridge spans one of the most delightful, most tranquil stretches of watercourse I've yet seen. Just beyond the bridge a spillway acts as a tiny dam to back up the normally small stream to a width of perhaps twenty or thirty yards. Flowering shrubs and lush trees line this wide part of the stream, casting dappled shade along the well-mown green banks. In all directions, nothing interrupts the unbelievably pastoral beauty of the setting.

In fact, this stretch of the stream is part of what was once a large private estate which has been converted into an exclusive trout fishing club. For the week or so that I sat beside my easel diligently working on this painting, dapper-looking people carrying fly rods would occasionally walk by, tip their tweed caps at me, and say, "Oh, I say, jolly good show!" (or something equally charming) as they saw my painting. I was so thoroughly taken with the gentility and peacefulness of the location that I invited my wife and children to the spot on several occasions to picnic in the sunshine beside the stream as I painted.

Oil on canvas, 16 x 20 in.

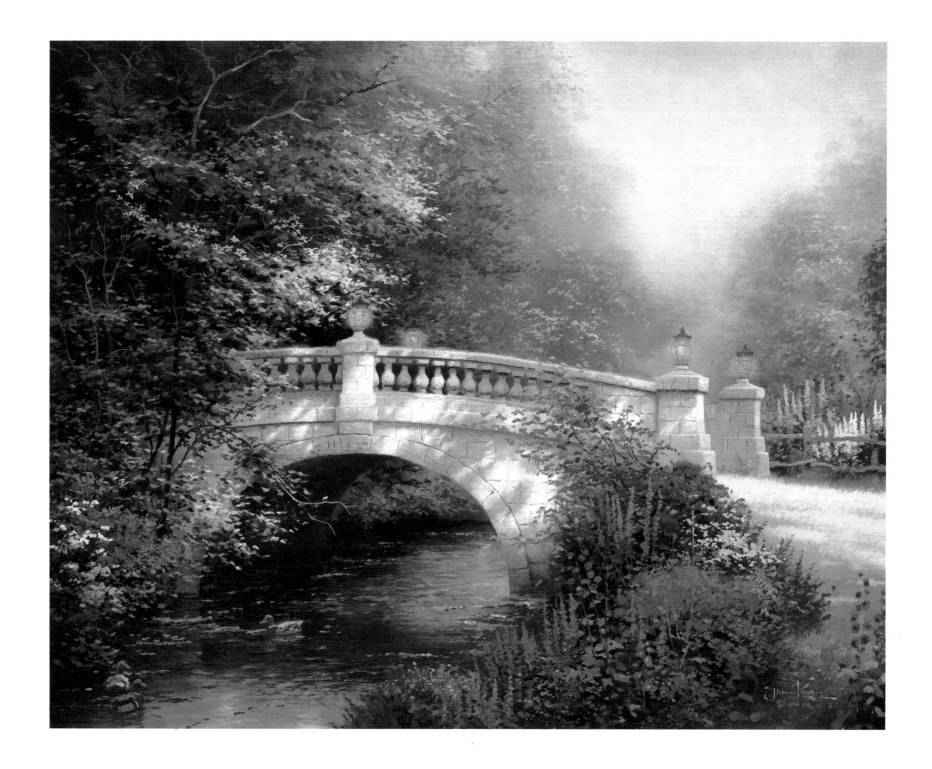

Entrance to the Manor House

The "lord of the manor"—I just love the sense of tradition behind those words. The title conveys a sense of domain and dignity that seems very British to me. I think many people have imagined life in a grand old manor house, managing estates, maintaining a wonderful stable, perhaps riding to the hounds, and of course, enjoying afternoon tea.

For these people perhaps the stately brick dwelling I've portrayed in *Entrance to the Manor House* would do nicely. Its proud facade suggests a reserved quality of the life that is very properly obscured from view. I especially like the austere simplicity of the gate and wall. The owners have entrusted nature with the task of decoration, and she has responded brilliantly with this lavish display of flowers. The collaboration between man and nature, a product of centuries, is a most attractive feature of these historic English homes.

A painting like this is an imaginative adventure for me. I try to put myself very much into a "manor house" frame of mind while I work on paintings like this. I hope the painting will have the same effect on your imagination. Tea, anyone?

Oil on canvas, 16 x 20 in.

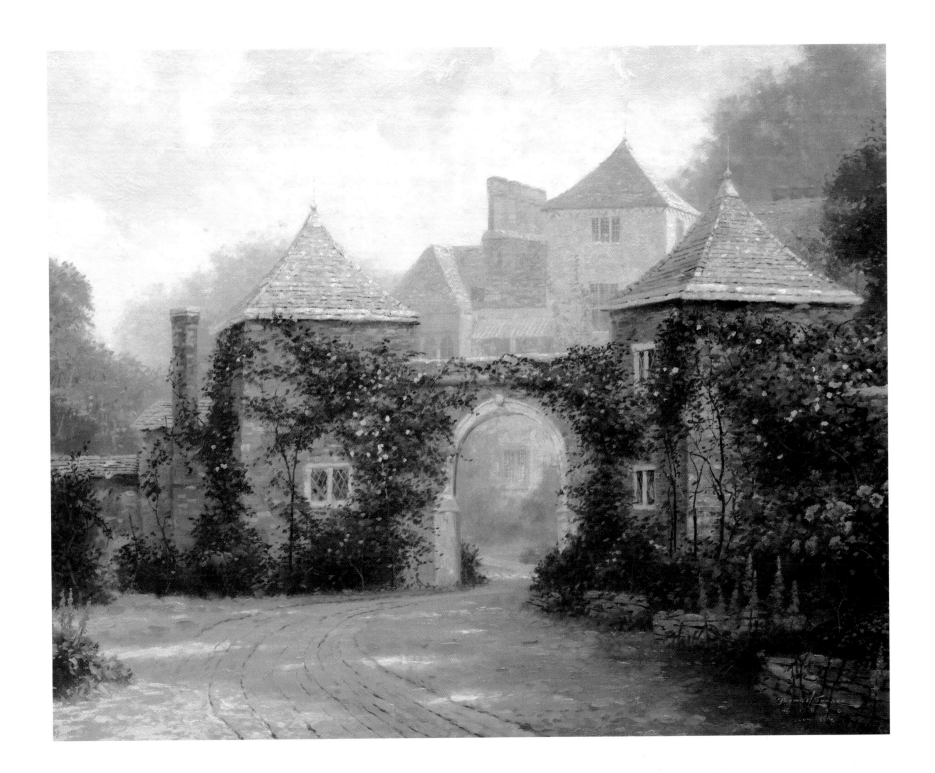

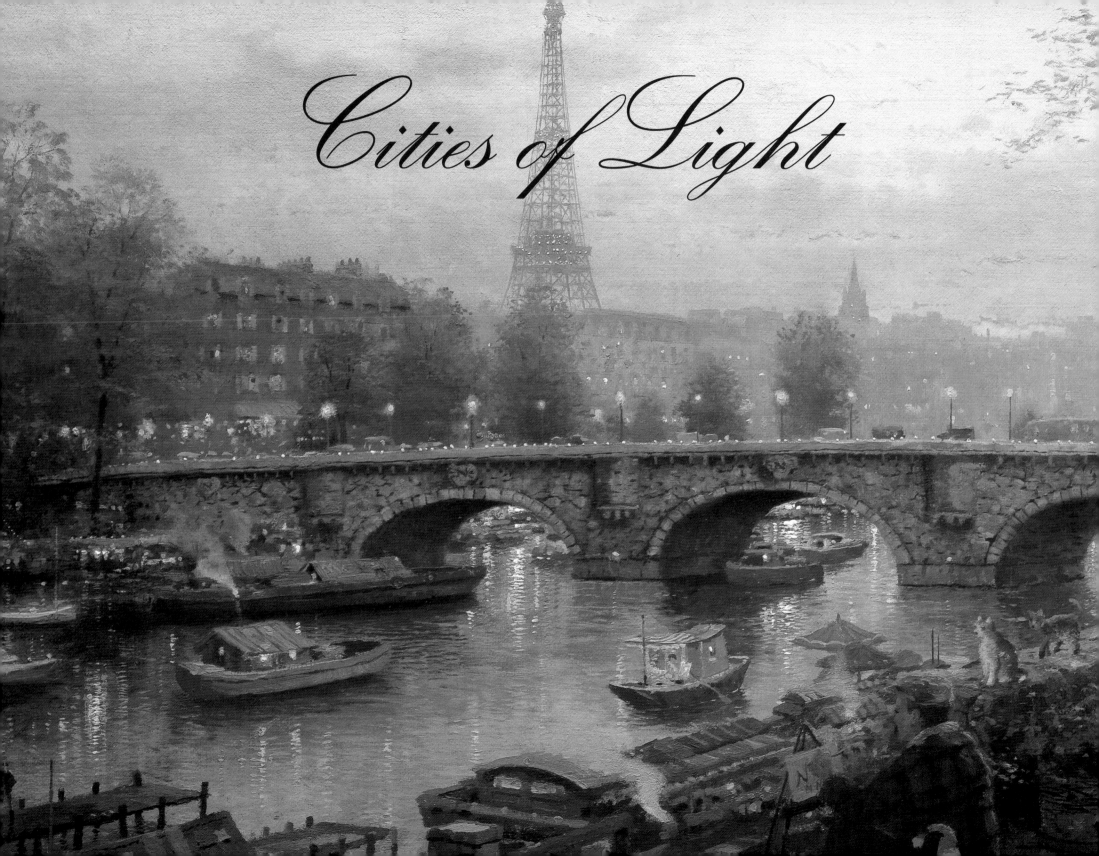

Cities of Light

grew up in the country. I love to paint rural scenes, but I love cities, too. San Francisco, Paris, Venice, London—these are some of my favorite travel destinations.

Cities are the richest and most complex creations of a people. Each of the cities and towns I enjoy has its very own distinctive character—a personality expressed in its buildings, its bustling streets, its holidays, and the humble pursuits its people value.

Whether I set up my easel on the busy boulevards of Paris, along the canals of Venice, on San Francisco's hills or along the Carmel coastline, I'm looking for that distinctive personality. One of the greatest compliments I receive is when people tell me one of my paintings has captured their memories of a certain place. Interestingly enough, to capture the essence of a city, where charm is often hidden by urban realities, you must look for hidden beauties. I suppose that is why I enjoy painting cities so much—to experience the joy of discovering something wondrous in an unexpected place.

The quiet of nature refreshes the soul and restores peace. As an artist, I feel that one of the great blessings I can offer people through my paintings is that sense of peace. But when I paint cities and towns, my imagination ignites with the bustling spirit of human activity. Cities are a microcosm of man's creative abilities, vast living sculptures that are constantly changing, constantly moving.

Cities can be places of hope, places of opportunity, places of creative stimulation. I like to think that through my city paintings I can share with others a bit of this hope and stimulation—a bit of the energy and beauty of mankind's great gathering places.

Main Street Matinee

When a subject is as familiar as a well-worn pair of shoes, the artist's challenge is to make it appear as wondrous and magical as Cinderella's glass slipper. Placerville is my hometown. I grew up in it; I returned to it with my wife Nanette to raise our young family; I've spent more than half of my life there. I love the place, but sometimes, as I'm walking or driving through, it seems just as comfortable and familiar as, well, an old shoe.

When I'm working on one of my annual Placerville Christmas paintings, I have to move beyond my own familiarity with the town and see it once again through fresh eyes. In this case, I utilized the power of winter and snow to transform the town and touch an everyday scene with magic. Downtown Placerville seems encrusted in diamonds; I am as entranced as the prince must have been when he looked down to discover Cinderella's glittering glass slipper.

By the way, about the time I was working on this painting, my wife, Nanette, and I had our first child, Merritt. I couldn't resist the family portrait that you see in the lower left of the painting. Nanette and I stroll the sidewalk while baby Merritt pokes her curious head out of the carriage. Also, the painting that appears in the window by our family group is a miniature version of this work—sort of a painting within a painting.

Oil on canvas, 18 x 27 in.

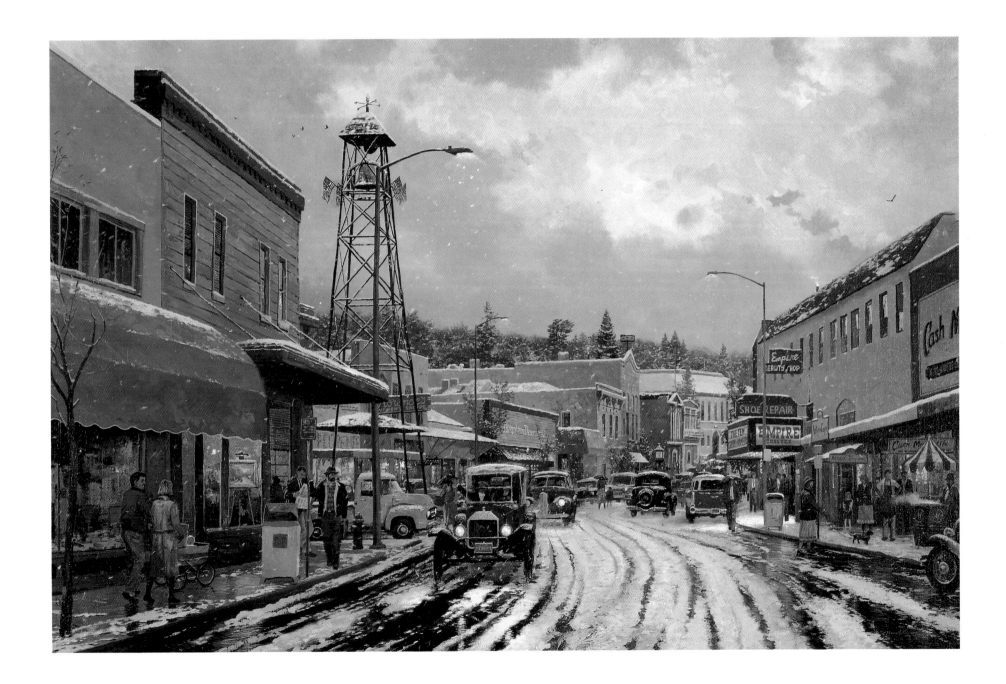

Main Street at Dusk, 1916

This is a great personal favorite of mine, one of the two prints that actually launched my career as a published artist and one of the rarest of all Thomas Kinkade prints.

It fascinates me now that I chose this nostalgic view of my hometown as the subject of the work of art that has played such an important part in my own personal history. I was intrigued by the idea that sleepy little Placerville had a history, that its streets were once filled with what we now see as vintage cars in the decade when it, like America, was awakening to the twentieth century.

As it turns out, my art also has a history. And *Placerville, Main Street at Dusk, 1916* has come to represent much of the same thing in my own body of work as the subject it depicts—a simpler past, viewed now in the warm light of nostalgic memory.

By the way, for those who might want to see this original painting, it was installed in 1984 as a permanent exhibit in the central room of the El Dorado County Main Library in Placerville. If you ever pass through the area, please feel free to stop for a peek. And if you're inclined, visit the historic main street of Placerville and see how much the town has changed since 1916!

Oil on canvas, 36 x 60 in.

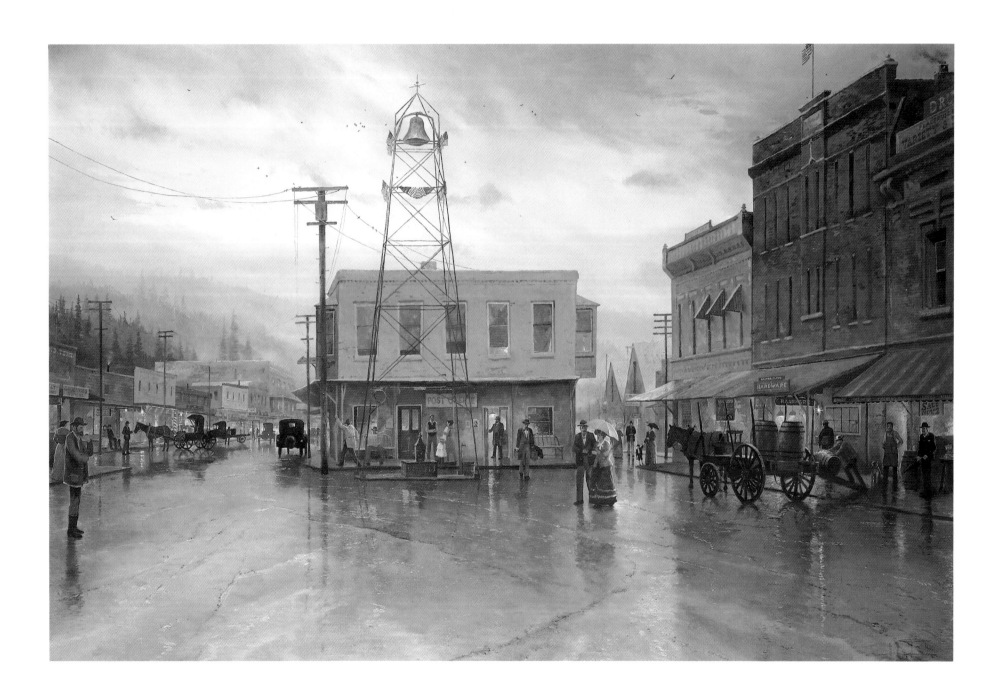

Ocean Avenue on a Rainy Afternoon

This painting is a loving tribute to the resort village of Carmel-by-the-Sea, California. In addition to boasting the world's most famous ex-mayor, Clint Eastwood, Carmel has long been a seaside art colony and one of the most delightful scenic regions in America.

Carmel has been a favorite family retreat for many years, so naturally I was excited to finally put on canvas some of my personal feelings about the area. I chose the view looking east along Ocean Avenue at the corner of Lincoln Street. This corner affords a broad panorama of several of the characteristics that make Carmel picturesque: Monterey pine trees, flowering hedges, and charming architecture. The corner also hosts the Pine Inn, one of Carmel's landmark lodging houses, which can be seen dominating the left-hand side of the painting. I chose a breezy afternoon with sunlight breaking after a rain in order to suggest the moisture in the air that I find so lovely about Carmel. Also, since Carmel has always been so reminiscent of a European village, I couldn't resist posing my wife Nanette aboard her bicycle making her way down the misty avenue carting a basket full of French bread.

Oil on canvas, 24 x 36 in.

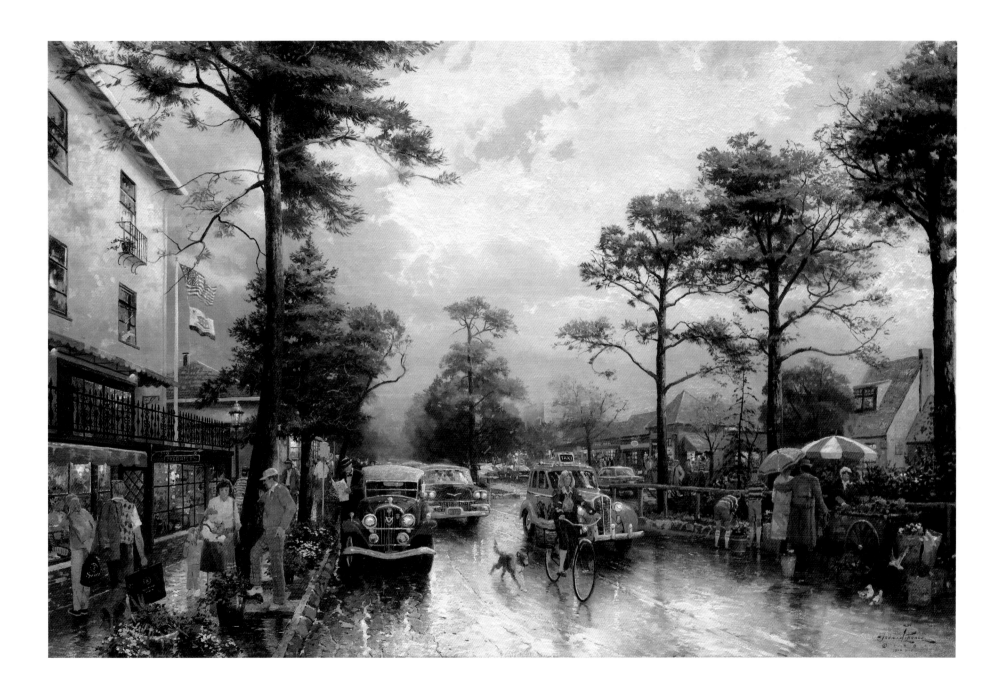

Dolores Street and the Tuck Box Tea Room

Besides the Tuck Box Tea Room, famous for delicious English scones, Dolores Street features many other Carmel landmarks which make for a charming stroll on a rainy afternoon. The mood on Dolores Street is a combination of timelessness and hustle-bustle. I tried to capture these aspects in my latest tribute to my favorite coastal village this side of England.

Interestingly enough, as I was at work on this Carmel painting, I received word that the print of my earlier Carmel painting, *Carmel-by-the-Sea: Ocean Avenue on a Rainy Afternoon*, had completely sold out. On further discussions with my publisher, I was gratified to learn that my first Carmel print had been popular everywhere, not just in the region of Carmel. This proves my long-held belief that beauty is universal, no matter what the specific location is.

It may also prove what a Carmel gallery owner once told me regarding the worldwide scope of visitors to the area: No matter where you live, if you travel, you'll eventually come to Carmel. I hope this Carmel print will bring a bit of the charm and energy of one of America's quaintest villages to people all over, whether they come to Carmel or not!

Oil on canvas, 20 x 24 in.

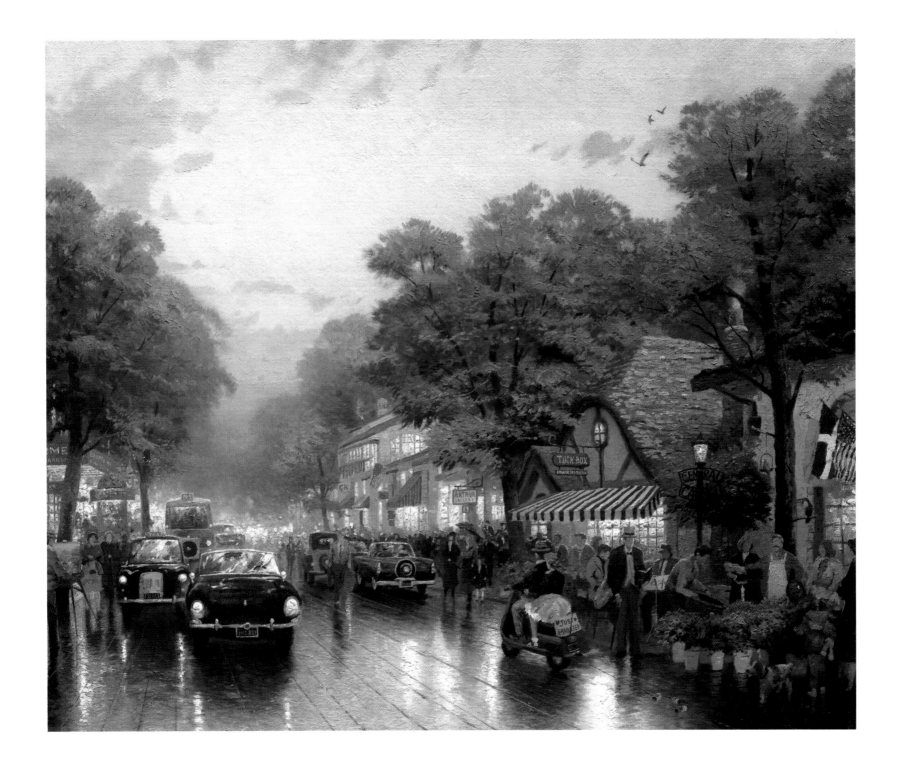

A View Down California Street from Nob Hill

I was recently talking to a friend who had relocated near San Francisco and who had never before been to that city. I was trying to summarize my various feelings about one of my favorite cities and found words completely inadequate to explain the sensations that grip me when I'm in San Francisco. Perhaps that's why I'm an artist. The lights, the mood, the flying flags and windswept wisps of fog, the bustling people and quaint bits of architecture that are San Francisco can perhaps best be captured on canvas. Yet even this is inadequate, for a purely visual image cannot relate the ambient sounds and smells that are so much a part of the City by the Bay. For example, if you were standing at the location I painted, your ears would probably be filled with the sounds of clanging cable car bells, the whistle of hotel bellmen flagging taxis, and perhaps the lonely call of seagulls overhead. Likewise, if you took a deep breath you might notice the aroma of fried rice rising from Chinatown below, or perhaps the pungent smell of sourdough bread that seems at times to be omnipresent in San Francisco. But before I ramble on too much, perhaps I better just make plans to get back to San Francisco for another visit!

Oil on canvas, 24 x 20 in.

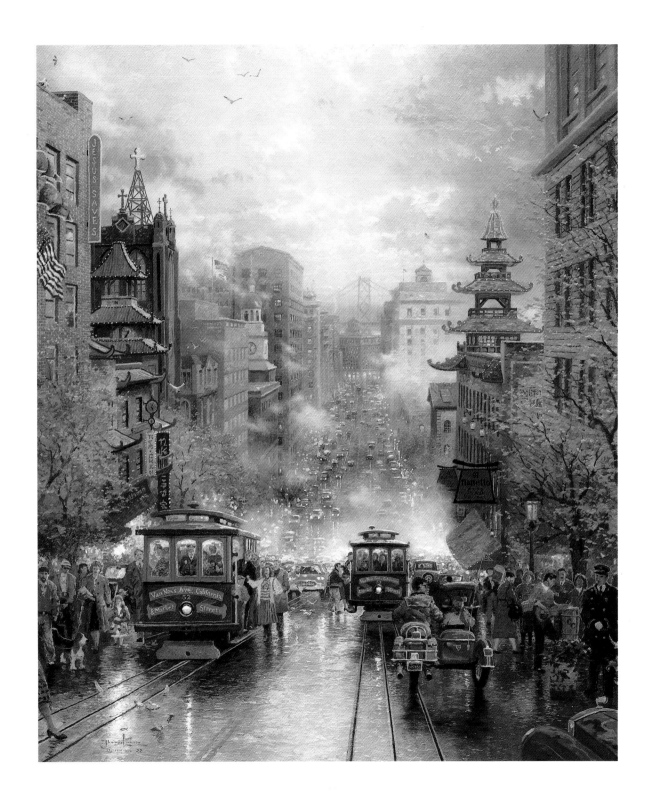

Market Street

San Francisco, Market Street is the first San Francisco painting since my well-known *A View Down California Street from Nob Hill* to involve cable cars—and this itself is cause for celebration. Perhaps that's why I couldn't resist including numerous high-flying flags in my painting. To me every visit so San Francisco feels like a celebration.

In *San Francisco, Market Street* I took the liberty of turning back the clock to a vivid and very colorful era. The time is approximately 1900—before the great earthquake transformed the face of the city and automobile traffic filled its picturesque streets. It was an era when the cable cars were an efficient way of getting around the City by the Bay, and when Market Street was truly the heart of San Francisco. It was a time when ferries tied the city to bustling communities across the bay, and dray wagons hauled products and produce to and from the busy port. In fact, you can see the Ferry Building in the distance in my painting. Also featured are the Chronicle Building (at left) and the Central Tower (at right), which is often proclaimed to be San Francisco's first sky-scraper. But the real landmarks of San Francisco are those charming little cars that make their way up the towering hills and winding streets of this beautiful city. Cable cars—part of the reason San Francisco is still the city where I left my heart.

Oil on canvas, 20 x 24 in.

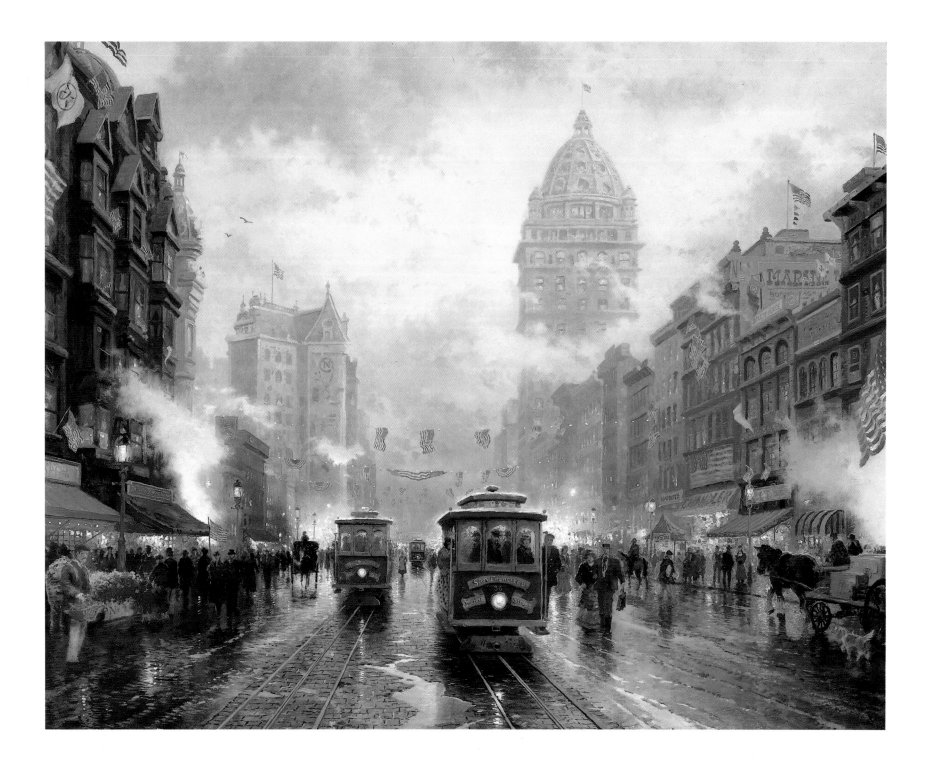

Fisherman's Wharf

Recently, my wife Nanette and I rediscovered the heart of a favorite city. Imagine yourself on a picturesque fishing pier, looking back at some of the world's most famous scenery.

A luminous sunset shrouds the scene in a tranquil golden glow, as richly colored fog banks and clouds dance overhead in my new *San Francisco: Fisherman's Wharf*. In the distance, the lights of the famous Coit Tower begin to twinkle high atop Telegraph Hill, while San Francsico's skyline rises majestically over the waterfront.

And what a waterfront! Quaint fishing boats of all descriptions sleep quietly at their moorings (study their whimsical names carefully—you may find some hidden Kinkade family references). The lights of the wharfside shops glow softly, creating brilliant patterns as they caress the rippling water of the tranquil bay. Steam rises here and there from sidewalk crab steamers, and seagulls soar overhead in the brisk sea air.

What an enchanting location! If, like me, you're a citizen of the City by the Bay at heart, my *San Francisco: Fisherman's Wharf* will bring a little music to your soul.

Oil on canvas, 24 x 36 in.

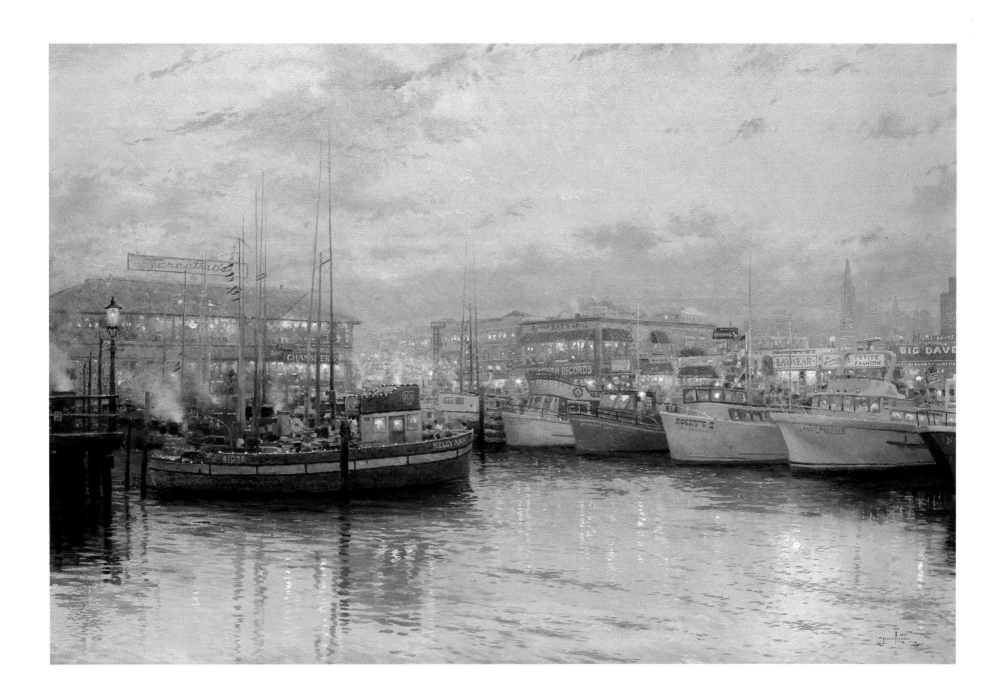

Market Street and the Ferry Building, at Dusk, 1909

The heart of San Francisco is the bay, with its wharves and myriad fishing boats, its bustle of activity in the morning and again in the evening, when the fleet returns laden with fish.

That's true today and it was ever so much more true in 1909, when the sea provided a bountiful harvest. There's the promise of adventure in the very smell of the briny air; at the turn of the century the bay was alive with seafaring men of every description— colorful characters who spoke exotic languages and told marvelous tales.

The voyages that began and ended at the old ferry building were of a somewhat more modest character and yet not without their own romance. Ferries plied the bay, connecting San Francisco with the many quaint villages along the shore. In *San Francisco, Market Street and the Ferry Building, at Dusk, 1909,* we visit a time when auto travel was less than convenient, and the ferries that came and went from the old building at the foot of Market Street provided the most practical transport to the bustling bay-area towns.

Practical, and yet, so romantic. With its cable cars and ferries, San Francisco has always been a city where travel is a charming adventure.

Oil on canvas, 30 x 48 in.

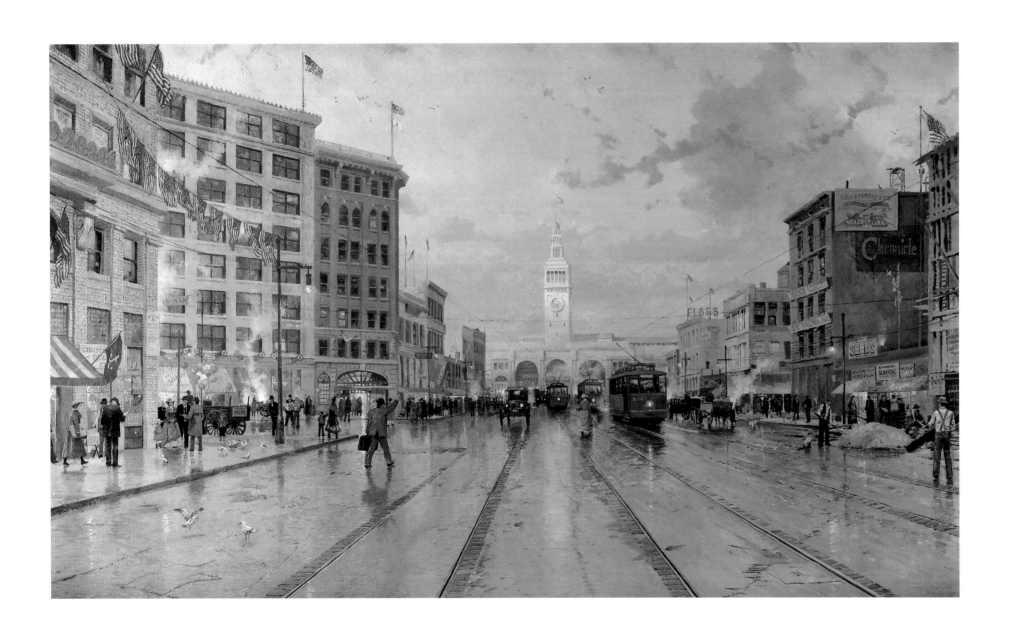

Late Afternoon at Union Square

As a young boy, my first glimpse of San Francisco came during a sightseeing trip with my brother and father. Upon passing over the Bay Bridge and being awestruck by the mysterious beauty of the lights reflecting on the bay, my father turned to me and said, "Now you know why they call it The City." Since that moment, San Francisco has always remained The City in my heart.

In *San Francisco, Late Afternoon at Union Square,* I wanted to capture the lights and motion that are the essence of San Francisco. I chose the view looking uphill on Powell Street to emphasize the sense of distant activity. Since the Powell Street line is one of the most popular cable-car routes, I naturally included a heavily loaded example making its way to Fisherman's Wharf.

As well as fine shops and hotels, Union Square is home to many art galleries. As a student at nearby U. C. Berkeley in the mid-seventies, my artistic direction was shaped by the great landscape paintings on display in these galleries. Since we visit Union Square so often, I included a cameo portrait of my wife, daughter Merritt, and myself in the lower right-hand corner as joyful observers of the busy scene.

Oil on canvas, 36 x 30 in.

Main Street Celebration

This painting was originally commissioned by a retired California politician who wanted to share some of the charm of old Sacramento with others. It has since come to be a very popular print that for most people is far more universal than the specific city it portrays. I think the reason for this is clear; we all like a celebration.

Main Street Celebration depicts festivities that could occur on any holiday in any city in America. The mood is joyous. The activities are plentiful. The energy is contagious. I especially like many of the hidden details in this piece. The fluffy dog is a portrait of a friend's family pet. Many of the models for the people were family members or friends. Even the signs have special meanings; the "Grady's Fajitas" sign barely visible on the ground floor of the main building to the left is a tribute to an old friend whose cooking is legendary!

Oil on canvas, 18 x 27 in.

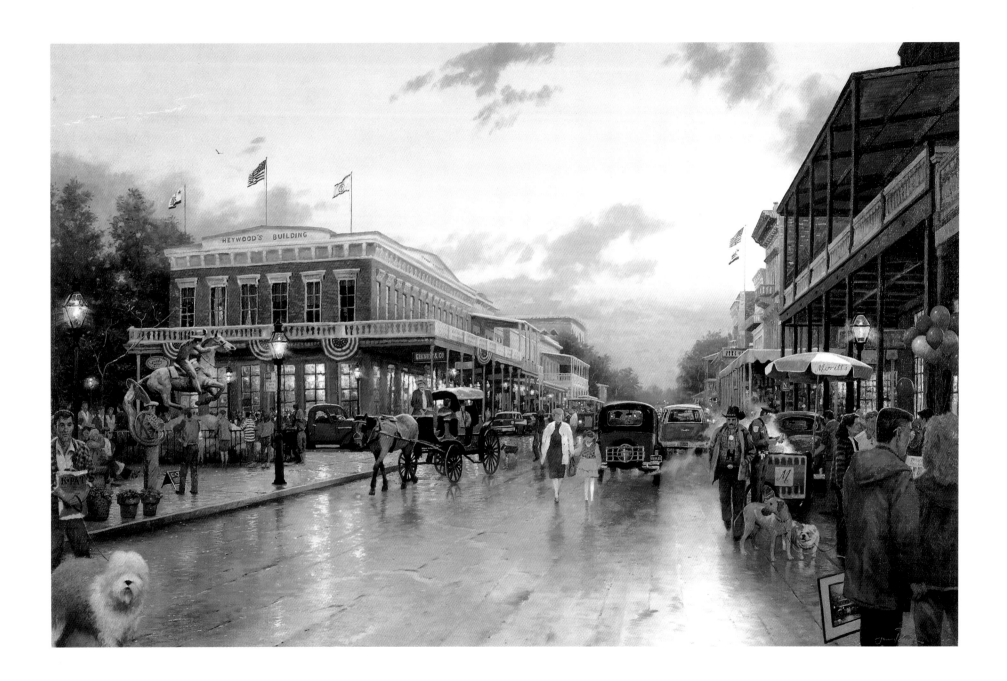

The Yukon River with Gold Seekers Landing by Moonlight in 1898

This work returns me to the beginnings of my career as an artist. Along with *Placerville: Main Street at Dusk 1916*, it was my first offering to the print-collecting public. This exciting subject also returns brings me back to one of my grandest artistic adventures. Some years ago, I packed my paints and took a two-week sketching tour through the far reaches of the Alaskan wilderness.

It was often so cold that the watercolors I was using simply froze; I finally solved that problem by mixing the colors in rubbing alcohol instead of water. I'm grateful for that inspiration; it allowed me to create some canvases that, upon my return, expressed the intense isolation and fragile beauty of that remote, frozen region.

This work depicts the famous Yukon town of Dawson during the height of the northern gold rush, around 1898. We see gold seekers arriving in the primitive, crudely made boats with which they navigated the Yukon River. Even with today's technology, surviving in extreme conditions is a challenge. The era I depicted in Dawson must have been brutal indeed. Yet, with the hardships of survival comes the exuberance of camaraderie. I hope I've captured both aspects in this work, one of the most detailed of my early career.

Oil on canvas, 24 x 36 in.

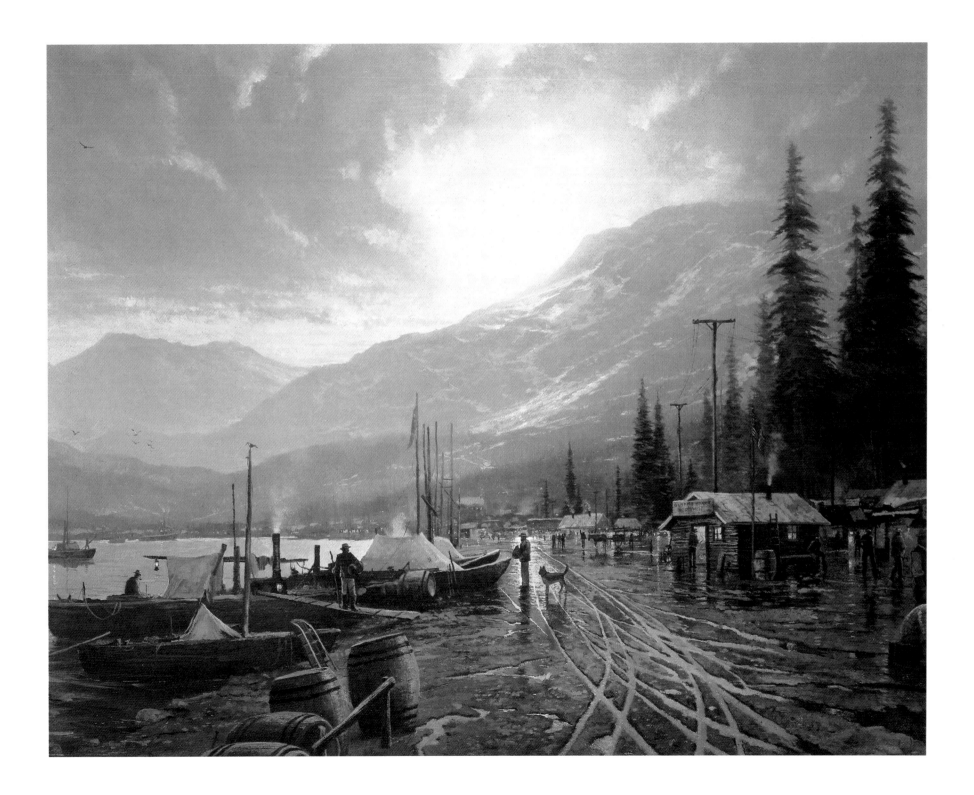

An Evening Stroll through the Common

*B*oston is a city for walking! Some ingenious person has even installed computerized machines at popular corners to disperse custom-printed maps for pedestrians, complete with distances and points of interest. One of my favorite strolls is along the tree-lined corridors of Boston Common and the Public Garden. One begins by passing the lake in the Public Garden where, for decades, the famous swan boats have carried lovers young and old along a fragrant summertime route framed with lawns and lush flowering hedges. From the garden, one steps across Charles Street to Boston Common, a paradise for promenaders since the eighteenth century.

Among the delights of the late-winter Boston trip that inspired this painting were the long walks I took with my wife Nanette and our two-year-old daughter Merritt in her stroller along the leafless lanes of Boston Common at dusk. A wet storm front was breaking up overhead one chilly evening when I got the inspiration for this painting. I was impressed by the glowing facade of the famous Park Street Church, almost like a lighthouse seen through the mist of some rocky coast. The sweet, warm fragrance of candied peanuts roasting in the sidewalk vendor's cart is a standard fixture in Boston Common, so I included a peanut vendor in my painting. The combination of myriad glowing lights, low-hanging coastal clouds, and abundant moisture that seems to coat everything in a nostalgic glow make Boston one of my favorite subjects to paint.

Oil on canvas, 16 x 20 in.

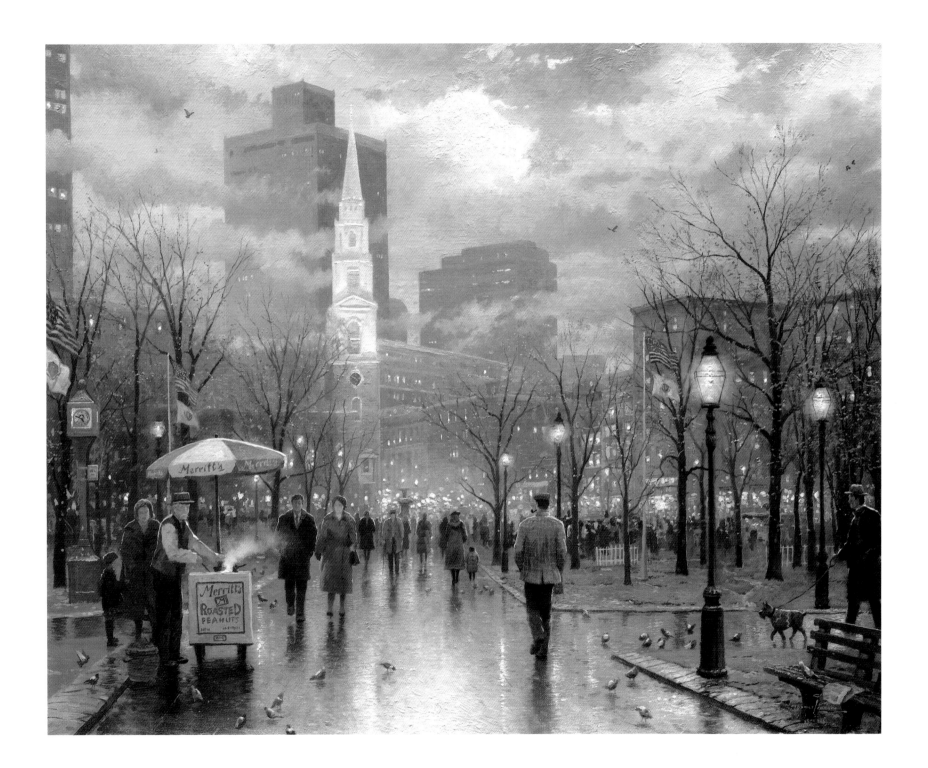

Central Park South and Sixth Avenue

That a kid from rural Northern California should have come to love New York City may seem improbable to many people; sometimes it even seems improbable to me. But, tell me, is there another town with the energy and verve and sophistication of the Big Apple? I've toured—and enjoyed—great cities around the world, and I've come to believe that New York is simply one-of-a-kind.

This is Central Park South at Sixth Avenue, a corner that typifies the ebullience and energy that is New York at its best. I've tried to capture the motion of the street in this canvas, one of my earliest efforts depicting a city setting. I also had fun painting the hansom cabs that are to this day one of the great traditions of Central Park.

At its best, New York is a place of great optimism and new beginnings. I hope this captures a bit of that optimistic energy on canvas.

Oil on canvas, 30 x 24 in.

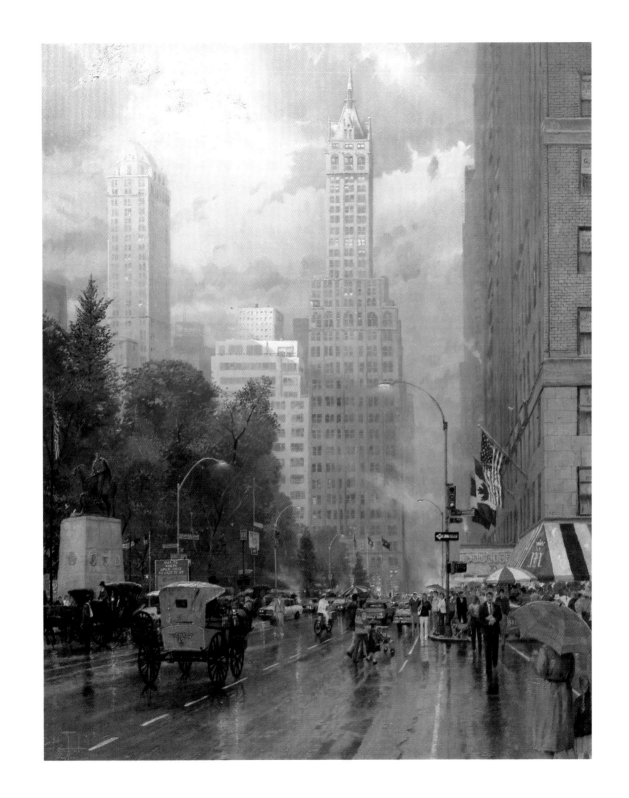

Snow on Seventh Avenue, 1932

For the most part, I paint places I can see and experience first-hand, though occasionally I enjoy the challenge of creating a romantic vision of another era. Seventh Avenue in New York in the twenties and early thirties was a bustling center of activity. The Pennsylvania Hotel, seen at the right of my painting, was the largest hotel in the world when completed in 1919. Across the street, the neoclassic entrance to the famous Pennsylvania Station (opened in 1910) buzzes with people preparing for departure.

To set the mood in the painting, I included many vintage vehicles, among them a Ford five-window coupe, a Cadillac V-16 touring car, an early checkered cab, and a few Seventh Avenue trolleys. Signage and billboards are mostly period, though I frequently fabricate signs just for the fun of it. For example, the billboard to the immediate left of the Pennsylvania hotel proudly announces the virtues of "Church Brand Cleaner" with an image of an erupting volcano as a background. This sign was invented for fun: a tribute to a great painting by one of my favorite nineteenth-century painters, Frederick Church.

Oil on canvas, 24 x 30 in.

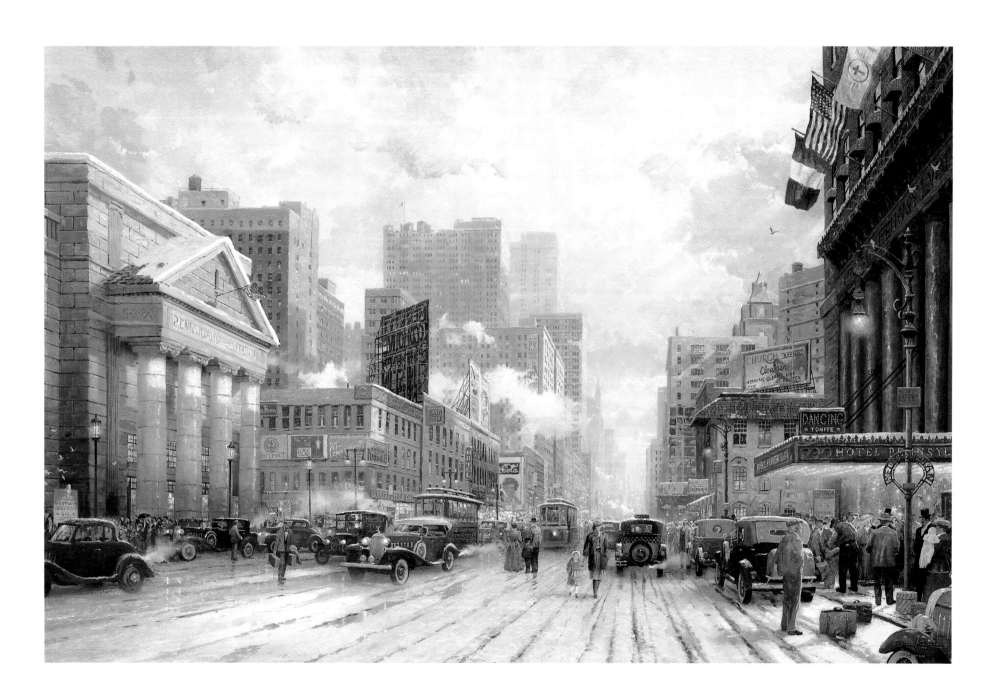

Eiffel Tower

Paris, Eiffel Tower celebrates two famed Parisian landmarks—the River Seine and the Eiffel Tower—and the two sides of my beloved City of Lights "personality" as well.

Yes, Paris has a dual personality. One aspect is the brilliantly lit, fast paced, energetic pageant of life that unfolds on the Seine's bridges and boulevards, and dances on the river's surface as a colorful armada of quaint boats.

But the City of Lights is also an imposing, timeless symbol of civilization and human aspiration that's best exemplified by the Eiffel Tower. The 984-foot tower was constructed for the 1889 International Exposition by Gustave Eiffel. Yet facts and figures can't convey its awesome presence, or the way that it anchors the intricate Parisian tapestry of light and color.

As with all my works, I attempted to go beyond the topographical details of the setting and into its heart and mood to achieve my artistic goals. Bridges and buildings were moved and adjusted, colors and lights were enhanced, and of course, whimsical details were added. Note, for example, the small floating boat below and slightly to the right of the Eiffel Tower. If you look carefully you will see the Impressionist artist, Claude Monet, aboard his famous floating studio, painting the passing scene. Like me, Monet enjoyed capturing the delights of Paris on canvas!

Oil on canvas, 18 x 27 in.

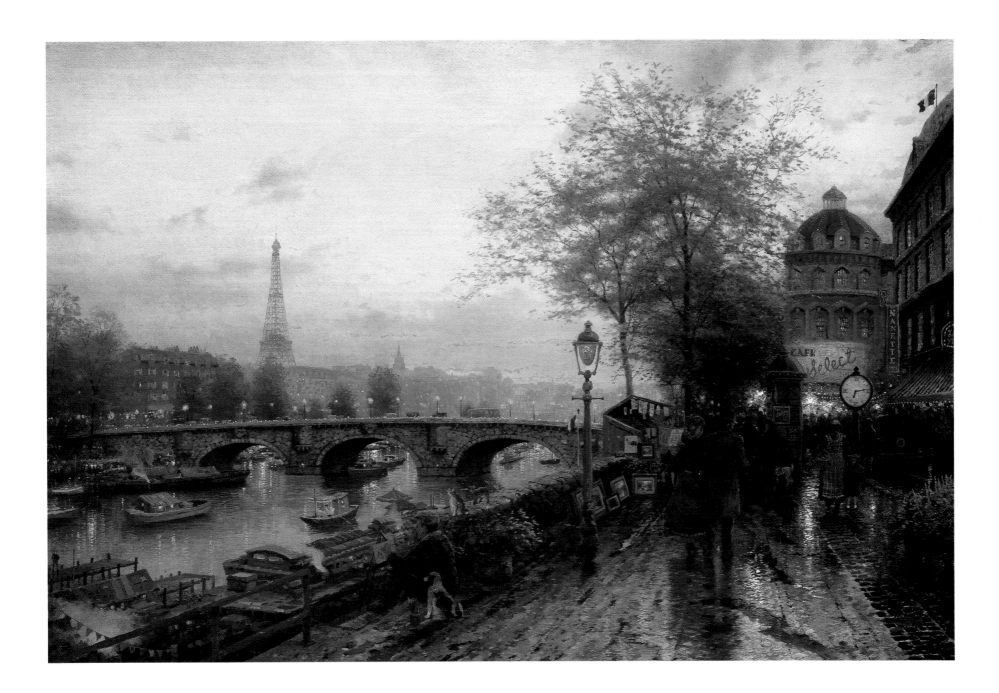

City of Lights
Le Boulevard des Lumières at Dusk

*M*y love affair with Paris started when I was a struggling young painter. You see, one of my first patrons maintained a caravan (or motor home as we call it) in Europe and I traded him a painting for its use for six weeks one spring. Nanette and I drove it into Paris and actually lived on the streets of the City of Lights for a blissful five days while I painted away to my heart's content.

Since then, Paris has been a romantic favorite. Broad boulevards, flower vendors, sidewalk cafes, and the ceaseless bustle of cars and people; it's all part of the charm of one of the world's most cosmopolitan cities. I found it a great pleasure just sitting in the cafes at night, nursing a cappuccino and watching the pageant of Parisian life pass by.

Paris, City of Lights could be titled *The Kinkade Family in Paris.* I've set the time machine back a few decades and included myself (in the red beret), painting the fabulous Café Nanette (named after my wife). The real Nanette, holding baby Chandler, hails a cab, while our oldest daughter Merritt looks on. I've even signed the tiny canvas on the street artist's easel—to my knowledge the smallest Kinkade signature on record! And in true Kinkade tradition, fifteen hidden "N's" grace the painting as a tribute to my Parisian belle, Nanette.

Oil on canvas, 20 x 30 in.

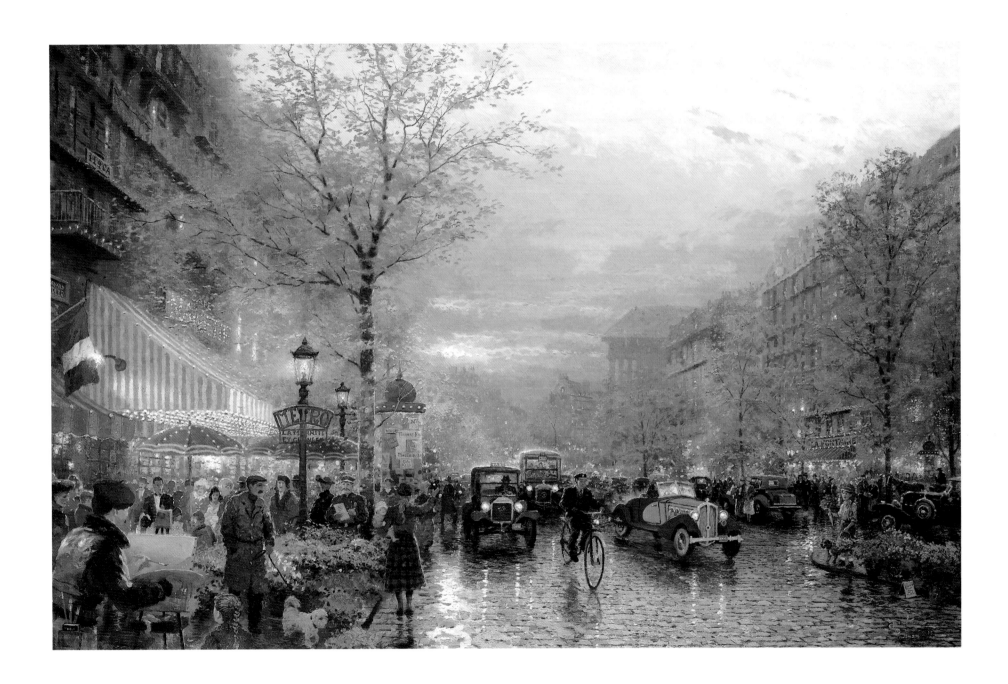

Though I don't usually paint faces, I do paint portraits. Portraits of the quiet dignity of honest, simple people as reflected in honest, simple homes: the cottages or village houses of another era. I like to think of homes as pieces of living history—silently documenting the struggles and triumphs of their inhabitants.

I'm fascinated by the places in which people live, particularly by the humble cottages that have provided shelter to family after family, often for hundreds of years. Every detail of their appearance—their carefully thatched roofs, their painted shutters, the way the wood or stone has weathered, the furnishings glimpsed through windows, the flagstone walks, the bowers and gardens that surround them—all bespeak the creative human effort and the peaceful serenity of a life lived close to the land.

These cottages remind us of the things that people value most. In an important sense, each one is a revealing portrait of the family that has lived within its walls and called it home. My Cottages of Light are often something else as well. They can be romantic embodiments of our hopes and dreams, ideal expressions of our fondest sentiments and aspirations. Some of these cottages are my dream-visions of a perfect weekend hideaway with my wife, Nanette. Some may be an ideal vacation spot, or the ultimate mountain retreat, or perhaps a dream home with an ocean view. I've lived in each one—at least in my imagination. And there's room in each cottage for you, as well. Come on in, the tea is brewing!

Heather's Hutch

I have just the prescription for anyone who's feeling cynical or flippant or world-weary: Daughters!

The playful high spirits and sense of wonder that my older girls, Merritt and Chandler, bring to my world inspire and invigorate me. What imaginations they have! They'll notice one tiny detail in a painting and weave a whole story from it.

I've paid tribute to the "everything nice" world of little girls before, but my new Sugar and Spice Cottages series is the first solely devoted to dollhouse cottages that my little girls would love to live in. *Heather's Hutch*, which leads off the series, is no doll-house—it's inspired by a real stone cottage I discovered in the English Cotswolds. But the thatched roof and pink and white dogwoods make it especially attractive to young ladies and I just know there's a little play garden behind the gate.

The hen with her chicks and pigeons are for my little Chandler, who gets so excited whenever she sees birds. And the rich plum color on the doors above the windows is for another favorite "girl" of mine—my lovely wife, Nanette.

Oil on canvas, 8 x 10 in.

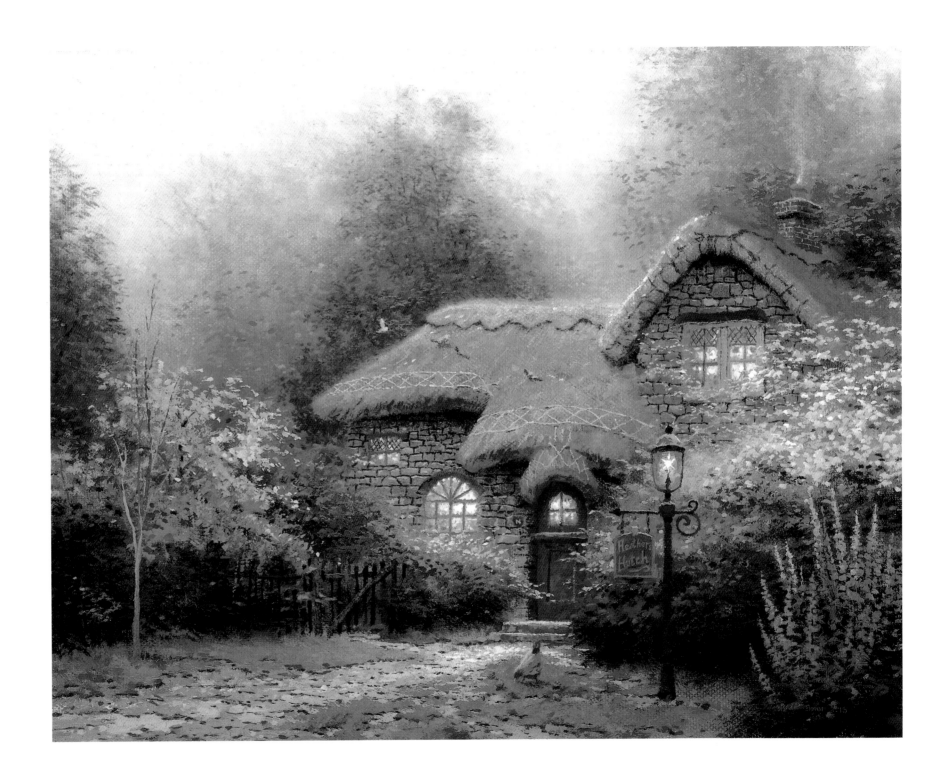

Autumn at Ashley's Cottage

How fondly I remember the fragrant scent of the leaf-burning that was a favorite autumn ritual of my boyhood. When I was very young, my friends and I would leap and wrestle about in the great piles of crisp leaves that our fathers had raked up. Later, we wielded the rakes, sweeping the brown and orange leaves into towering heaps at curbside. When we applied the match, curls of pungent smoke would rise into the crisp autumn air.

I accept the changing circumstances that have resulted in the banning of leaf burning in most communities, even as I regret this sad symptom of our loss of innocence. But lately it has occurred to me that, at least in my paintings, I can once again savor the aromatic leaf fires of my childhood. *Autumn at Ashley's Cottage*, the second in my Sugar and Spice Cottages series, is the first fruit of that realization—my first autumn scene in quite some time.

My older girls, Merritt and Chandler, have schooled me in the preferences of young ladies. I'm confident that this perfect little gem of a cottage, with its chickens bustling in the yard and its heaps of crisp autumn leaves, would delight them. But I confess that *Autumn at Ashley's Cottage* delights the little boy in me as well.

Oil on canvas, 16 x 12 in.

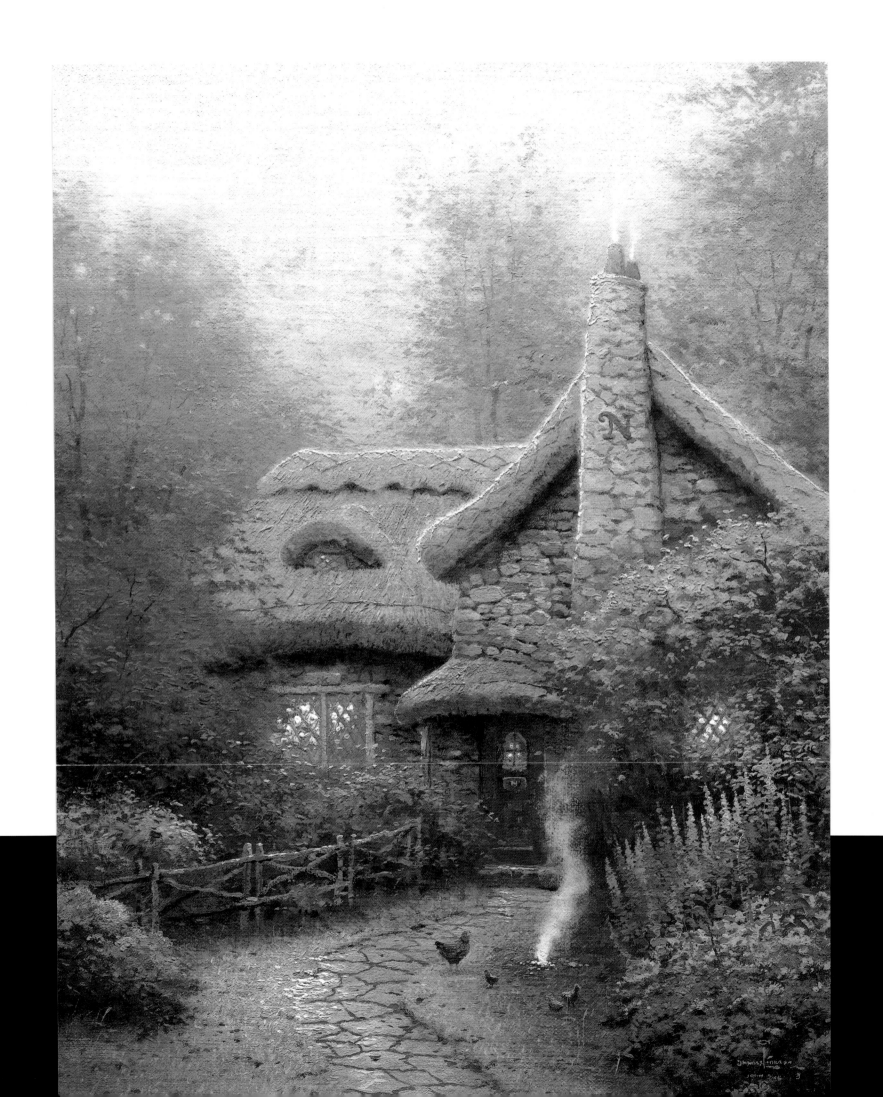

Moonlight Lane I

We couldn't have known how romantic it really was, or how much we would cherish the memories, when Nanette and I began our tradition of taking long, moonlit walks.

Twenty years later, we still love to walk hand-in-hand in the moonlight. In fact, I believe that the only place I cherish where we've never had a chance to stroll under the stars is England, possibly because moonlight is rare in that land of mist and rain. Hence *Moonlight Lane I*—our long-overdue romantic walk through the English countryside.

For a painter, of course, moonlight, with its dramatic moods and colorations, its rich transparent shadows, and its warm lemon-yellow highlights, is a challenge and a delight. In this painting, I was particularly pleased with the way reflections of moonlight and of the illuminated cottage interior mingle in the puddles on the lane and cottage walk. Indeed, I'm so intrigued by the idyllic aura of *Moonlight Lane I* that I intend to follow it in future paintings—much as I have with the Lamplight Lane series.

Above all, moonlight is intensely romantic. And yes, the half-hidden couple strolling in the gathering shadows is Nanette and me.

Oil on canvas, 16 x 20 in.

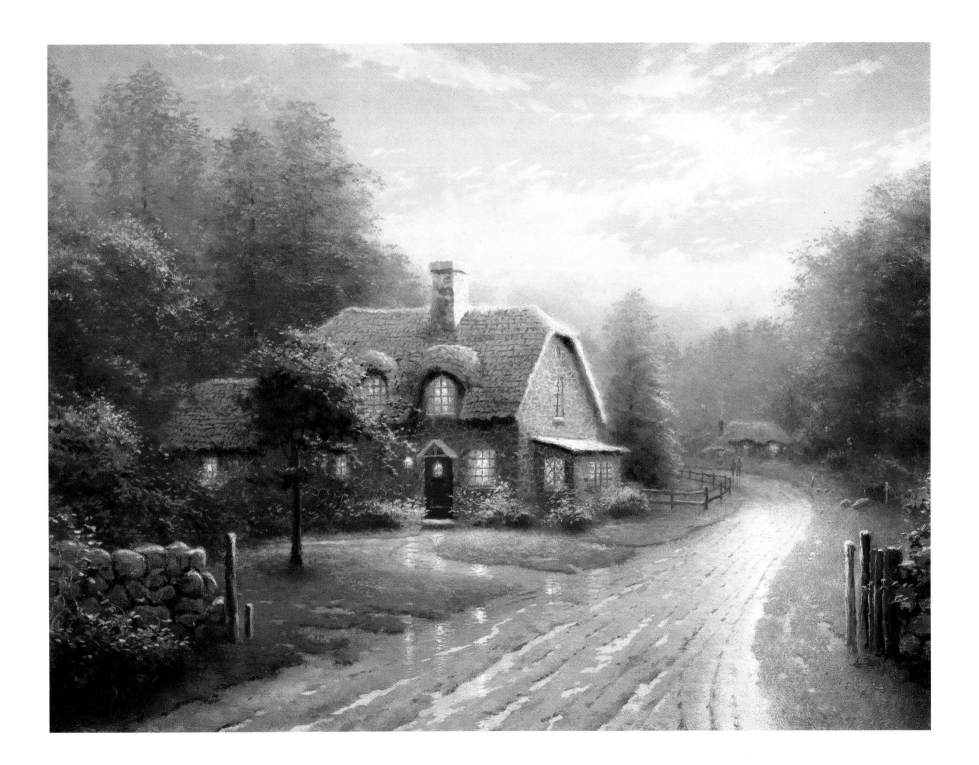

A Tranquil Dusk at Falbrooke Thatch

I guess I'm a hopeless romantic—but proud to be one! No series of mine makes that more clear than my Sweetheart Cottages. For the second work in the series, I've conjured a vision of a perfect romantic hideaway. Falbrooke Thatch is nestled right next to a charming little waterfall, with an arched footbridge leading from the front door over the falls. Twilight warms the mist; at nightfall the sound of falling water will sing a gentle lullaby just for lovers.

This is just the kind of quaint cottage with its stone steps, tidy thatched roof, antique lampposts, and bower of bright flowers where Nanette and I love to go for our frequent second honeymoons. I've devoted *A Tranquil Dusk at Falbrooke Thatch* to Valentine's Day (note the 214 address just below the heart-shaped window) and to romance. In fact, I've hidden hearts throughout the painting as a tribute to my own sweetheart, Nanette.

Oil on canvas, 16 x 12 in.

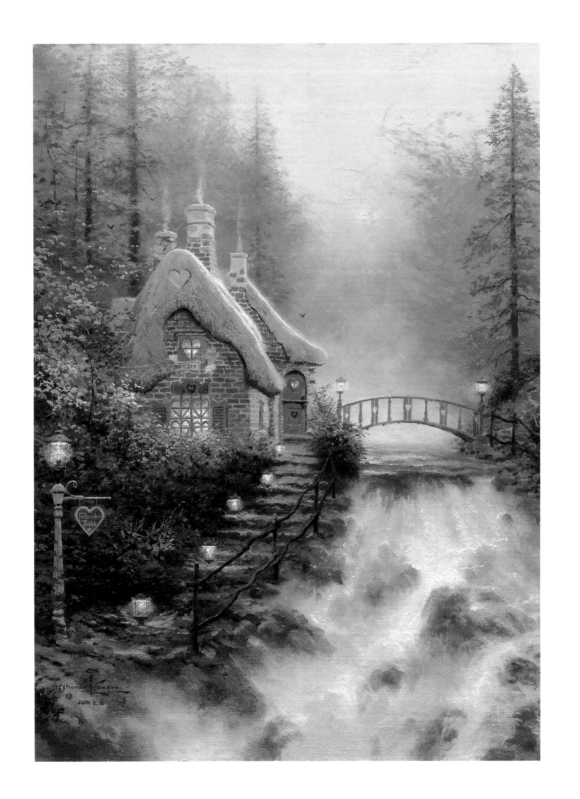

The View from Havencrest Cottage

For me, one of the great pleasures of travel comes before the actual trip. It's the anticipation—reading Baedekers, watching travelogues, daydreaming about the places I'll visit, even sketching some of my most vivid imaginings.

That's just what I've done in *The View from Havencrest Cottage*, the third in my Sweetheart Cottage series. Nanette and I have been planning a trip to the Austrian Alps for months. I've wandered the verdant, flowering Alpine valleys in my mind, even climbed the soaring, snowcapped peaks—very likely the only way I'll do that! And this delightful vista expresses the best that I've seen on my imaginary ramblings.

Havencrest Cottage is poised on a hillside midway between the towering, sun-dappled mountains and the Alpine meadow that is festive with blue lupines. The jutting rock is the perfect perch from which to view the vast sweep of God's grandeur.

A rainbow symbolizes promises kept—my profound hope that the real trip that Nanette and I take will live up to my lovely expectations.

Oil on canvas, 18 x 24 in.

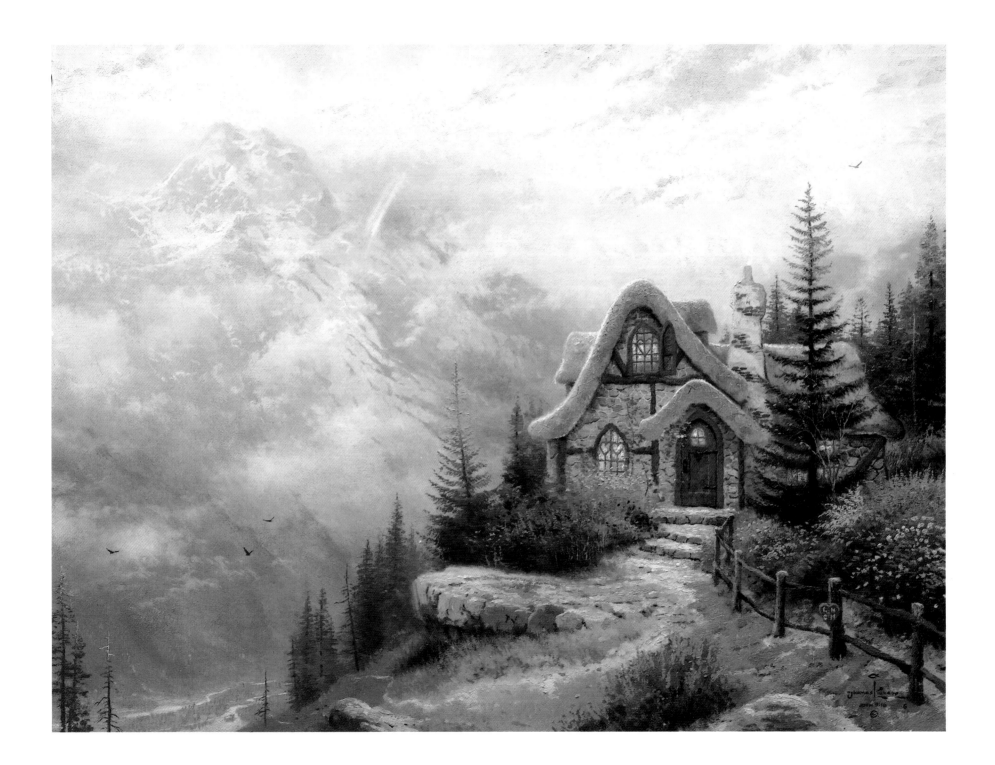

Brookside Hideaway

I consider myself truly blessed. As my marriage progresses, I find that I grow ever more romantic in my appreciation of the love of my life, Nanette.

My Sweetheart Cottage paintings were a way for me to share this love. I'm very fond of them. But lately, it has occurred to me that if I pulled back my focus just a little, I could create perfect romantic hideaways, where lovers live in blissful ignorance of the world.

That's just what I've done in *Brookside Hideaway*. A footbridge over untroubled waters provides the only entry to this haven for lovers. Just a wisp of smoke rising from the chimney, and a glimmer of light at the window, are the only hints of a human presence in this idyllic world. Graceful flowering dogwoods—the white of purity and the pink of passion—drop their petals on the charming cottage in a benediction of love.

Brookside Hideaway is my Valentine's Day gift to lovers everywhere. It is lavish with flowers—and upon close examination, you'll also find an abundance of hearts hidden away in the distance, among the delicately colored foliage. Ah, sweet love!

Oil on canvas, 20 x 16 in.

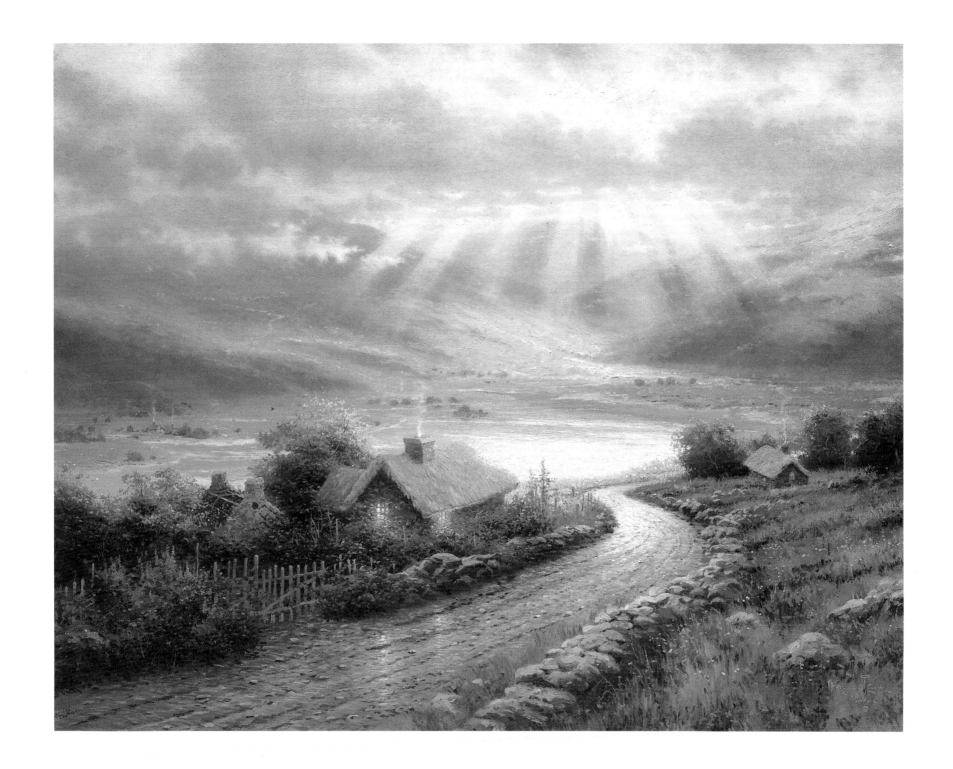

Chandler's Cottage

Cottages have personalities. I firmly believe that, and I've lately discovered that I share my belief with some very surprising, and surprisingly wise, little people: my own beautiful daughters, Merritt, Chandler, and our newest daughter, Winsor.

I love to watch my older girls at play—their energy and humor and surprising insights are an endless source of amusement. They love their doll houses, love to decorate them in the most fanciful manner. They treat the houses like little playmates, friends with very definite personalities. Lately, in my travels, I've been on the lookout for cottages that would make perfect dream dollhouses for my girls. How little Chandler would love to have a real miniature version of this delightful, flower-bedecked hutch complete with blooming garden, in her playroom. Like most little girls, she loves fancy, frilly things and this hidden little house seems to be a confection of gingerbread and spun sugar.

I originally created *Chandler's Cottage* and its companion piece, *Merritt's Cottage*, as tributes to my two girls. I suppose the special love I lavished on these paintings has borne some special fruit, for both have been enormously popular. Perhaps other proud parents can see their daughter's dreams inside the walls of these special places as well.

Oil on canvas, 16 x 20 in.

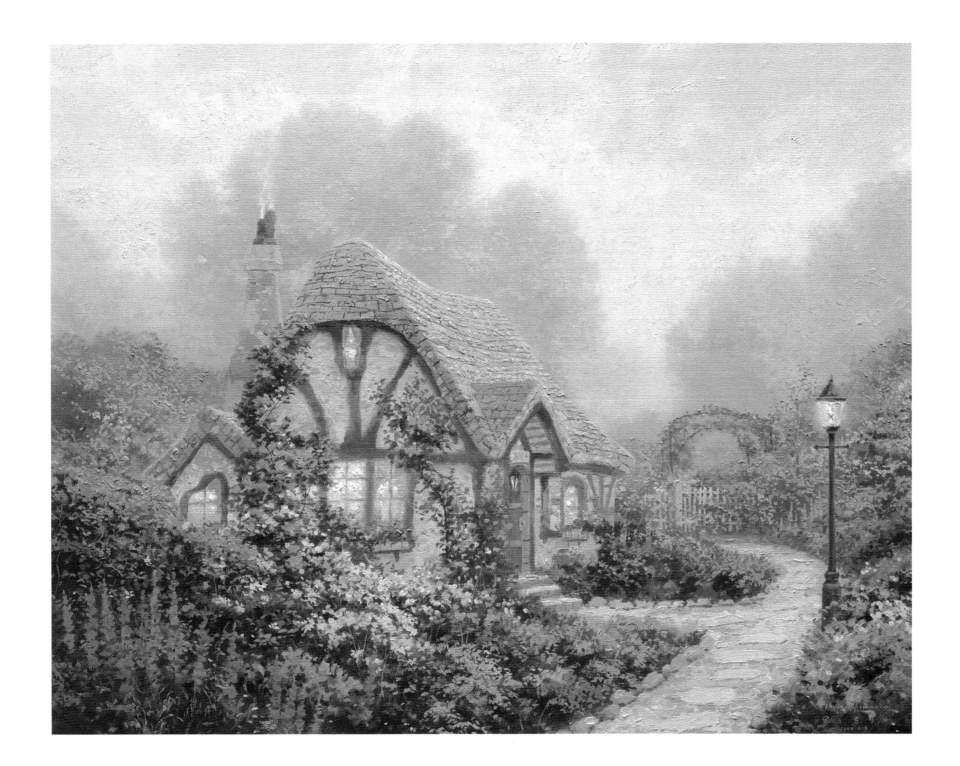

Evening at Merritt's Cottage

My daughter Merritt loves sunsets. So of course, when on the lookout for Merritt's dream cottage, I paid particular attention to sunset. The house should come alive in the warm glow of dusk, just the way my oldest daughter does.

Evening at Merritt's Cottage is exactly what I was looking for—and Merritt certainly agrees. The cottage glimmers most invitingly in the pink-purple evening light; it seems almost to smile its welcome. My little Merritt is very neat and tidy, delicate and ladylike. She loves to entertain her girlfriends at prim and proper doll teas, and she'd be delighted if her daddy's friends could drop in for dessert and share an Evening at Merritt's Cottage. I'm sure the painting has had a strong effect on her little imagination. After all, its the only print of daddy's work that hangs in her room. In fact, it's given a place of honor: right above her bed.

Oil on canvas, 16 x 20 in.

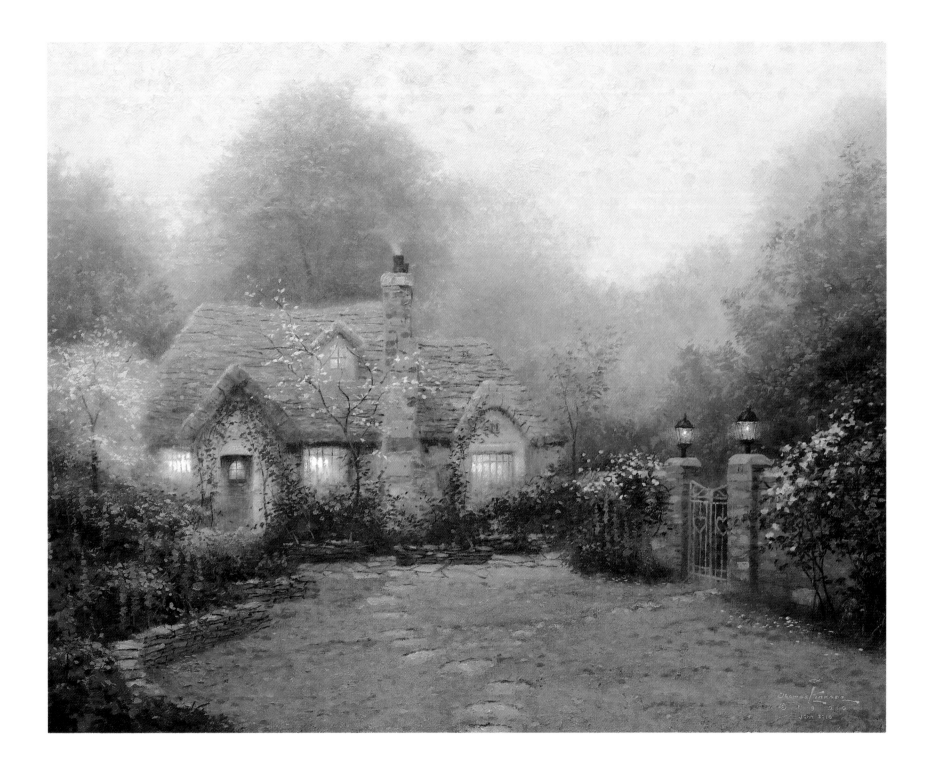

Glory of Morning

I like to think that one thing that separates artists from most people is that we're alive to the world around us; we take delight in things many people never even notice. Delight—the word itself intrigues me because light is such an important part of it. For me the quality of light is a delight! The play of light and shadow on a day dappled with clouds, the way sunlight teases nature's colors into life—these are my great artistic challenges.

Twice each day nature puts on a light show of wonderful subtlety. Morning light is warm with the energy of a new day, yet cool with the moisture of mist. My *Glory of Morning* sparkles with the light of just such a morning—warm light filtered through myriad tiny water drops until the colors glisten.

You can see that light reflected on the flowers of a fabulous garden. Each color is so vibrant that the garden becomes a living rainbow. Flowers are alive to the quality of light. Spend a day in a garden—watch it change as the light changes—and you'll see what I mean. *Glory of Morning* celebrates the wake up call for nature's colors.

Oil on canvas, 8 x 10 in.

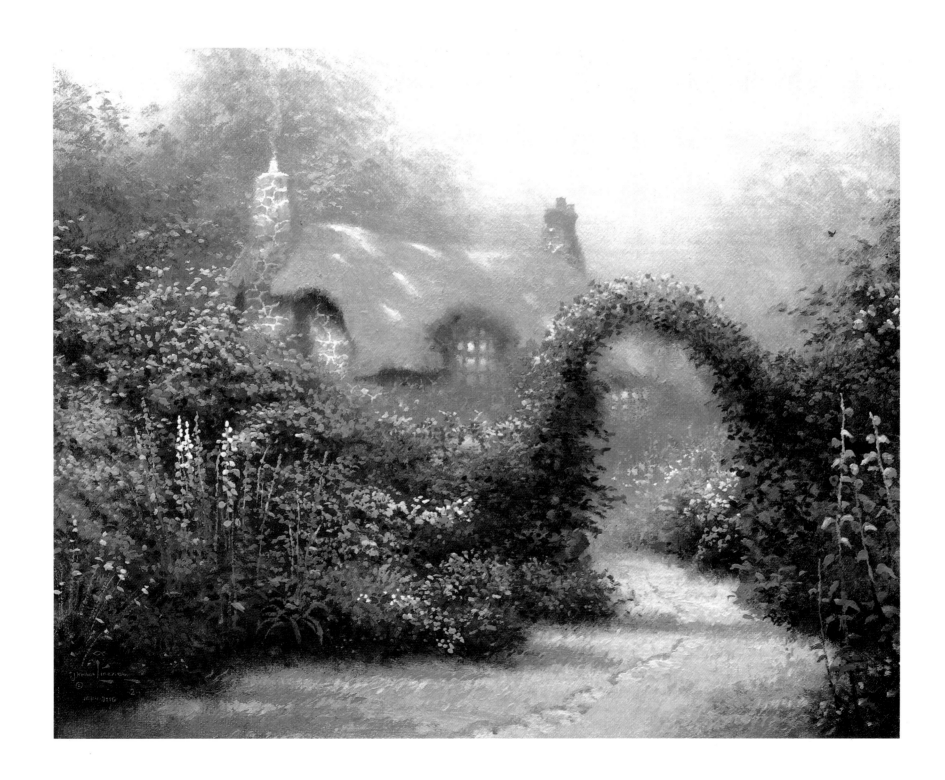

Glory of Evening

*I*t may seem that sunset is the mirror image of sunrise, but a painter who pays close attention to visual detail knows that isn't so. I painted *Glory of Evening* as a companion piece to *Glory of Morning,* yet each is unique. I'm fascinated by the subtleties of transitional light—the interludes between dark and day when the sky flames with a special radiance, when colors are heightened and shadows dance on the ground.

Glory of Evening was created to be as distinctive as a sunset where the dust of a busy day and low-lying clouds reflect the violet rays of the sun. The cozy thatched-roof cottage answers the glow of dusk with its own warm radiance, providing safe haven against the advancing dark. It's a new addition to the fabulous imaginary village of perfect little homes that grow only on this artist's canvas. As the sun moves to meet the horizon, its lavender radiance colors the garden flowers, deepening their hues. Such glorious evenings as this lay a regal purple cloak upon the land—and every home becomes a castle.

Oil on canvas, 8 x 10 in.

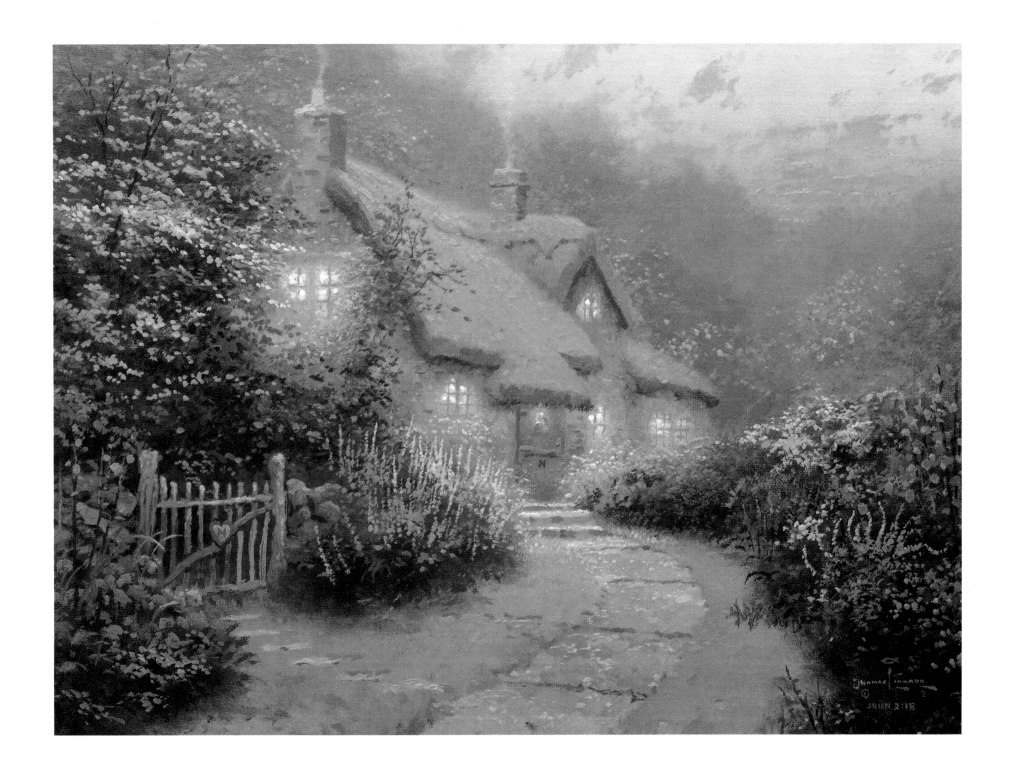

The Hidden Cottage

How many of us get to come face to face with our fantasies about fabulous, joyous places that are simply more special than our everyday world? It happened to me, especially in England, where so many rural paths seem to lead to utterly charming, half-hidden cottages like this one, where rustic gates open onto romantic hideaways.

The English countryside is rich with human history: even the gardens and cobbled paths have a "lived in" look. The very stones are worn by the touch of human hands; lives have been lived and romantic dramas played out within these walls. Even the soft, luminous atmosphere, heavy with fog and mist, is richly nostalgic.

The Hidden Cottage is a treasure composed in equal measures of dreams and memories. Once discovered and painted, it is a treasure for all to share.

Oil on canvas, 16 x 20 in.

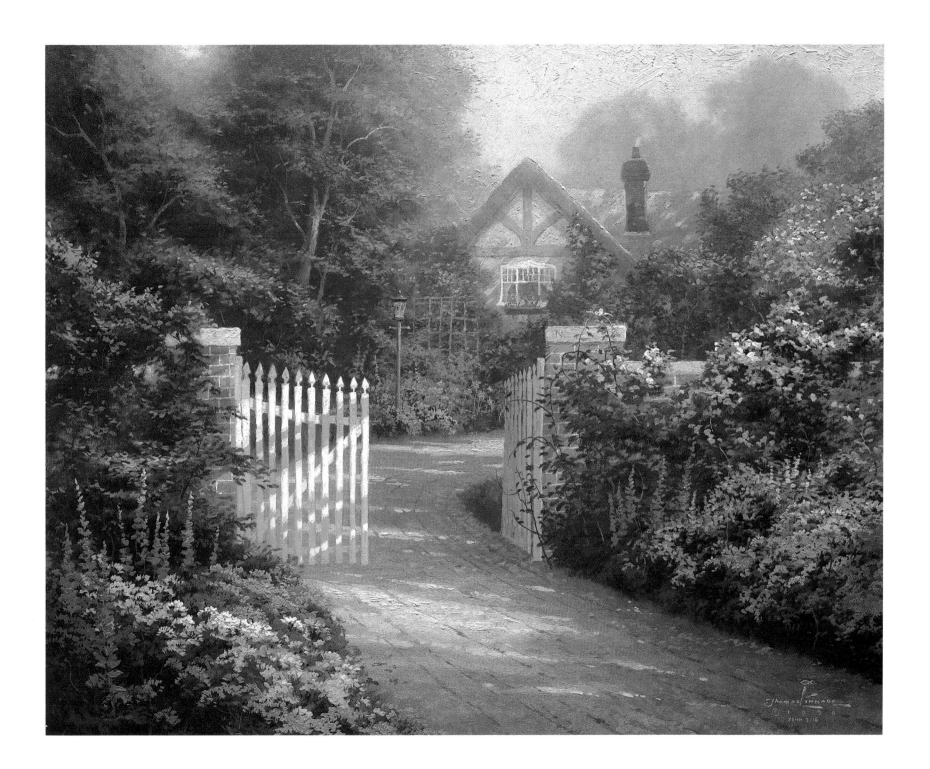

The Hidden Cottage II

I take great pleasure in finding out-of-the-way places, small wonders that sometimes seem to go unnoticed until they're transformed into works of art like *The Hidden Cottage II*. I discovered this inspiration in the town of Carmel-by-the-Sea, where there are lovely little cottages bathed in my favorite light—strong, oblique rays of sun that paint long, feathery shadows on the ground as they pass through the slats of antique wooden gates.

I'm not really sure whether it's the act of exploration or the charming cottage that crowns it that pleases me most. I firmly believe that the world rewards the bold and curious with exciting discoveries—and the Hidden Cottage series bears me out.

Great cottages like this are built by people who understand the urge to explore. The cottages are always half-hidden behind hedges, fences, at the far end of long gardens. That's why I like them so.

Oil on canvas, 16 x 12 in.

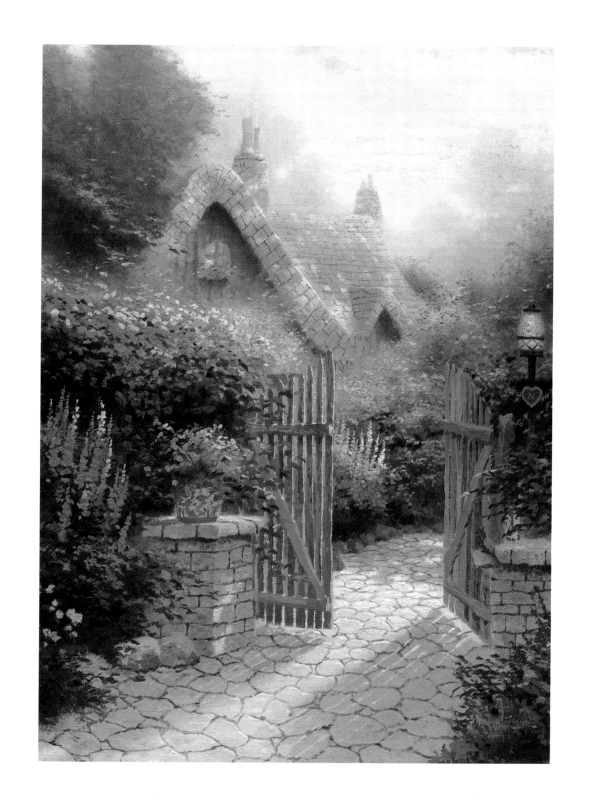

Julianne's Cottage

Researching subjects can be such a serendipity of circumstances that I can only thank God for His divine guidance! This painting is a good example. While visiting England one fall, my wife and I decided to take a driving trip to the lake district—an area of England known for its spectacular scenery as well as for being the home of Beatrix Potter, the famous creator of *The Tale of Peter Rabbit* and other stories. While we made our way north, we thumbed through some tourist guides and found the names of one or two bed-and-break-fasts where we could set up shop for a few days as I worked on a lake district painting.

On arriving in the area, we soon discovered that not only were all of our lodging choices completely booked, but so was virtually everything else we could find was full as well! With hungry, tired children in the back seat, we said a quick prayer and drove on, searching for some place, any place, to put up for the night. While heading down an obscure country road, we passed several large farms, one of which had a tiny, almost unnoticeable sign out front that said simply: "B & B." Not only did this farm have a comfortable room available for the night, but it turned out to be a farm originally owned by none other than Beatrix Potter herself! I quickly set to work the next morning, surrounded by the sounds of sheep, geese, and other farm creatures, and the result is the painting I call *Julianne's Cottage.* By the way, our room during our stay is the one in the upper left-hand corner of the cottage!

Oil on canvas, 12 x 16 in.

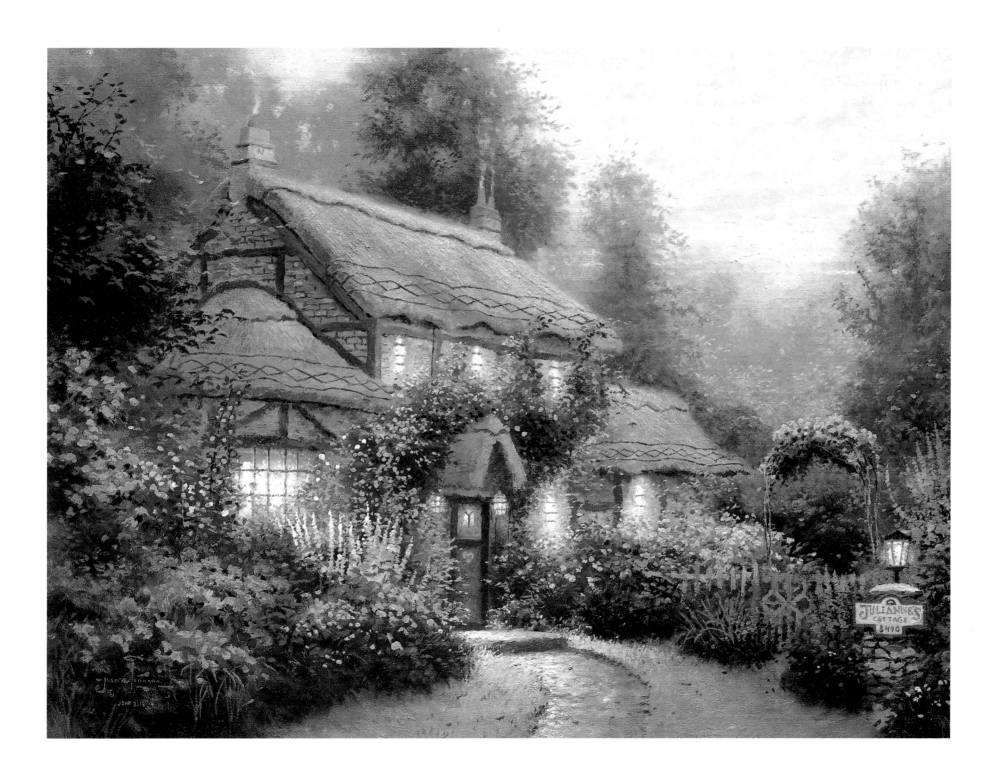

The Brooke Windermer and Cottage Row at Dusk

An artist's imagination is affected by both his inner thoughts and his surrounding world. *Lamplight Lane I: The Brooke Windermer and Cottage Row at Dusk* shows just what I mean.

Talk about an idyllic spot: quaint English cottages running along a footpath, a lively stream spanned by an ornate Victorian bridge, sunlight breaking through clouds. It's all so perfect that I must have dreamed it up, right? Not at all. Actually, I painted this work almost completely on location, at a charming little village in the English Cotswolds that looked very much like this image. My imagination supplied only the finishing details. To heighten the romance I added lampposts running along the brook like a string of luminous pearls. For drama, I supplied golden beams breaking through the clouds so that it seems the floor of heaven has cracked open and God's own light is pouring out.

I hold this first work in the Lamplight Lane series very dear. In fact, I gave the original to my wife as a housewarming gift for our new home. My hope is that it may grace your home with warmth and joy as well.

Oil on canvas, 12 x 16 in.

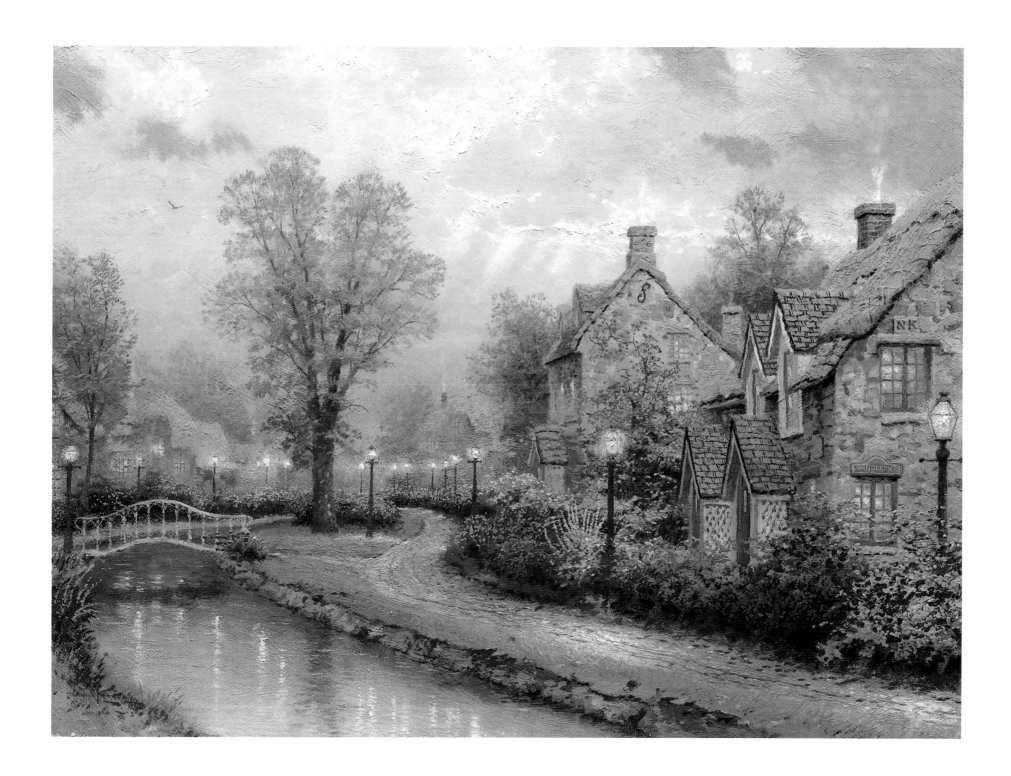

Lamplight Brooke

There is a mystery about brooks and rivers as they meander along their courses. Where did they start? Where are they headed? What will they see on the way?

As I painted my previously published *Lamplight Lane I: The Brooke Windermer and Cottage Row at Dusk*, I couldn't help wondering about the sylvan stream that runs alongside the village lane. In my mind, I had christened it the Brooke Windermer, and imagined it wending its way through the English countryside. I even daydreamed that I was floating in a skiff (as many Englishmen do) past its picturesque villages and farms.

Lamplight Brooke is the delightful result of this voyage of the imagination. As the next work in the series, I envision this as the village that lies just downstream. The quaint village, with its thatch-roofed cottages linked by flagstone paths, its sculpted hedges and flowering shrubs, its brightly-lit windows and smoking chimneys, and its ducks and geese, is roughly based on Bourton-on-the-Water, a charming English town of my acquaintance.

Where will the Brooke Windermer meander next? Keep an eye out for the answer; I promise you won't be sorry.

Oil on canvas, 18 x 24 in.

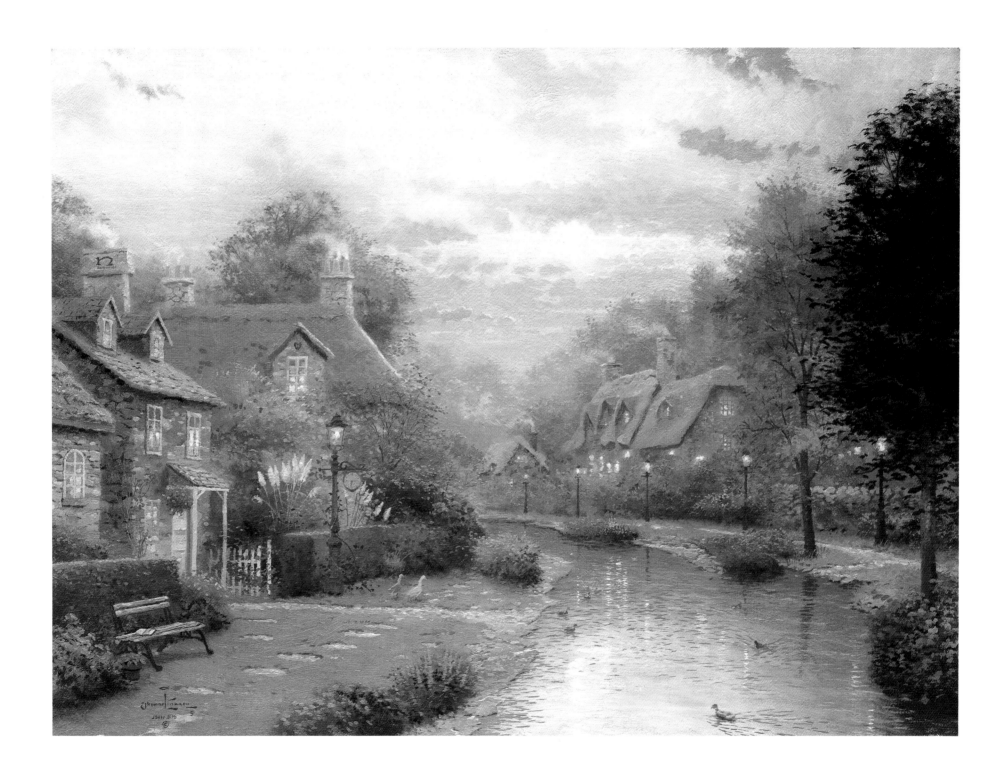

Lamplight Inn

*T*he Brooke Windermer has become the favorite river that flows through my mind. As you recall, we first saw the charming little English country lane that followed its meanderings. We next pictured ourselves floating in a skiff down the sylvan waterway, and passing the rustic cottages portrayed in *Lamplight Brooke*. Now, in the third painting in the Lamplight Lane series, we follow the Brooke Windermer as it takes us at last to the outskirts of a substantial English town.

Lamplight Inn looks to be a wonderfully hospitable place. Above the river, where two boats bob lazily at their moorings, the graceful arched bridge invites us to make our way to the inn's front door. The massive stone facade is softened by a thick growth of Virginia creeper, turned a radiant red for fall. This spacious old country inn has room enough to welcome all weary travelers; it promises to refresh our spirits.

And tomorrow, when we again follow our brook? The fascinating prospect of exploring an English village awaits us.

Oil on canvas, 18 x 27 in.

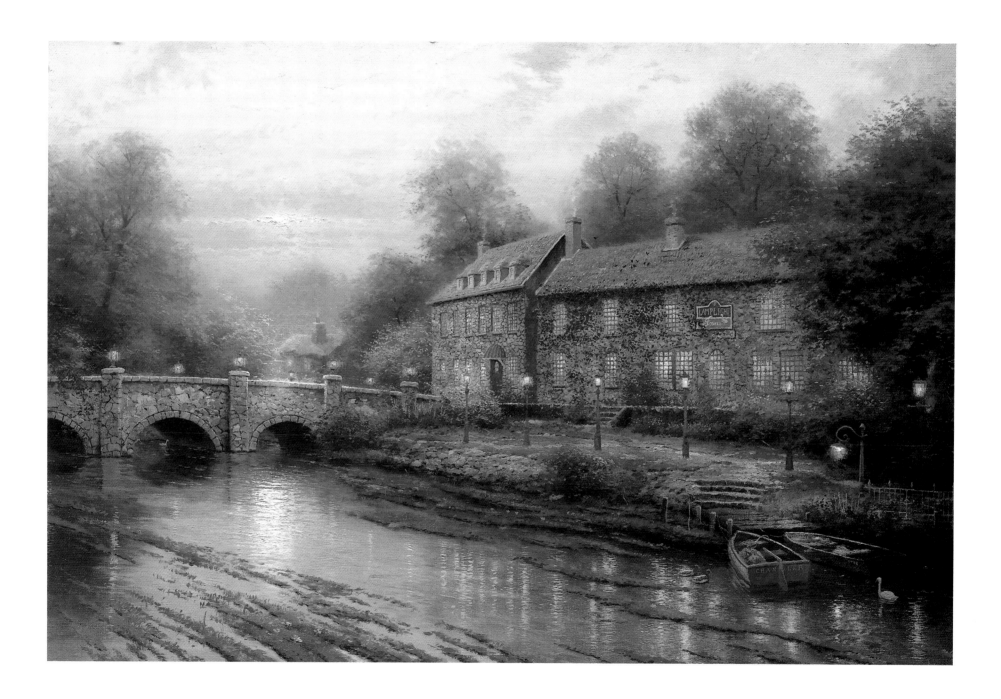

Lamplight Village

*H*ow delightfully the Brooke Windermer flows. It wanders through the English countryside, and each evening, just at dusk, it brings us to an idyllic lamplit locale.

Lamplight is the subject of every painting in the very English Lamplight Lane series, but sunlight is in some sense the subject of all my art. In *Lamplight Village*, the fourth stop along the Brooke Windermer, the interplay of sun and lamplight produces effects that I find spectacular. The blaze of sunset makes silhouettes of the trees and dapples the village row houses; the twinkle of distant lamps enhances the dance of light and shade.

Lamplight Village is more bustling and more highly charged with energy than any of our previous stops along Brooke Windermer have been. Villagers stroll briskly along the paths, while a fisherman and his dog wait for a bit at the river's edge. The tower and spire of the Gothic church in the distance hints at a fascinating history; this is a town that invites exploration. An intriguing path leads away from the stone bridge and into the village that awaits beyond, the chimneys of its stone cottages puffing faint wisps of smoke.

Oil on canvas, 18 x 24 in.

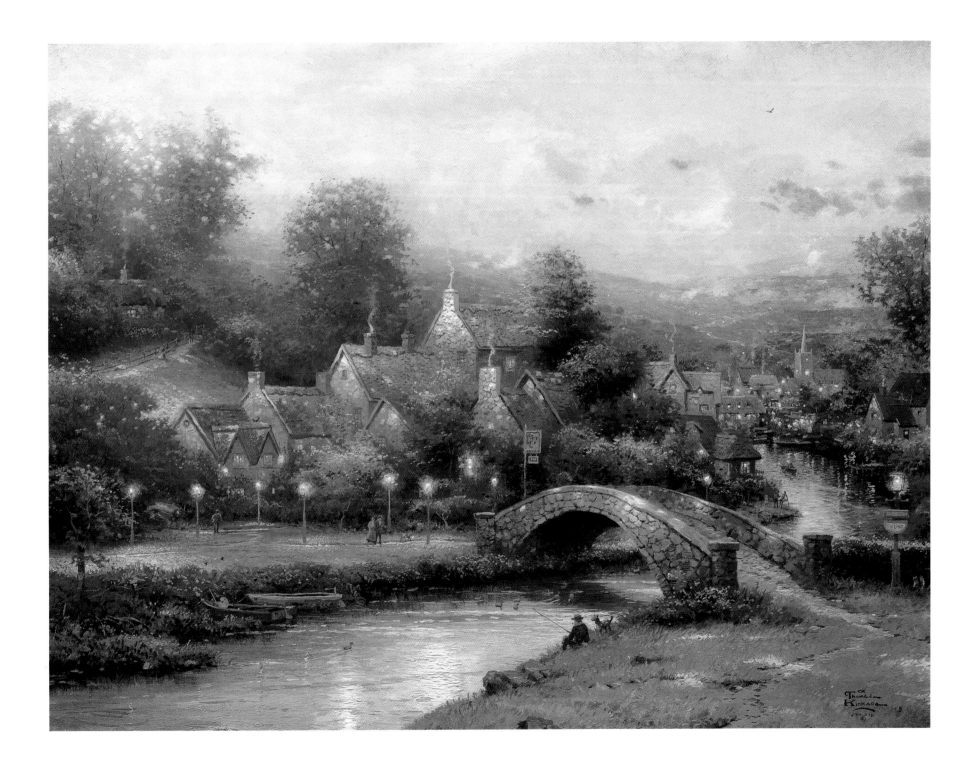

Olde Porterfield Gift Shoppe

Snowfall is like morning mist at the ocean; it silently shrouds the landscape and creates a nostalgic, dreamy mood. I love the hush that snowfall brings, as though the whole world has taken a deep breath in anticipation and quietly awaits some magical moment.

As an artist, I face the challenge of painting falling snow in such a way that suggests how the gentle movement of the flakes throws the world into a subtle blur. It's also necessary to portray the depth of the falling flakes, with larger snowflakes in the foreground and smaller ones receding into the distance. Lastly, I always try to avoid being too monochromatic in my palette with snow scenes. There's a tremendous amount of color in even the most subtle of settings. In this case, I tried to suggest the different tones of the sky as contrasted to the subtle grays and mauves of the foreground snow. I also enjoyed the effect of light cascading from the windows onto the snow below as though an illuminated welcome mat were inviting passersby to inspect the wares of the gift shop.

Oil on canvas, 16 x 20 in.

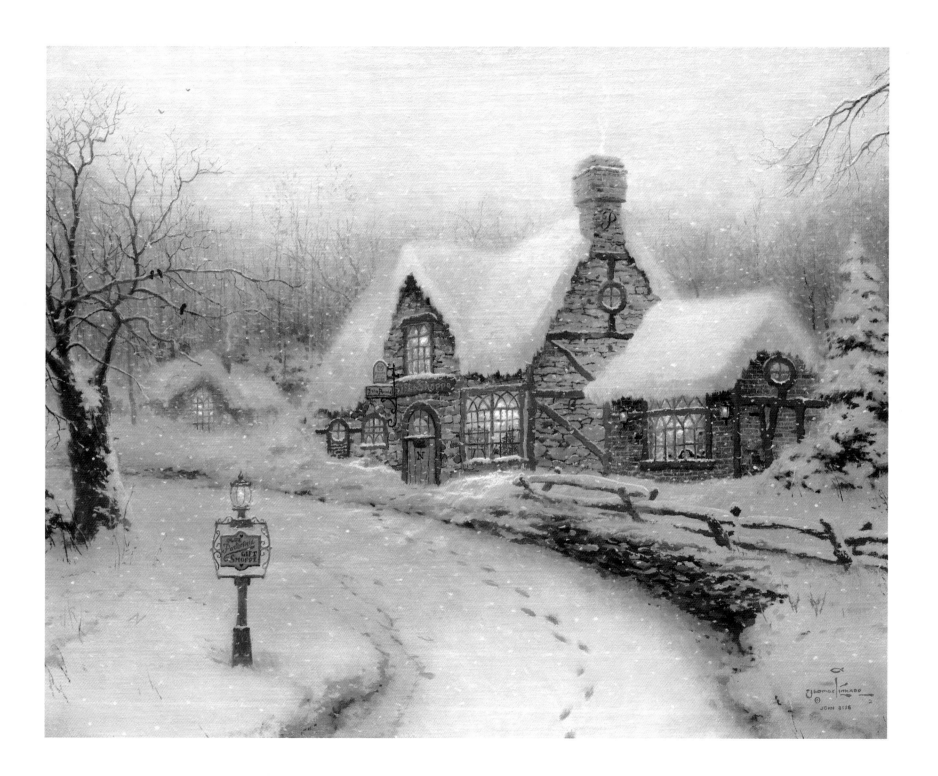

Olde Porterfield Tea Room

It seems that every time I visit England, another new aspect begins to enchant me. On my most recent visit, my wife and I were completely taken with the traditions of English tea. It became almost as though we were on a search to find the finest serving of High Tea in the land. As we traveled about, each village where we would stop to paint would provide another opportunity for sampling the local tea rooms. Our favorite places served what are called "creamed teas," so named for the rich local cream that accompanied the steaming pots of tea.

Olde Porterfield Tea Room, though imaginary, is based on those wonderful tea rooms that, along with pubs, seem to be the social center of every English country village. In this case, the tea room is fashioned from what was originally a cottage. As is so often the case in England, this cottage features architecture that is an amalgamation of every addition and alteration that came through the successive generations. Though one occupant preferred stone construction, another might prefer brick windows; dormers and extra rooms were added as needed. No general plan was necessary—you simply changed what was there to suit your needs. Though this kind of construction may seem haphazard to an American, the end result is, simply put, charming.

Oil on canvas, 16 x 20 in.

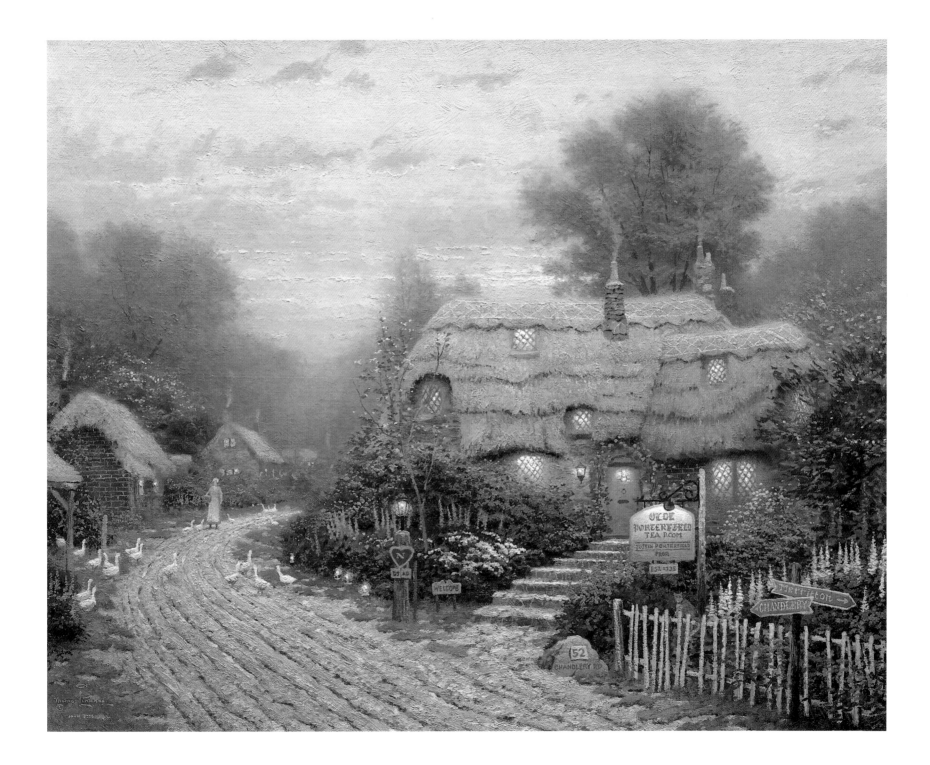

McKenna's Cottage

There seems to be a quiet stateliness to classic English cottages. Everything about them seems timeless and enduring. Every stone is placed by hand, every bit of thatch carefully bound in place. No hydraulic tools are used to create a cottage—no electric saws or bulldozers; this is a patient labor of love.

I am reminded of these somewhat elusive characteristics when I see the painting *McKenna's Cottage*. This piece was executed almost entirely on location as I watched evening approach over this lovely thatched cottage. As I painted, an elderly gentleman with a wheelbarrow was painstakingly repairing a portion of the stone wall in the foreground. I was struck by the man's silent diligence. The thought occurred to me that the scene I was watching could just as easily have been taking place a hundred years ago.

Though I never discovered the name of this cottage, I named it *McKenna's Cottage* as a tribute to McKenna, the toddler daughter of a good friend who purchased the original painting.

Oil on canvas, 12 x 16 in.

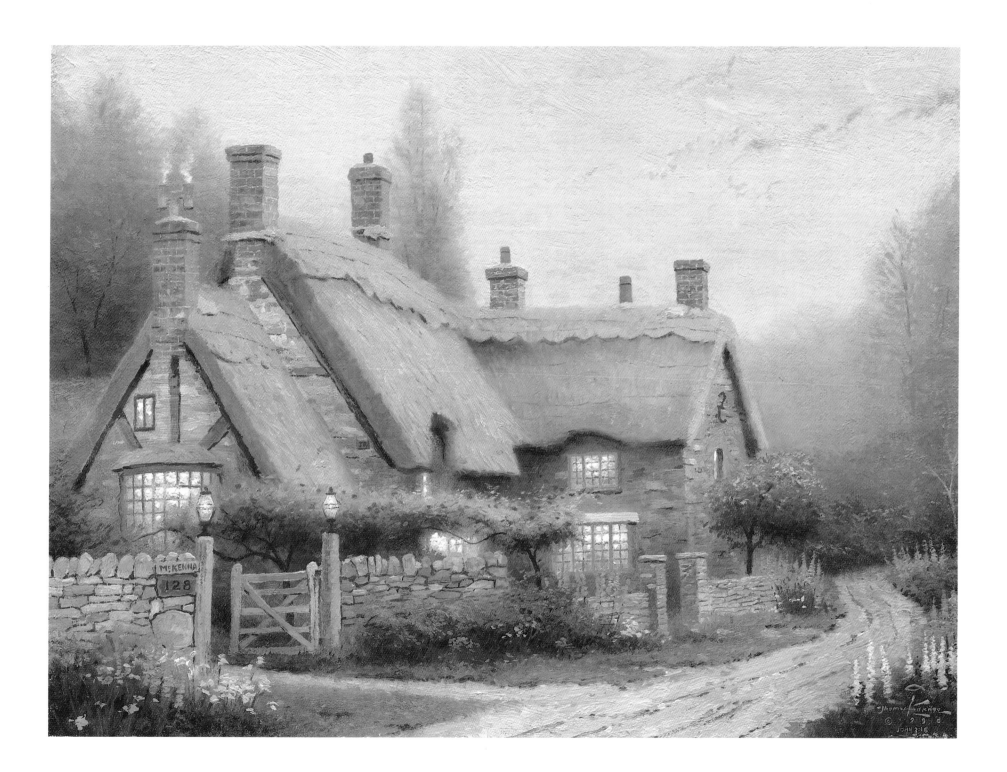

The Miller's Cottage, Thomashire

During my recent stay in the Cotswold district of England, I was struck by the simple and measured routine of daily life. Rituals and habits are not built around cars and freeways, but around the plodding pace of foot travel and village life. *The Miller's Cottage, Thomashire* is a tribute to one of the most pervasive of English village rituals: feeding the ducks at the local mill pond. As I sat observing the tranquil scene, I was amazed at how many people would visit the pond to throw stale bread and biscuits to the ducks and geese. Indeed, at certain times of the day I would observe entire lines of young mothers pushing baby carriages (prams as the English call them) waiting their turn to toss bread. I'm sure the ducks at that pond are among the best fed in England!

By the way, the water warden who looks after the pond lives in this quaint cottage, which actually was once a functioning mill. The water runs down these waterfalls, or raceways, which travel under the stone cottage and originally turned a large waterwheel inside the mill. Though the water wheel is gone, the waterfalls added a pleasant sound as I sat in the sunshine working on this painting. Over the weeks I was at work, I, too, got in the habit of feeding the ducks. In time, the more adventurous of these would regularly settle themselves in the shade beneath my easel!

Oil on canvas, 12 x 16 in.

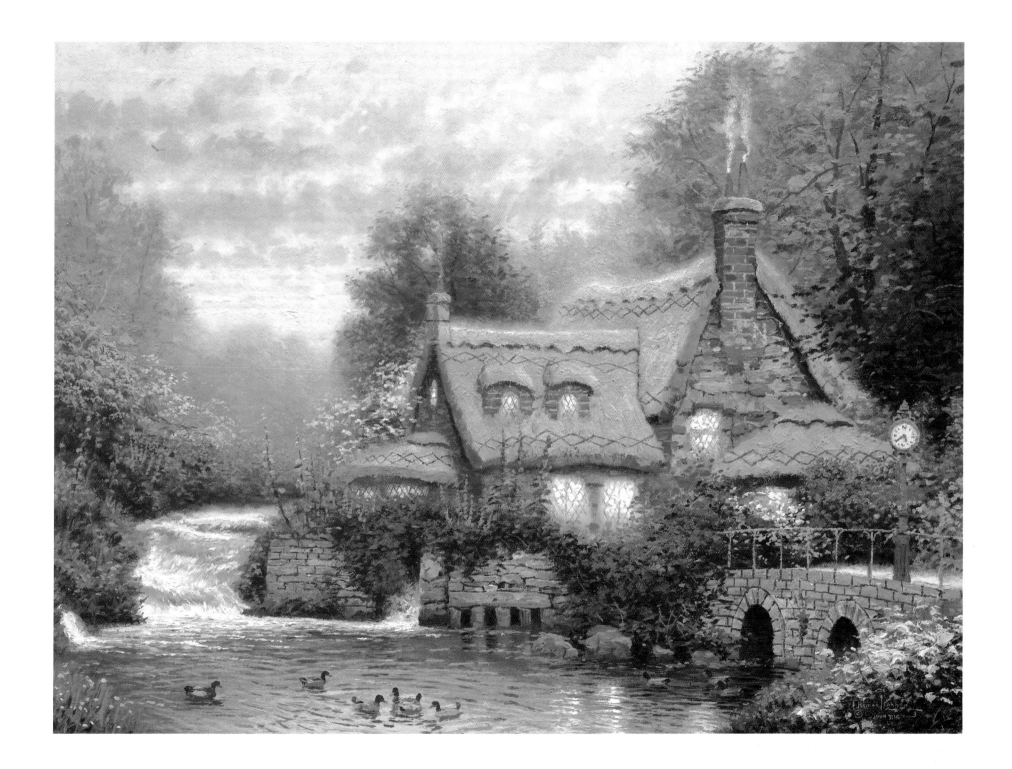

Open Gate, Sussex

\mathcal{O}pen gates are an invitation to visit, especially when lights glow warmly within an English cottage. If you're in the mood to chat, you might wander up the rutted lane and knock briskly on the old, weather-worn door. If your neighbor is home, you will soon be sitting beside the hearth with a warm cup of tea, sweetened lightly with fresh cream.

On a chilly October evening Nanette and I were invited inside a charming cottage similar to the one depicted in *Open Gate, Sussex*. The elderly couple who owned the cottage had been so excited by the painting I was working on in the lane outside their home that they had immediately extended an invitation to "come inside for a warm-up." The toasty kitchen just inside the door was aglow from the fire in a small fireplace and the ample windows looked out over a garden that even in October was radiant with color. Even geese couldn't resist visiting such a delightful spot!

Oil on canvas, 8 x 10 in.

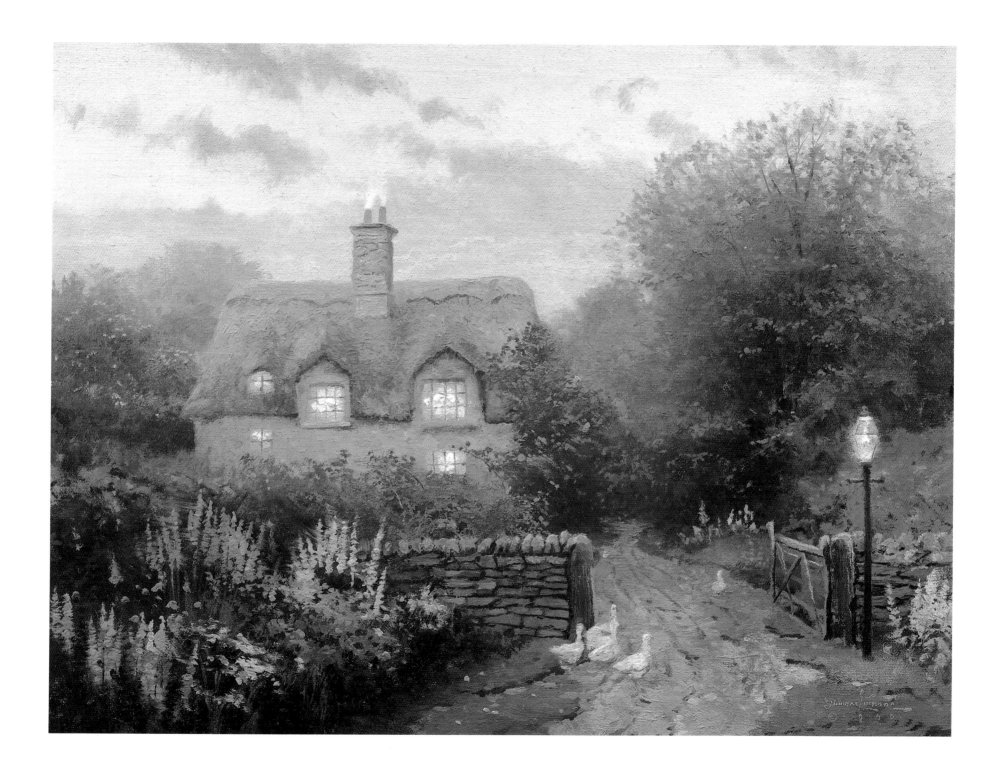

Evening at Swanbrooke Cottage, Thomashire

In England, walking trails accompany even the smallest stream, and on a summer's evening, a peaceful stroll beside a gently whispering brook is guaranteed to restore even the most burdened soul. On one such evening walk in England, my family and I came upon the cottage on which I based this painting. The brookside walking trail led invitingly to the doorstep of the cottage, almost as though a welcome were being extended. The next week I set up my easel on the bank of the brook opposite the cottage and for several days worked on this painting with the sound of the brook in my ears.

I began to imagine myself living in this idyllic cottage, with the entrancing sound of the tiny brook as a constant backdrop to a peaceful life. I was intrigued by the simplicity of the life of the cottage's inhabitants, with patient gardening and a daily ritual of feeding ducks and swans taking center stage in their existence. I hope *Evening at Swanbrooke Cottage, Thomashire* captures on canvas a bit of the peacefulness of such a life, for I'm sure each of us has, at times, daydreamed of living beside a lush and beautiful stream.

Oil on canvas, 20 x 24 in.

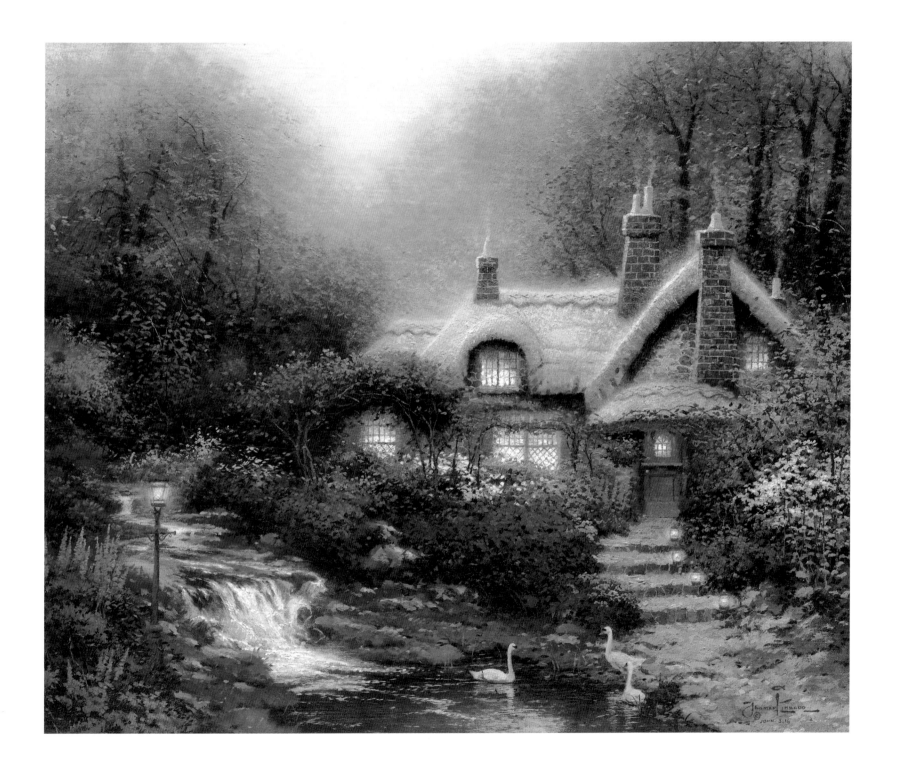

Weathervane Hutch

Behind the overgrown garden walls of the studio I used while visiting the Cotswold region of England was the hidden pathway leading to Weathervane Hutch. I discovered it by accident one day, when searching for a shortcut to the village square. From the moment I saw its flower-draped facade, I knew I would paint it some day. As one might expect, this tiny cottage was inhabited by an absolutely charming elderly woman who, in her very British way, gave me a brief history of the little cottage. She gave me permission to set up my easel in the narrow drive that led to her cottage, and a few days later I began work.

Like many of the paintings from this stay in England, this piece was executed almost entirely outdoors, directly from the subject. As I scrutinized the details of the small house, I became enchanted with the weathervane atop the slate roof, which was so detailed as to almost appear to be a small sculpture. The weathervane depicts a plowman working behind a large draft horse in the manner common to rural farms of this region in the era before steam power became the norm. Though in my painting this detail is only a fraction of an inch in size, the weathervane is the cornerstone of the small cottage and I couldn't resist including it in the title. By the way, the word "hutch" is often used in England to refer to cottages that are especially tiny.

Oil on canvas, 8 x 10 in.

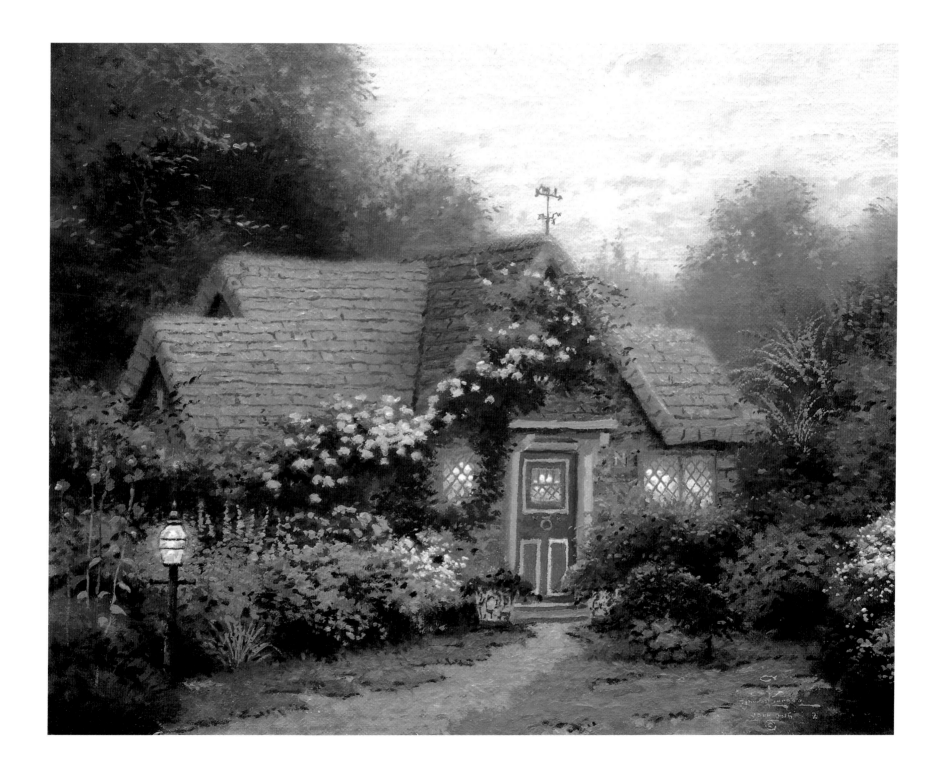

Seasons of Light

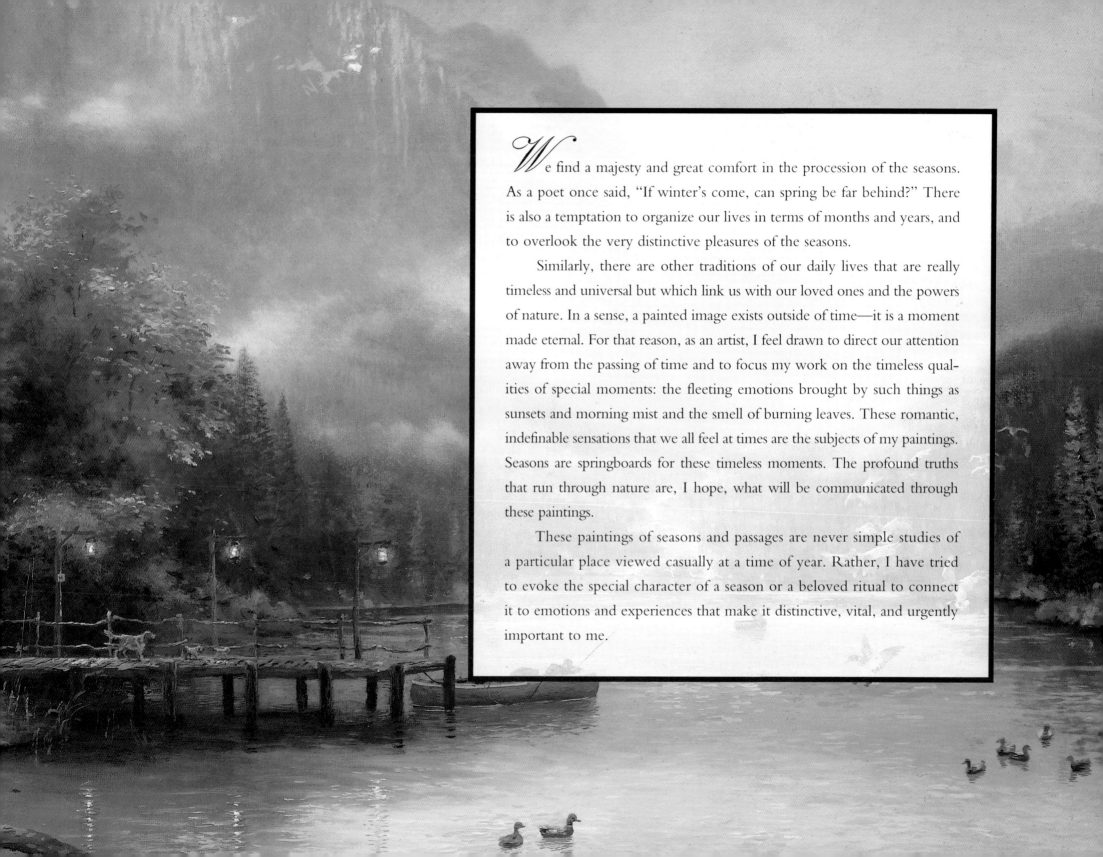

We find a majesty and great comfort in the procession of the seasons. As a poet once said, "If winter's come, can spring be far behind?" There is also a temptation to organize our lives in terms of months and years, and to overlook the very distinctive pleasures of the seasons.

Similarly, there are other traditions of our daily lives that are really timeless and universal but which link us with our loved ones and the powers of nature. In a sense, a painted image exists outside of time—it is a moment made eternal. For that reason, as an artist, I feel drawn to direct our attention away from the passing of time and to focus my work on the timeless qualities of special moments: the fleeting emotions brought by such things as sunsets and morning mist and the smell of burning leaves. These romantic, indefinable sensations that we all feel at times are the subjects of my paintings. Seasons are springboards for these timeless moments. The profound truths that run through nature are, I hope, what will be communicated through these paintings.

These paintings of seasons and passages are never simple studies of a particular place viewed casually at a time of year. Rather, I have tried to evoke the special character of a season or a beloved ritual to connect it to emotions and experiences that make it distinctive, vital, and urgently important to me.

Blessings of Spring

I try never to get so busy that I don't have time for walks. Walks renew my enthusiasm, restore my spirit, and refresh my soul—not to mention the fact that I make such wonderful discoveries when I'm on a ramble.

Lately, I've been strolling back home from my studio and enjoying myself immensely. It's spring here; the trees have burst into bloom and the quiet evening air is heavy with their fragrance. But what I've discovered is a quality of light—a vibrancy of evening that touches the new blossoms with a rare intensity of brilliant color.

That radiant atmosphere pervades *Blessings of Spring*. The stately manor house is one that Nanette and I discovered in our travels through England. (It's an inn now, and you can actually spend the night there.) The flower-filled urn—its red and white blooms magically backlit by the last rays of the setting sun—and the stately circular drive are taken from life.

In the luminous glow of a spring evening, it's easy to imagine the very proper Victorian guests of the manor stepping out of their carriages to make a grand entrance— and that vision truly is a blessing.

Oil on canvas, 16 x 20 in.

Blossom Hill Church

Country churches seem to nestle into their surroundings like a small child on his mother's lap. I've often noted how a church can seem to be such an organic part of its environment—almost as though without it, something would be missing. *Blossom Hill Church*, the second piece in my Country Church collection, is especially fused with its setting, immersed within the enchanting web of spring's full bloom. If I seem particularly romantic about this church, I am. For me, *Blossom Hill Church* will always exist in a world of spring and flowers. After all, inside this church on a brilliant spring morning in 1982, my wife Nanette and I were married. Interestingly enough, for many years we and our two children made our home less than five miles from this historic and magical setting. Notice the small placard along the pathway indicating the resident minister. Its words, "Rev. Merritt Chandler," form a tribute to my two oldest daughters, Merritt and Chandler. My trademark "N," signifying my wife Nanette, adorns the doorway.

As dusk settles on Blossom Hill Church, the evening service is at hand. The glowing lights tell of worshipers inside, perhaps praising God in a joyful chorus. As a man who deeply values his Christian faith, I cherish the sense of warmth and hope engendered by this illuminated church. I hope this painting will share this hope with others. After all, men build buildings, but only God's love can build a church.

Oil on canvas, 24 x 30 in.

Walking to Church on a Rainy Sunday Evening

*I*f you're like me, the word "hometown" conjures up a whole storehouse of memories. In my new collection, Hometown Memories, I would like to attempt to tap into that rich storehouse of associations and recreate some of those memories on canvas.

As we stroll down the tree-shrouded lane, you'll notice the landmarks that are familiar to every hometown—neighborhood houses aglow with lights, the people of the village, well-worn sidewalks, and even a family or two—the Dalmatian in a front yard, the cat darting across the rain-slicked street. These are the places where families thrive, children grow up, and memories are made. In the distance, you will see the steeple of the village church—the spiritual foundation of every hometown. One can imagine that the Sunday service is about to commence on this rainy spring evening.

The man with a pipe at the lower left of the painting is a tribute to one of my favorite artists. Can you guess who he is?

Oil on canvas, 24 x 30 in.

The End of a Perfect Day

As much as I love lush gardens and quaint cottages, I also love the unspoiled grandeur of woods and wild places. Paintings like *The End of a Perfect Day* express my growing appreciation for the real beauty of nature untamed.

This rustic stone cabin is nestled in a glorious setting—a secluded jewel of a lake framed by distant mountains and warmed by the golden glow of sunset. Here, the night still belongs to the owls and coyotes whose lonesome voices will soon echo through the evening skies. The cabin is a safe haven, graced with human touches that mark it as a comfortable retreat: a rocking chair on the porch, fishing poles neatly stacked where they've been left after doing combat with rainbow trout. A fireplace warms the living room, illuminating the overstuffed chair and mounted animal trophies glimpsed through open windows.

I'll admit it—even my paintings of nature's wild places often include the charming and comfortable signs of man's presence. Retreating to a lakeside hideaway after a day enjoying the tranquility of nature is my ideal way to end a perfect day.

Oil on canvas, 16 x 20 in.

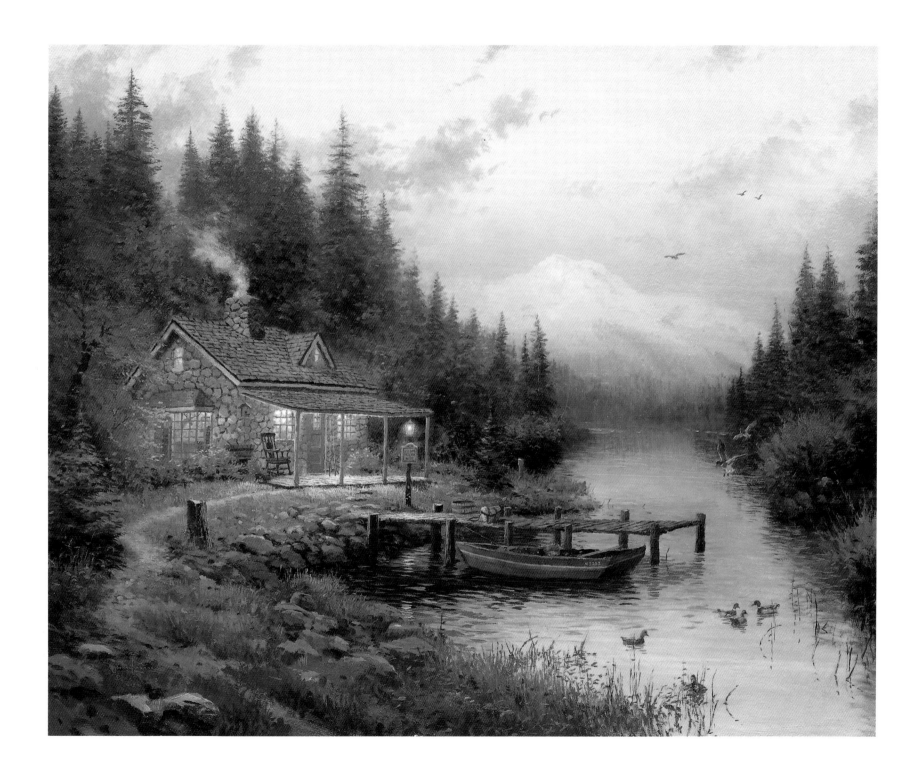

A Quiet Evening at Riverlodge

Activity followed by contemplation, strenuous effort rewarded by a well-earned rest, the awesome grandeur of nature complemented by the intimate charms of domesticity—these are the rhythms that define a civilized life.

I continue to explore these essential harmonies in *A Quiet Evening at Riverlodge*, the second in my series The End of a Perfect Day. Once again, we visit a cozy, rustic cabin nestled in a setting rich with natural drama. A mountain rises powerfully over the scene, reflecting the extravagant colors of sunset. A fishing river races alongside—its crisp, clear waters hinting at the presence of graceful, hard-fighting rainbow trout.

What better retreat after an exhilarating day wading hip-deep into the icy waters of a mountain stream, fly rod in hand, and trout basket at the hip? A campfire stands at the ready; soon a company of friends will gather around the fire, savoring mugs of steaming cocoa and swapping outlandish stories about the one that got away.

Now that truly is the perfect end to a perfect day!

Oil on canvas, 24 x 30 in.

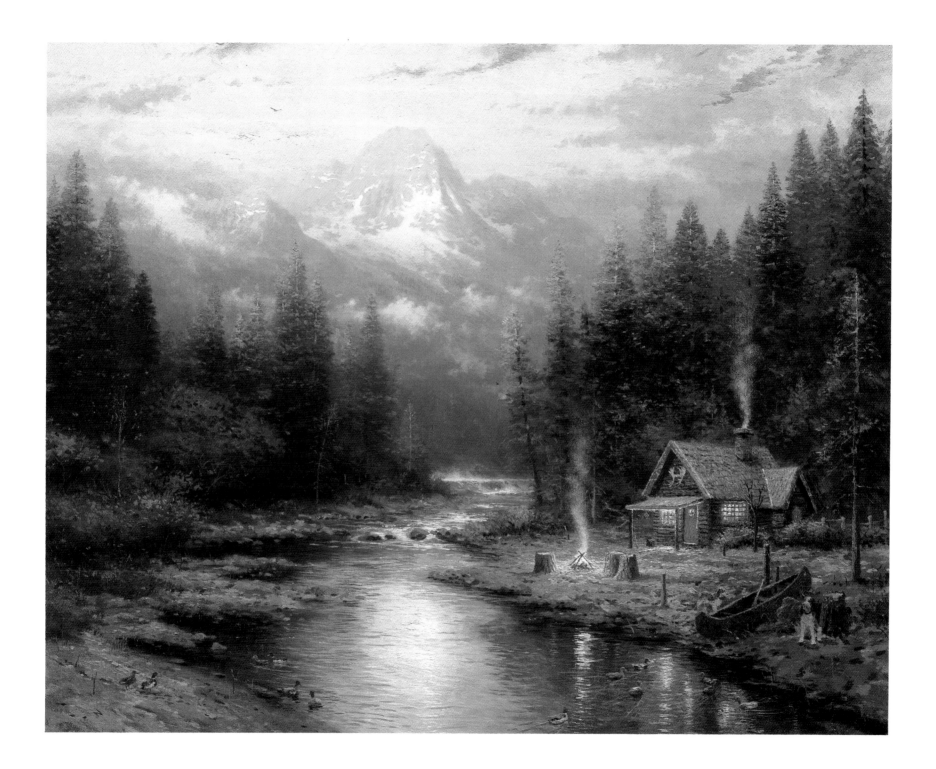

The End of a Perfect Day III

*G*od may very well be in the details…which is why I'm so fond of intimate, intricate settings in my art. But His grandeur is assuredly to be found in heroic vistas that blend rock, water, and sky in glorious harmony.

The End of a Perfect Day III, the third in my End of a Perfect Day collection, celebrates the majesty of God's creation in a panoramic 24-by-36-inch image. The size is crucial to the effect: I particularly want to embrace nature's rich diversity here.

Wilderness invites exploration, and I hope that *The End of a Perfect Day III* does the same. The canoe is our vehicle of choice; the mountain waterways lead to hidden worlds of wonder. A lovely stream in the distance invites us to explore or fish, and trails wind up and away to valleys and vistas that we can only imagine. Nature seems to surround us. Look closely—is that a deer making its cautious approach to the cabin?

Over all this grandeur looms the majesty of heaven, radiant with light. In the drama of sunset, the explorer returns to his own small world: a cozy stone cabin warmed by a hearth fire, and the promise of comfort at day's end.

Oil on canvas, 24 x 36 in.

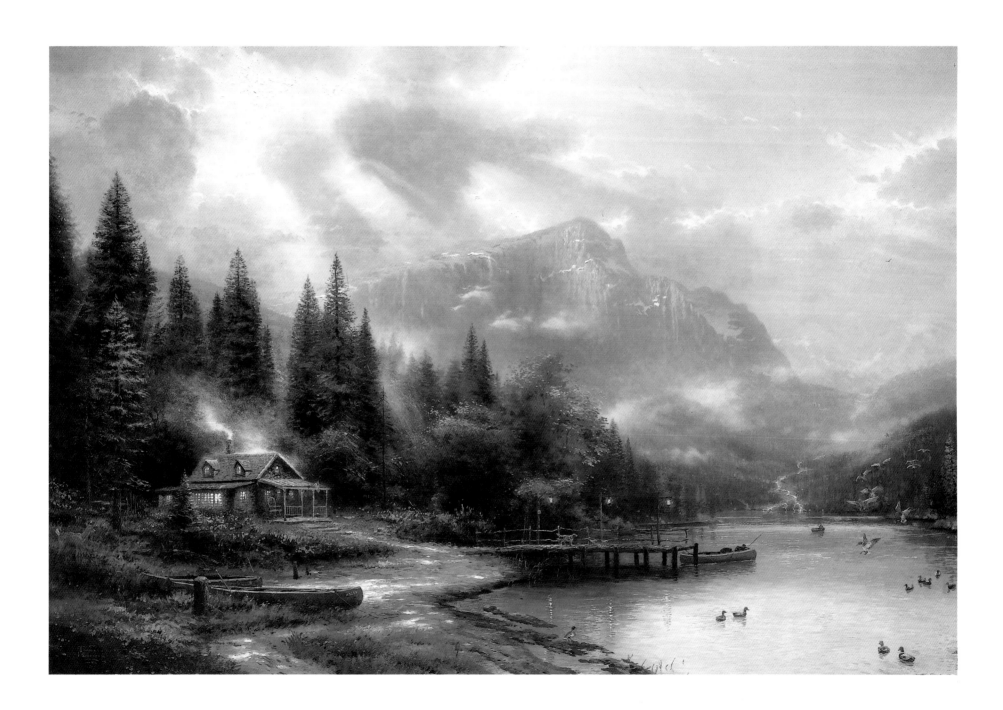

The Old Covered Bridge at Thomaston Brook

While visiting New England recently, my wife and I decided to search for some of the old haunts of our mutual hero, Norman Rockwell. While touring Arlington, Vermont, we came upon the house where Rockwell lived during the forties and fifties. This beautiful old colonial house is located near a tiny covered bridge and is situated on a village green. Behind the house sits the barn-like building Rockwell used as his studio. I was speechless with excitement. Here was the very location where many of Rockwell's best-known paintings were created! What's more, we discovered that the current owners of Rockwell's studio had converted the ample buildings into a charming country inn! We managed, with a bit of haggling, to reserve Rockwell's studio for the night. That evening, while warming ourselves in front of the fireplace, we could almost imagine Norman Rockwell sitting beside us reminiscing about his painting career.

The series Country Memories is a loving tribute to the charming country area Rockwell called home for so many years. It is also a tribute to the simpler, wholesome era he captured in many of his paintings, when a night out meant a ride in a horse-drawn carriage and a day off meant a trip to the village fishing hole. Incidentally, the village in the background is a compilation of many of the villages we visited on our trip. So, don't be disappointed when you don't see this exact view if you ever visit Norman Rockwell's home territory!

Oil on canvas, 16 x 20 in.

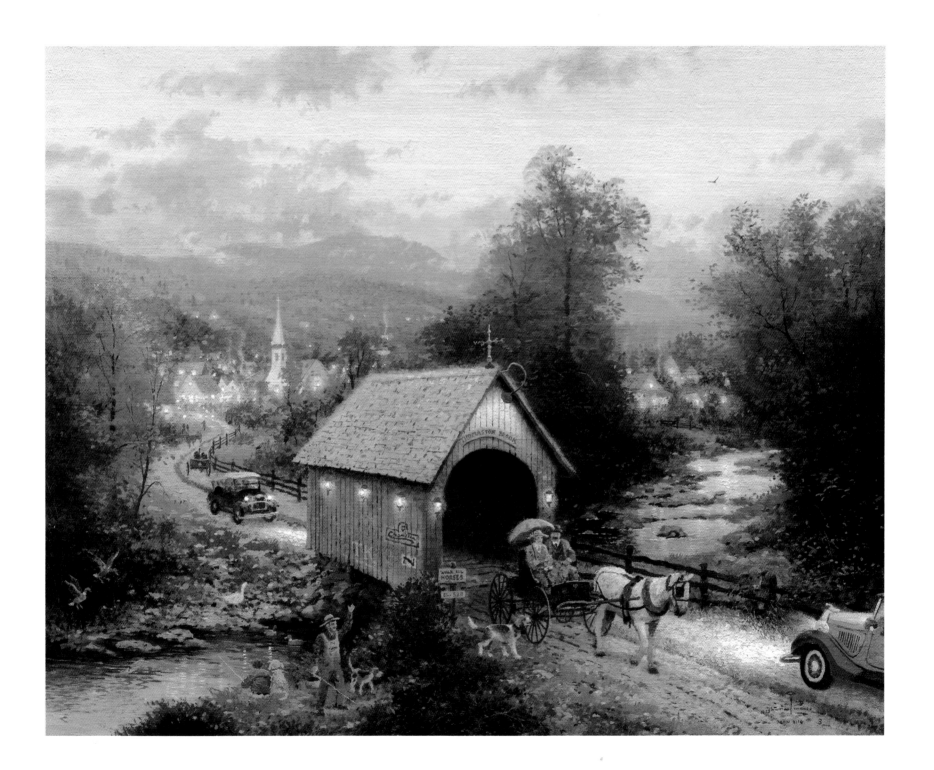

The Village Inn

*N*anette and I fell in love with the bed-and-breakfast during our travels in England—where a "B & B" sign outside a home (its only advertising) promises comfortable lodging, good company, and a hearty morning meal. If you want to learn about a place and its people, stop at a B & B. There's no substitute.

That's why we're so delighted to see charming country inns popping up in our country as well. *The Village Inn* features climbing blue wisteria and ornate white wrought iron furniture that invites you to enjoy the verdant lawn. I softened the focus just a little, and heightened the romance of a very romantic setting to make this B & B my dream-vision of an intimate, utterly charming bed-and-breakfast.

High-rise hotels can be quite comfortable, but Nanette and I prefer the charm of a quiet bed-and-breakfast, where we feel more "at home." I hope this country inn will make others feel at home as well.

Oil on canvas, 12 x 16 in.

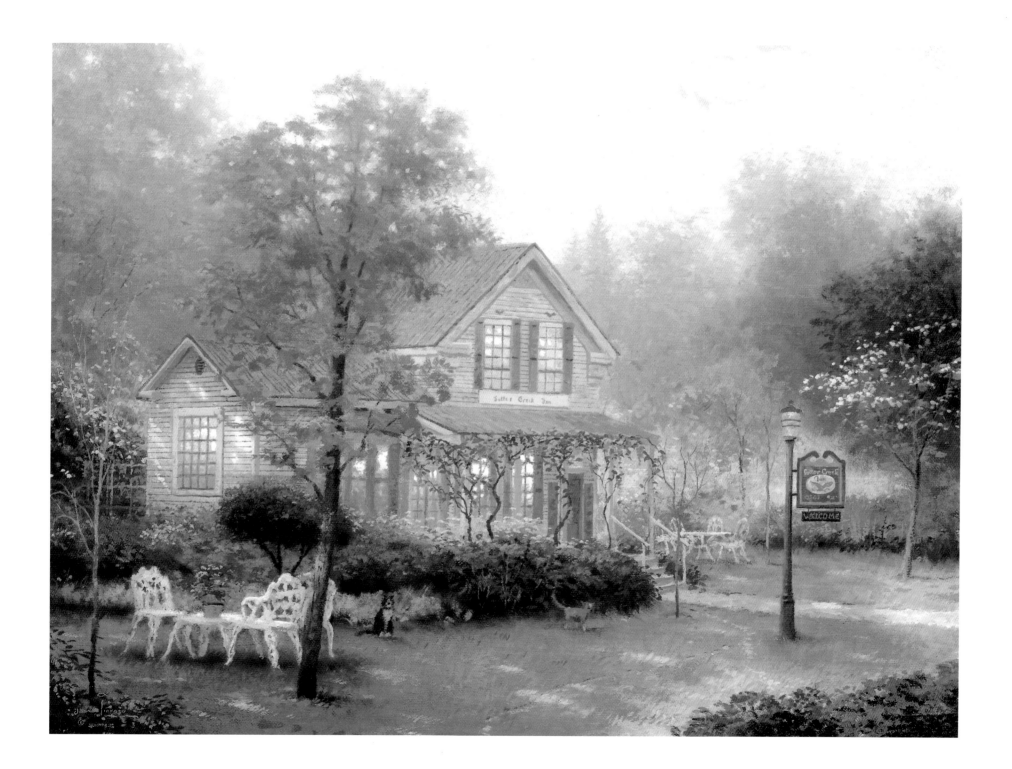

Sunday at Apple Hill

Perhaps for as long as there have been Sunday afternoons there have been Sunday afternoon drives. In the spring, I enjoy packing up the family after our Sunday worship at church and wandering about in search of wildflowers and picnic spots. Though the carriage we wander about in is of the horseless variety, I sometimes envy the days when the family outing to church meant sitting aboard a buggy and slowly touring the country-side. It seems the slower pace of horse-drawn travel makes for a greater appreciation of the beauty of the scenery. Also, there is something magical about being surrounded by the sounds and smells of the countryside as you travel in an open-air buggy. A fragrant field of flowers seems to explode with life as the air carries the scent to the passer-by, and the songs of birds on a sunny afternoon would lift any spirit.

The house featured in *Sunday at Apple Hill* is a vintage farm house that is actually located in an area near my home known as Apple Hill. Though the setting is based on this lovely old house, I enhanced the flowers and foliage surrounding it a bit to add color to the painting. And, of course, I couldn't resist adding the family returning from church as a tribute to the slower-paced life of yesteryear.

Oil on canvas, 20 x 24 in.

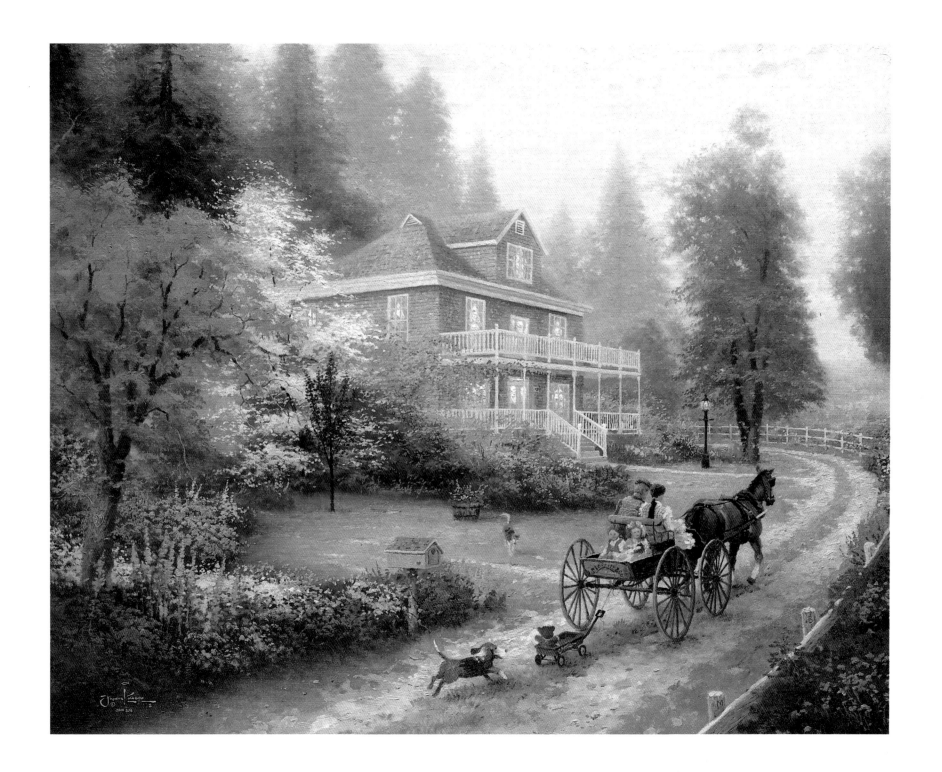

Amber Afternoon
Burning Leaves on a Quiet Saturday

Henry Wadsworth Longfellow's admonition to "stay at home, my heart and rest" is easy for me to understand on an autumn day. The gathering breezes carry leaves to the ground, while all around, the crimson veil of color creates a glow that warms the soul. I enjoy putting on sweaters for the first time in months and building that first fire of the season in the fireplace. Above all, I look forward to the scent of autumn: the cooling moisture of rains and mist and the occasional scent of burning leaves. It's time to set aside the yearnings and adventures of summer and turn our hearts to home and rest.

This painting is a poem for fall—a romantic love sonnet from the heart of one who feels deeply the charms of the autumnal season. I chose the subtle colors of a vintage Victorian house as a means of accentuating the brilliant fall color, and of course, I had to include the smoldering pile of leaves.

Oil on canvas, 16 x 20 in.

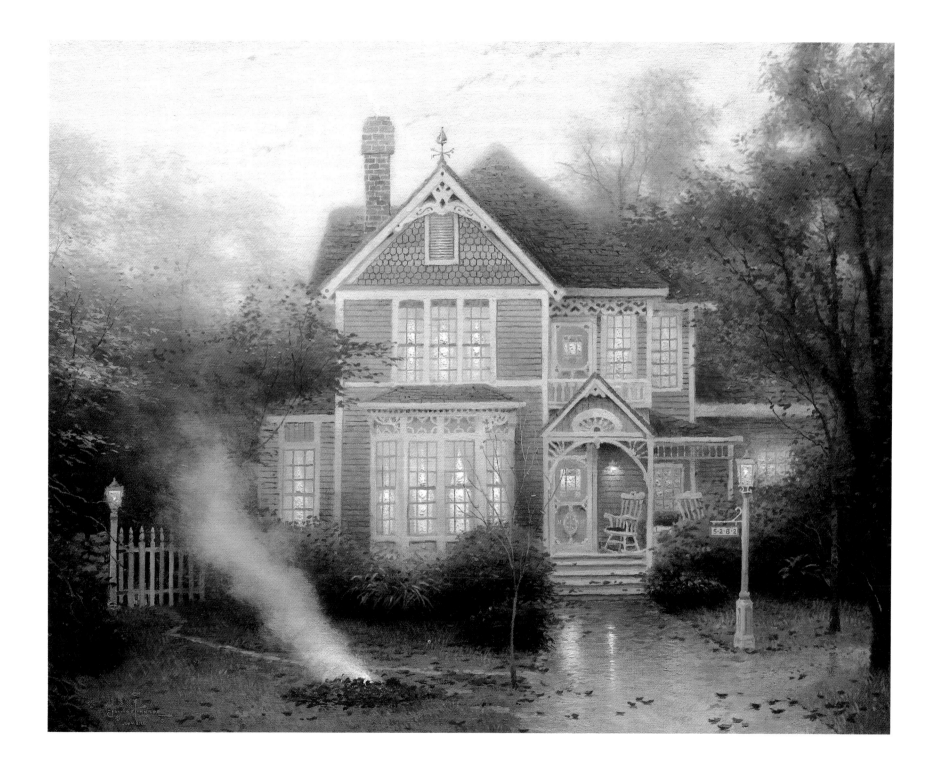

Yosemite Valley
Late Afternoon Light at Artist's Point

*N*owhere on earth am I more aware of the sheer awesomeness of God's handiwork than Yosemite Valley. This painting depicts the valley as seen from a little-known place called Artist's Point, named in tribute to the many nineteenth-century artists who favored it as a sketching ground. Thomas Hill, Albert Bierstadt, and countless others painted this view long before I was even born and, perhaps challenged by their example, I decided to attempt painting the same vista.

The first difficulty is reaching the spot. A steep, poorly marked trail leads up the western escarpment of the valley and Artist's Point lies along that trail. Topographical maps help in the location process, but even with those, it's difficult to find because of the dense second growth. In my case, the hike was intensified by the fifty pounds or so of easel, paints, and assorted other material strapped to my back!

The final result was worth the efforts however, because in 1989 the National Park System selected *Yosemite Valley* as their official print. This tribute was especially exciting since this piece was chosen out of about 2,700 other paintings created by many of America's top artists. In addition, *Yosemite Valley* was made into a commemorative stamp and gold medallion. I was thrilled with the honor, but after all, God alone deserves the credit for the beauty and majesty of Yosemite Valley.

Oil on canvas, 18 x 24 in.

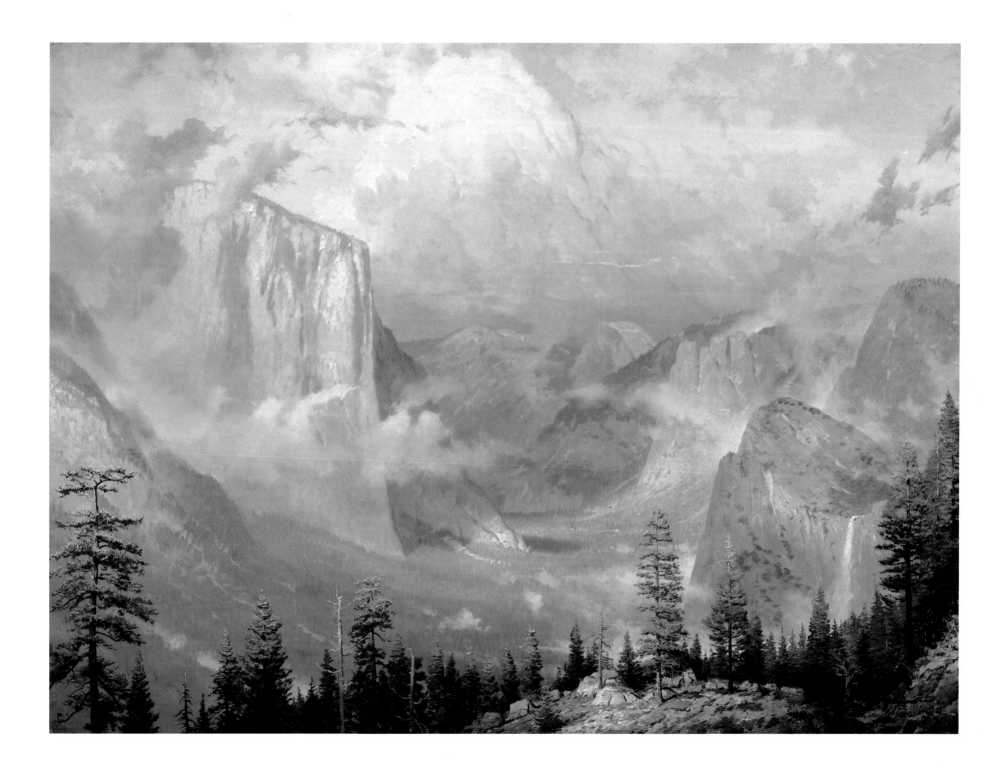

Beacon of Hope

*T*his dramatic lighthouse begins my new series entitled Seaside Memories, but in truth, the subject of *Beacon of Hope* is not memory, but faith.

The lighthouse, which guides ships around rocky shoals to a safe harbor, is a principal emblem of the spiritual life. And I'm very grateful to say that my own paintings have been described as "beacons of hope" by people who find spiritual comfort in them.

So *Beacon of Hope* celebrates not only the longing for salvation, but the power of art to express that aspiration. The painting, which is my first on the subject, is not a literal portrait; it is instead a product of my artistic imagination, containing the elements of an allegory of faith.

A small boat, barely visible on the horizon, rides heavy seas that surge and crash onto a rocky coast; the lighthouse beacon is its sole guide. The keeper's house is a safe haven against all storms—a charming cottage nestled near a flower-laden trellis. And, of course, light—radiant sunset and warm lamp glow—bathes the rocks, erasing their sharp edges.

Oil on canvas, 18 x 27 in.

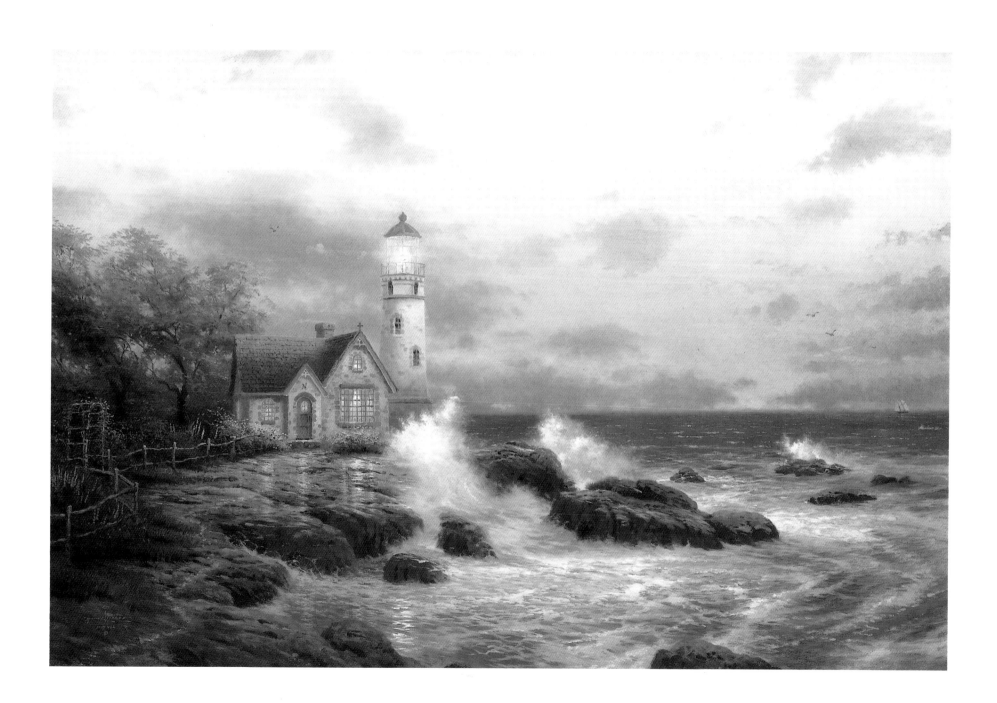

Home Is Where the Heart Is

Like many others, I enjoy the look of charming two-story homes such as this, with shutters on the windows, flower-lined walkways, and a shade tree towering over the front lawn. As I worked on this painting, I imagined my own family living in this beautiful setting. Of course, my wife Nanette would want white wicker furniture on the covered porches to allow us to enjoy the cool air on summer evenings as we watched our children play. For my oldest daughter, Merritt, a swing is in order, hung from one of the branches of the large front yard tree. My middle daughter, Chandler, would naturally enjoy playing with her toys as she explored the lawns.

In my painting, I left a teddy bear beneath the tree, where it would no doubt remain at day's end. As the children head inside to embark on the rituals of bedtime, the evening guardians of the premises, our cats, keep a careful watch on the yard—especially the birdhouse that hangs from the tree! By the way, the title *Home Is Where The Heart Is* has a double significance; three hearts can be found within the painting, including one carved into the large tree bearing the initials of my wife and me. Those same initials were emblazoned on a similar tree when we were first sweethearts almost twenty years ago!

Oil on canvas, 20 x 24 in.

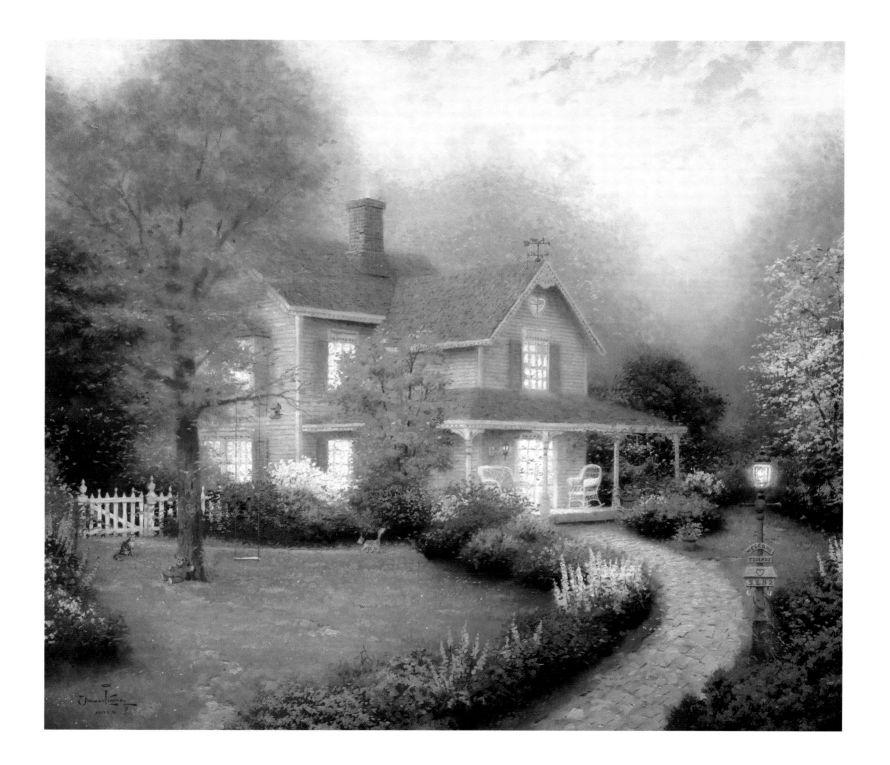

The Autumn Gate

A gate is an invitation to explore! I spotted this gate while driving through a tiny Cotswold village having just painted the cottage featured in my painting *McKenna's Cottage*. I knew at once I must record the gate in paint, yet since daylight was escaping, I quickly snapped a few reference photos and vowed to recreate the gate in my studio once I returned home.

Six months later, I began work on *The Autumn Gate* and had the most unusual experience. As I worked on the painting I became intrigued not with the gate itself, but the road that lay beyond! I just couldn't stop imagining where the tiny road led. Was it to a beautiful wooded estate with a lavish manor house just waiting to be painted? Or perhaps a lush cottage waited beyond with a garden of flowers withering in the chill air of autumn? Funny enough, while standing in England taking photographs of the gate, I had become distracted by a man tending a burning pile of leaves and had never even attempted to see what lay up the road. The mystery beyond the gate became almost an obsession. I had to know what it was. On a later trip to England, I actually returned to the spot, went beyond the gate, and painted my delightful discovery in *Beyond Autumn Gate*.

Oil on canvas, 24 x 30 in.

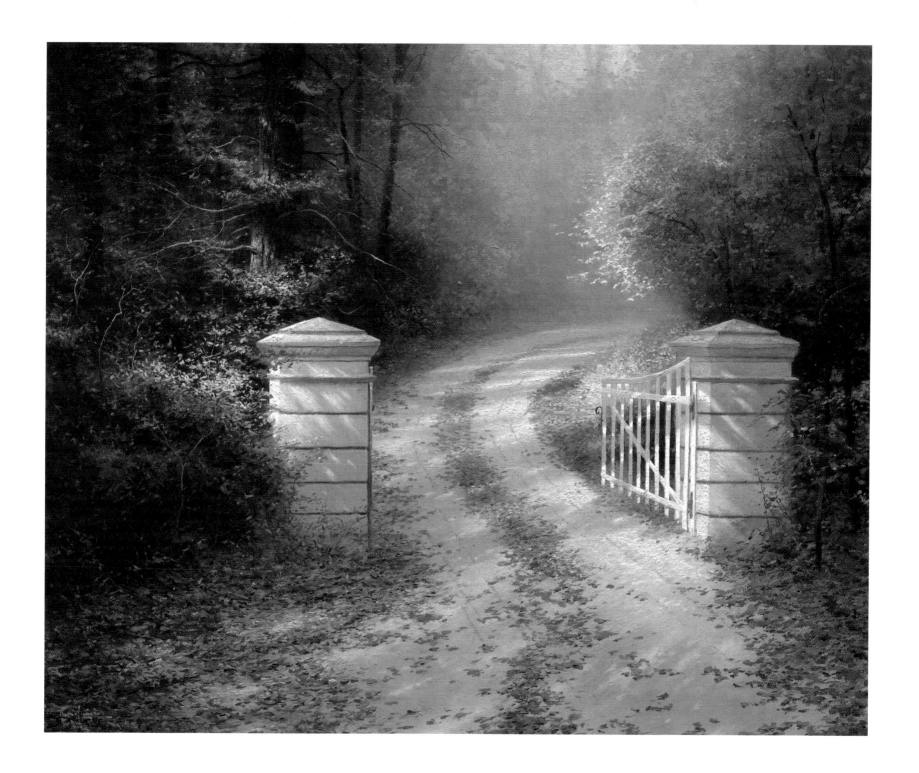

Beside Still Waters

*T*here is a place I visit only in my imagination—and share with you only in my art—because any human presence would spoil its perfect tranquility. It is a wonderful hideaway, bathed in a silvery light, ablaze with flowers of every hue and description, silent save for the murmur of gently rushing waters. I'm not sure to this day whether it's a dream or a memory.

Beside Still Waters is my vision of what the Garden of Eden must have been like. As a Christian, I sometimes speculate on the mystery and wonder of God's creation—nature unspoiled and perfect, as it was in Eden. As an artist, I convey through my art my own wonder at the richness and variety I still find in the natural world, in the joyous energy of sunlight and growing flowers. There is a warm, animated quality to the light here. It paints the leaves of the silver birch and dances on the water.

As I worked on *Beside Still Waters*, I often felt that I was trespassing on a world too perfect for people to see. Sometimes, as I applied the paint, I actually found myself holding my breath so I wouldn't disturb the silence of Eden!

Oil on canvas, 16 x 20 in.

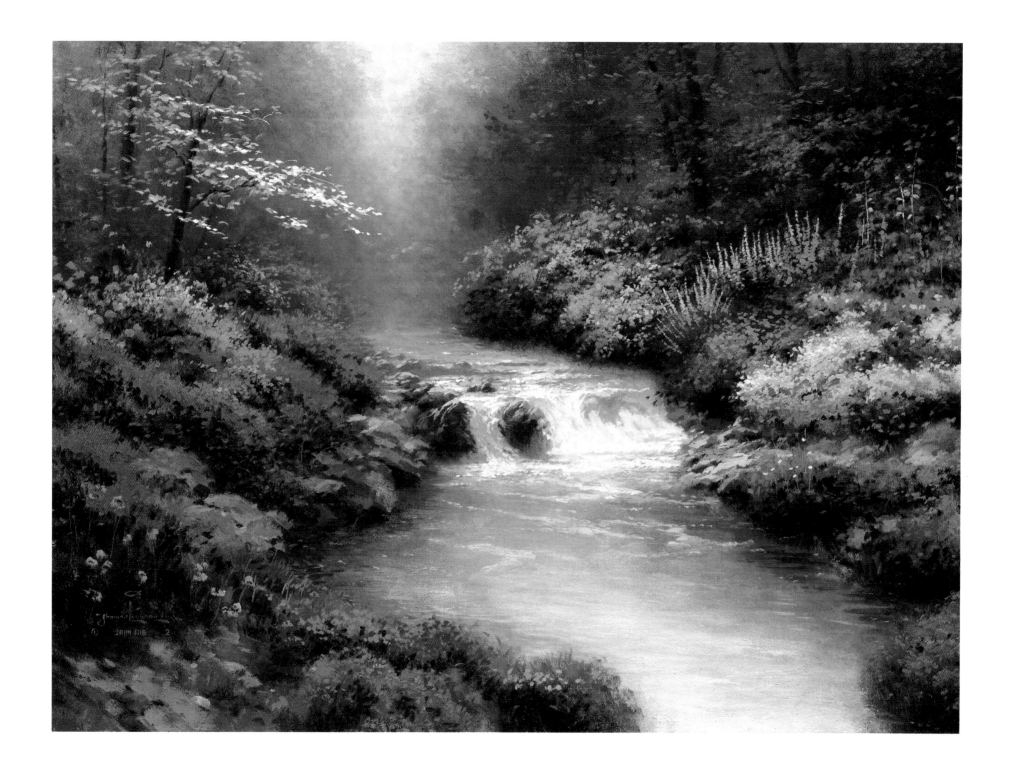

The Power and the Majesty

Of the four ancient elements, water is surely the most impressive. It can be calm, a perfect mirror of nature s wonders. Or water can surge and plunge and dash itself into a mist that dazzles us with the colors of the rainbow. Water can whisper; it can gurgle, laugh, crash, thunder. I like to think that water is alive with the poetry and power of God's creation.

The Power and the Majesty, second in my Streams of Living Water collection, once again treats water as a manifestation of God's presence in the world. The aspect of divinity revealed in this piece is very different from the tranquil mood of *Beside Still Waters*. Here we see the awesome power of God's might displayed in a thundering waterfall hurtling down a sheer precipice. And yet, for all the grandeur of the scene and the undeniable exhilaration one feels as a witness to it, one can also sense a profound peacefulness that is most reassuring. For though the power and majesty portrayed may seem inaccessible, we as children of a loving and peaceful God have access to His majestic presence. As a symbol of that access, you will notice the trail that marks a misty path to the very summit of the glorious waterfall. Stroll with me along the trail, and be refreshed by the power and the majesty of the living water.

Oil on canvas, 24 x 20 in.

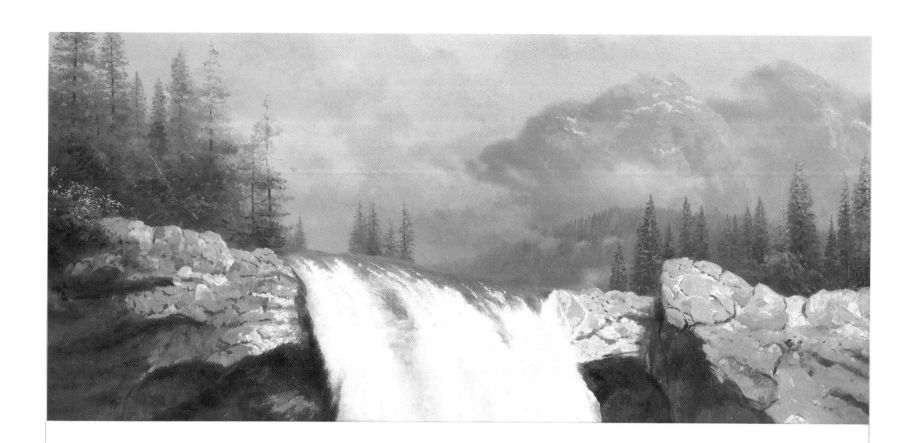

Morning at Ivycrest Manor

Some years ago, during my travels through England, I found a wonderful old stone gate—mysterious and inviting, suggesting all sorts of exciting possibilities. It was only when I was back in my studio, working on the canvas that would become my well-known *Autumn Gate*, that I realized I didn't know where the gate led. Was it the entrance to a glorious castle or simply a country road leading to some less picturesque setting? When people asked, I wasn't able to answer, because I'd never walked in to take a look.

This question intrigued me to such a degree that on a later trip, Nanette and I made a pilgrimage back to the setting for *Autumn Gate*. Walking through it, I was ecstatic to discover the stately, ivy-draped stone manor house I celebrate in this painting. Since this subject lay beyond the gate featured in *Autumn Gate*, I couldn't resist titling it *Beyond Autumn Gate*.

Setting aside the history of its inspiration, I also wanted to create a splendid evocation of a home more gracious than the humble cottages I often paint. I'm sure that deep down, each of us dreams of living in a setting such as this and being, if only in our imagination, "lord of the manor."

Oil on canvas, 24 x 30 in.

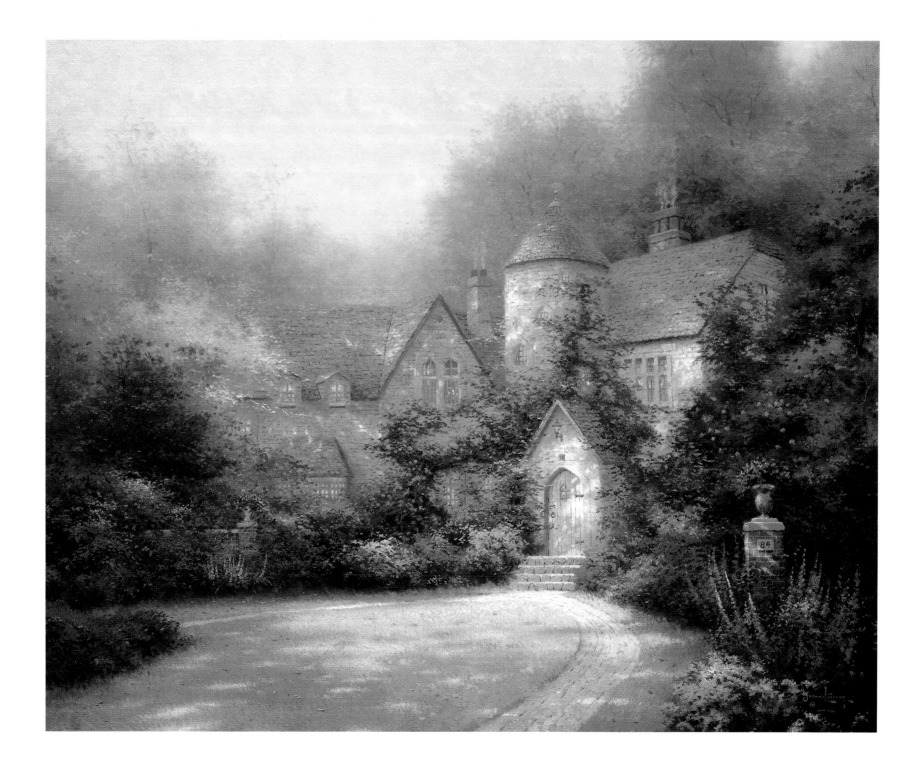

The Blessings of Autumn

*T*he *Blessings of Autumn*, which begins my new Blessings of the Seasons portfolio, was inspired by my stay in Norman Rockwell's Arlington, Vermont studio. The white frame house with green shutters is pure New England, as are the rich warm colors so typical of autumn in that area. But in the process of painting, I decided to go beyond the particulars of the scene to attempt capturing the very essence of the season.

Here is the fullness of autumn: the ripe orange plumpness of pumpkins, the Indian corn wreath on the front door, the flaming reds and golds of the maples, the soft blanket of fallen leaves, the brisk clarity of air and light. In this season, nature's promise of abundance is fulfilled. The rigors of winter lie ahead, but we've stored away autumn's rich harvest.

As an artist, I've learned that each season has its special pleasures; each speaks in its own way of God's gracious provision in our lives. I hope you'll share it all with me through my Blessings of the Seasons series.

Oil on canvas, 18 x 27 in.

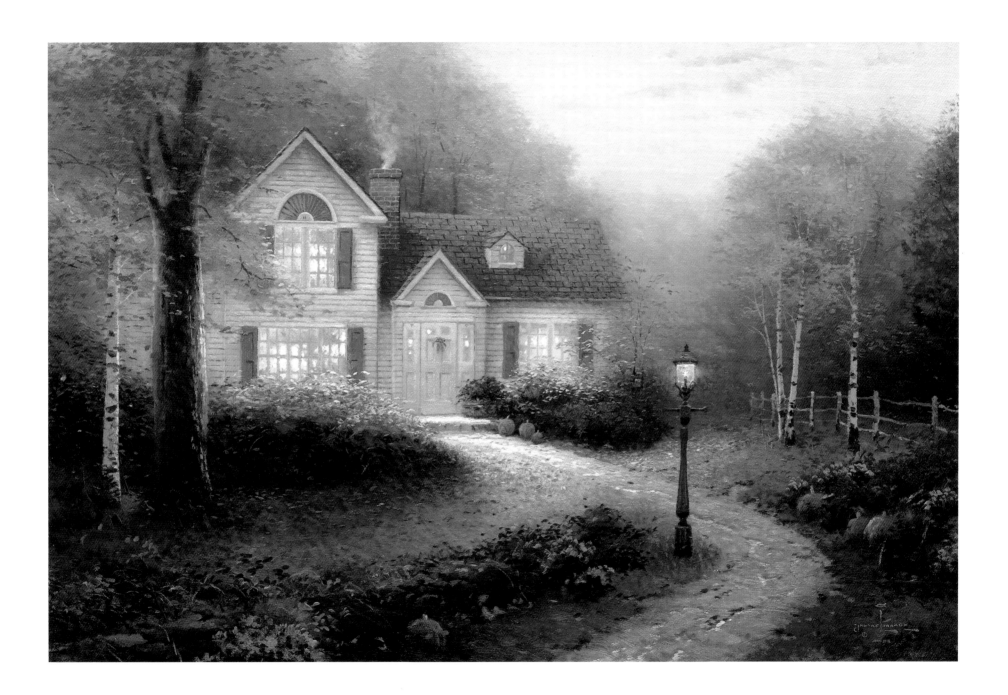

The Warmth of Home

*I*t will come as no surprise to you that the subject of home is near and dear to my heart—both as an artist, and as a father and provider. In *The Warmth of Home*, I get at the essence of the matter by stripping away all that is incidental—all the civilized, decorative touches that I love so much.

A cabin in the wilderness is the quintessential American home. It provides shelter in the storm, warmth in winter, light in the gathering darkness. And, as *The Warmth of Home* suggests, a modest mountain retreat can satisfy the romantic, poetic yearnings of human nature as well.

Sunset paints the mountains in glorious colors; it also announces the fall of night, when this idyllic spot will be touched with the mysteries of evening. I feel the strongest identification with the distant seeker, lantern in hand, who races the setting sun toward the modest comforts of home.

The mountains are majestic, as are many of the peaks that I have been privileged to see in my travels. They belong to no real range; I like to think of them as the Kinkade Mountains.

Oil on canvas, 12 x 16 in.

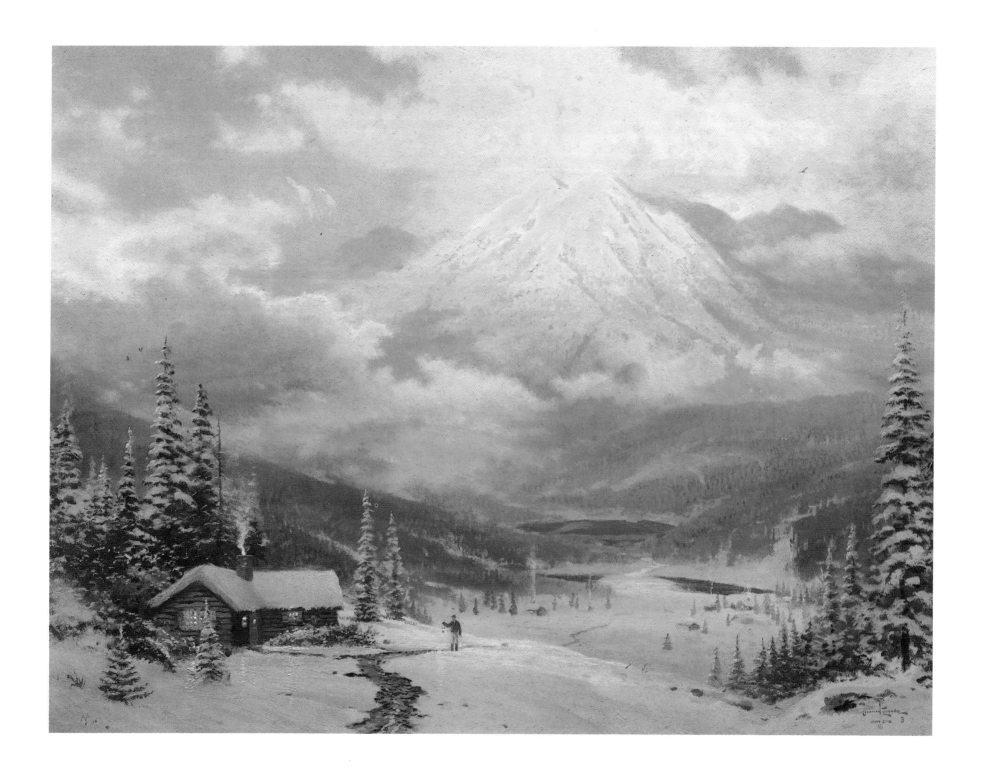

Homestead House

*T*he quiet beauty of things humble. That's been the focus of much of my art. And yet, though I love the tumble-down charm of cottages and country places, I'm also drawn to the more formal beauty of the truly grand estates whose substantial houses are triumphs of world architecture.

I've long wanted to balance my artistic account by celebrating some of these great palatial estates, starting with those located in our own country. Hence *Homestead House*, first in my new Great American Mansions series. Nanette and I recently toured the Deep South seeking examples of the grand plantation style. Homestead House, with its stately Doric columns and imposing facade, framed by lavish magnolias and live oaks hung heavy with Spanish moss, is the very essence of what we found. Here is an estate that would have delighted Scarlett O'Hara and Rhett Butler—indeed, if you look closely, you'll find some familiar initials carved into a tree.

America's great mansions. Very few of us will ever be privileged to live in them. But I invite you to enjoy their sublime beauty in my new series.

Oil on canvas, 16 x 20 in.

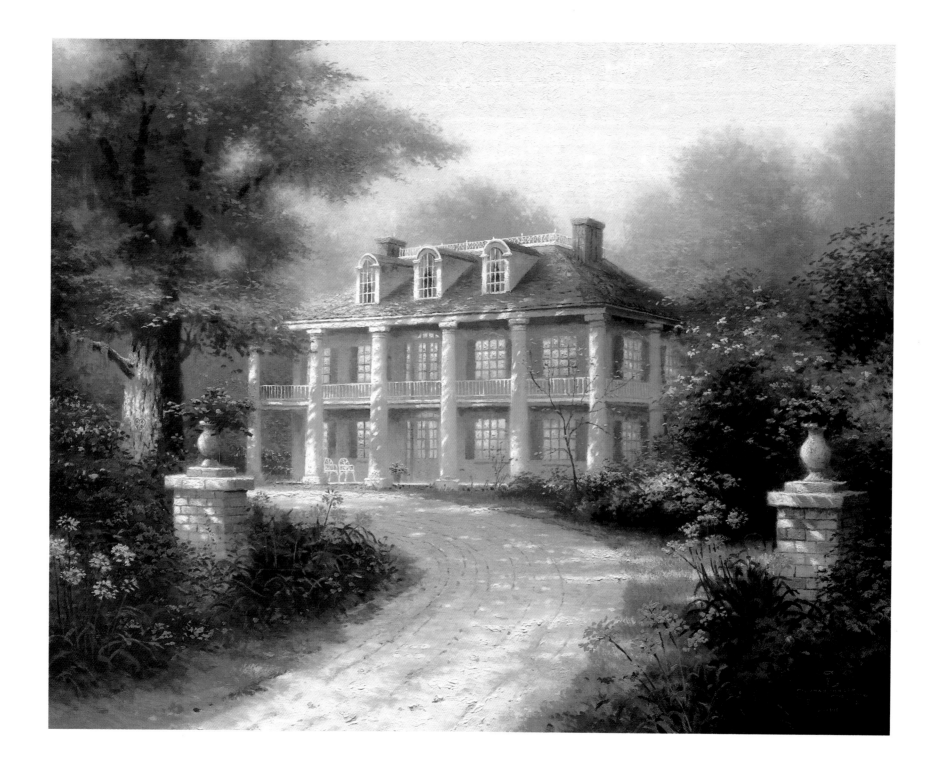

Sunday Outing

*F*amily traditions. They give us our uniqueness and character. And yet, because we're not really so different after all, they also affirm our common humanity.

A favorite Kinkade tradition is the Sunday drive. After church, we'll take off in the family car, find a lovely, lazy back road, and see what treats it has in store. Often, we'll do our driving in California's Apple Hill country, where the neat orchards and charming old farm houses provide a comfortable reminder that families have been enjoying Sunday drives along these lanes since the horse-and-buggy days.

Sunday Outing presents just such a family. How proudly father drives his buggy from the carriage house; how festive wife and baby look; how excited brother and sister are. The morning itself is radiant with light warmed by a lingering dew. (Mornings like this have become an artistic tradition with me!)

At Apple Hill the past is not dry or distant. It lives again in our lives—and I find that thought very comforting.

Oil on canvas, 16 x 20 in.

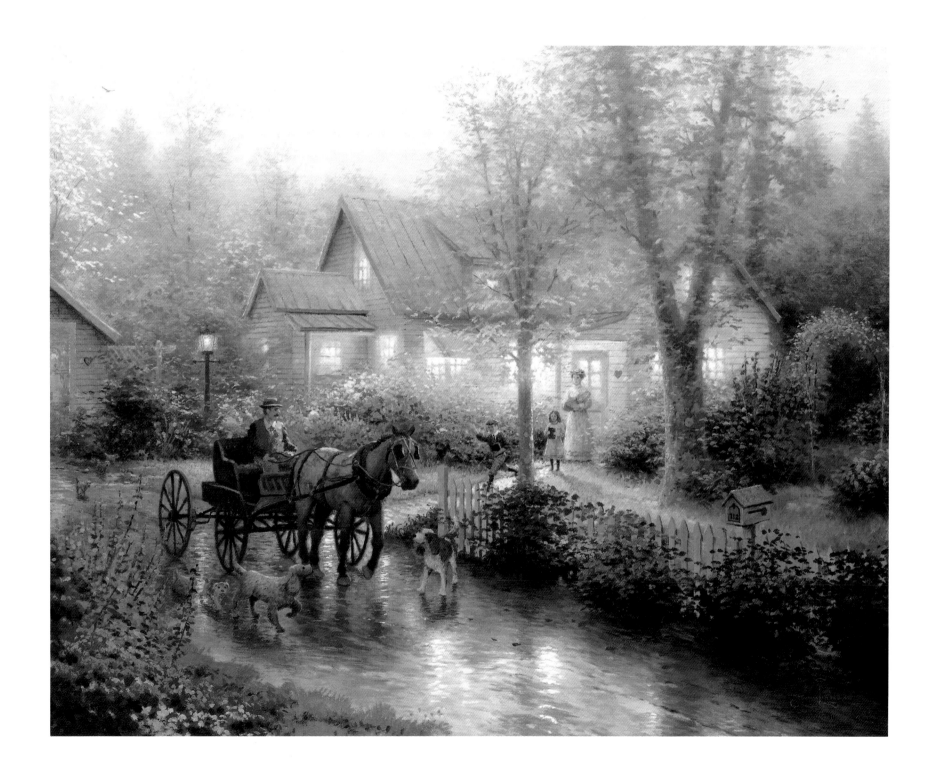

Winter's End

For poets, the changing seasons aren't just pages on a calendar; they can be symbols of life's passages from childhood to old age. Remember Robert Frost's famous poem—"Stopping By Woods on a Snowy Evening"—with its enchanted winter woods.

Painters sometimes do pretty much the same thing Mr. Frost did. Yes, my *Winter's End* is about that special time when winter warms into spring. But it's also about the tracks we leave in our passage through life. Sometimes I like to imagine that the sled that left its trail in the melting snow might be the same one that carried Frost's traveler. Certainly this evergreen wood, its trees crowned with the snows of a departing winter, is lovely, dark, and deep.

For me, the woods are a comfortable place—a memory of a simpler time. Maybe grandmother had her cottage nestled among those protective trees. Life progresses, of course; we have to move on. But the tracks a sled leaves in the snow will never completely disappear—not as long as you have *Winter's End* to keep the memory fresh.

Oil on canvas, 30 x 40 in.

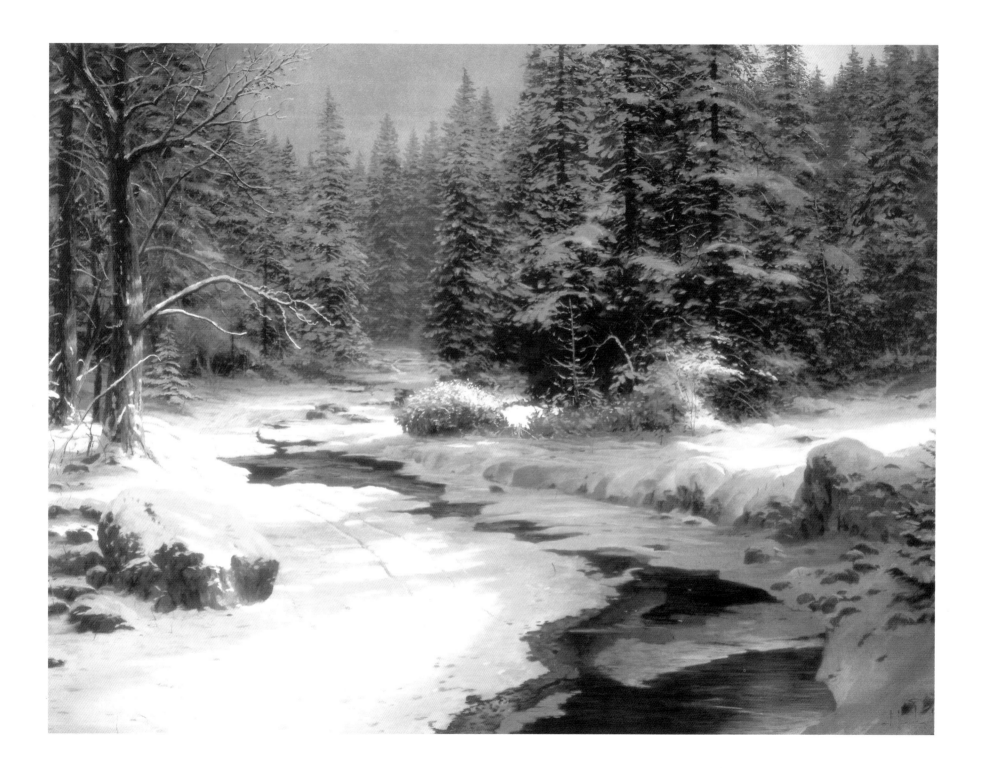

The Ice Harvest

There's something festive about even the hard work of winter. Maybe it's the colorful, heavy clothing of the season. Or the fires, needed for warmth, that flicker merrily, casting shadows. Perhaps, as in *The Ice Harvest*, it's the bustling activity of the groups of people who gather to accomplish the season's tasks, and to celebrate its holidays. Certainly the snow always adds a nostalgic touch.

Harvesting ice was one of the great communal activities that gave village life at the turn of the century its character and closeness. During the sparseness of winter, ice was a giant cash crop for farmers in northern regions, and like the autumnal harvests of grain and vegetables, it brought people together in a common cause. The draught horses are wonderful, muscular beasts who snort steaming clouds of breath into the air. Their sleds are piled high with ice and hauled to the thick-walled stone storage house, where the blocks will remain frozen throughout the year, to be sent to buyers from the great hotels and restaurants of nearby cities.

The whole scene is bathed in a golden glow that floods out of the windows of the ice house office—a reflection of the high spirits and good fellowship that warm the scene.

Oil on canvas, 24 x 36 in.

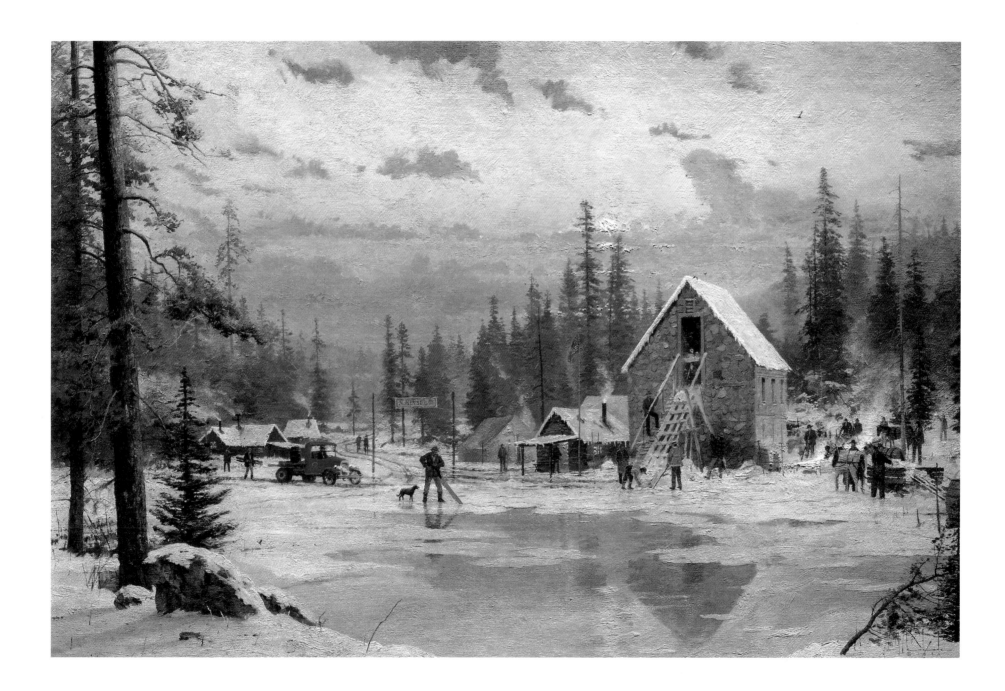

Moonlit Sleigh Ride

A few years back, I had a marvelous experience of cross-country skiing through a snowy valley by moonlight. I'll never forget the impression that the adventure made on me. Moonlight on snow is a beautiful sight—a combination of subtle, luminous light areas, and dark, mysterious shadows. My imagination was filled with visions of homesteaders making their way home through the snow by the light of the moon. I was especially struck by the cozy sight of our forest cabin as we concluded our moonlit ski trip. The warm, inviting glow of the tiny hut threw patches of radiant light on the surrounding snowbanks. This painting is a tribute to that romantic evening, with the exception of the skis: instead, a nostalgic sleigh whisks through the moonlit forest. What could be nicer than returning to the inviting glow of a warm fireside after a frosty evening sleigh ride?

Oil on canvas, 8 x 10 in.

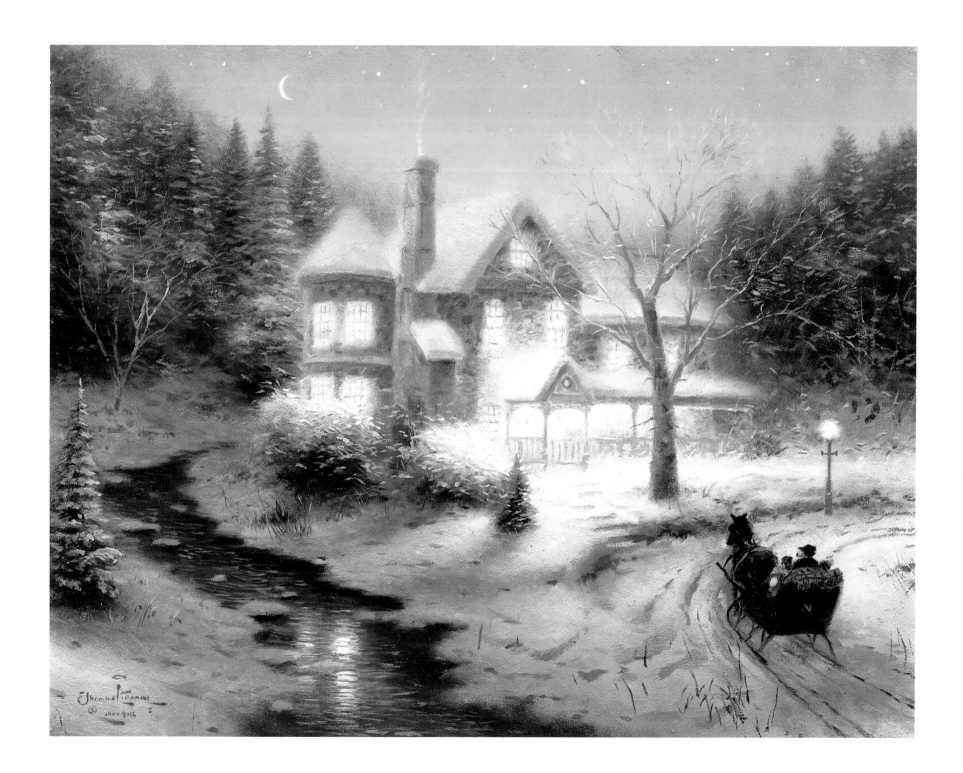

Moonlit Village
An Evening Service at the Church on the Hill, 1909

In my travels throughout America, I've noticed that churches are often built on a hillside or knoll as a means of emphasizing their presence in a town. I find this to be a particularly poignant concept. These hillside churches, like lighthouses, are high up, so that figuratively speaking their light might be seen from afar. I wanted to capture a bit of that feel in my painting *Moonlit Village*. To accentuate the beacon-like effect of the church, I chose a nocturnal composition that allowed me to illuminate the church from within. I also wanted to suggest the sense that the church was the social center of the village, so an evening service with villagers gathering from all directions was a natural composition. The snowy setting was chosen for no other reason than that I love the effect of moonlight on the snow with all the beautiful interplay of warm and cool colors.

Though the painting doesn't portray a particular town, I drew inspiration from towns in such divergent areas as Connecticut, North Carolina, Missouri, and even Northern California. As a final romantic touch, I was inspired by my neighbor, who places lit candles in small sand-filled paper bags to illuminate the way to his home at Christmas time. I included these glowing lights along the road in my painting, an appropriate touch, since these candle bags were a tradition on festive winter evenings at the turn of the century.

Oil on canvas, 36 x 30 in.

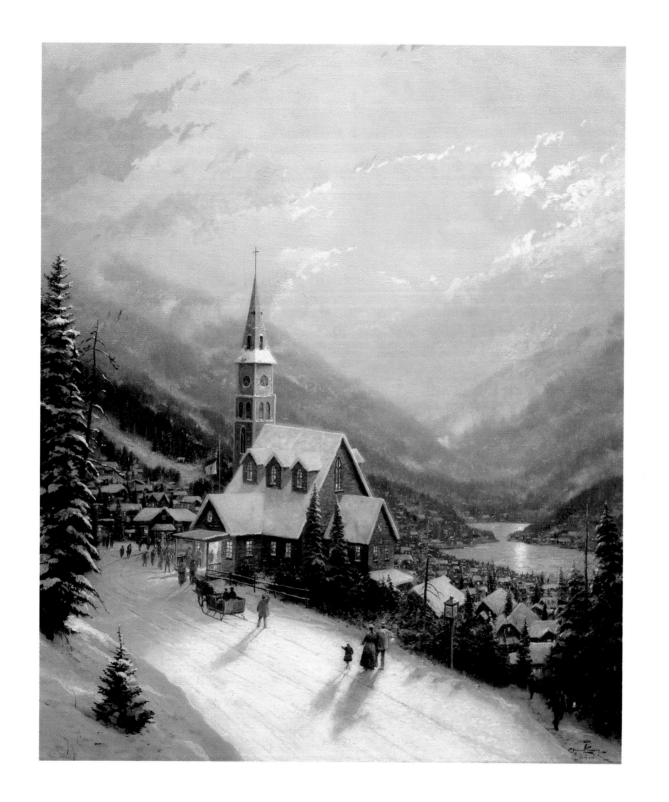

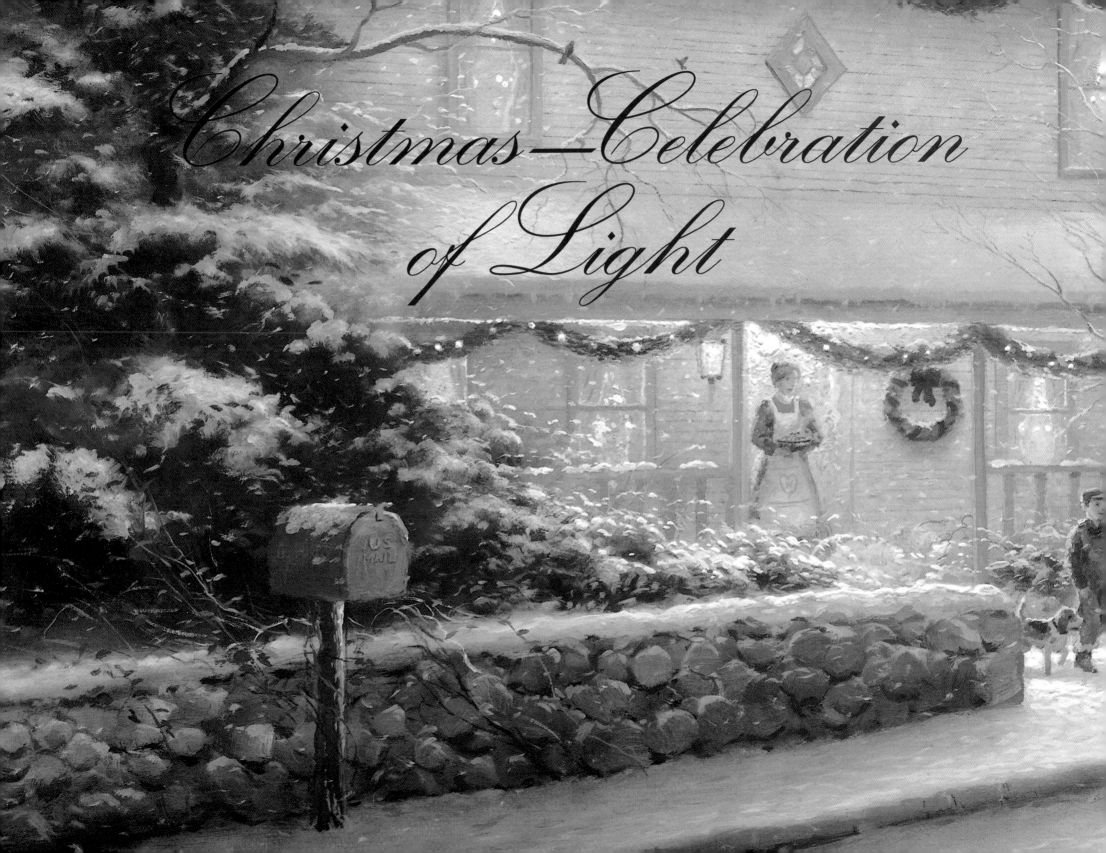

Christmas—Celebration
of Light

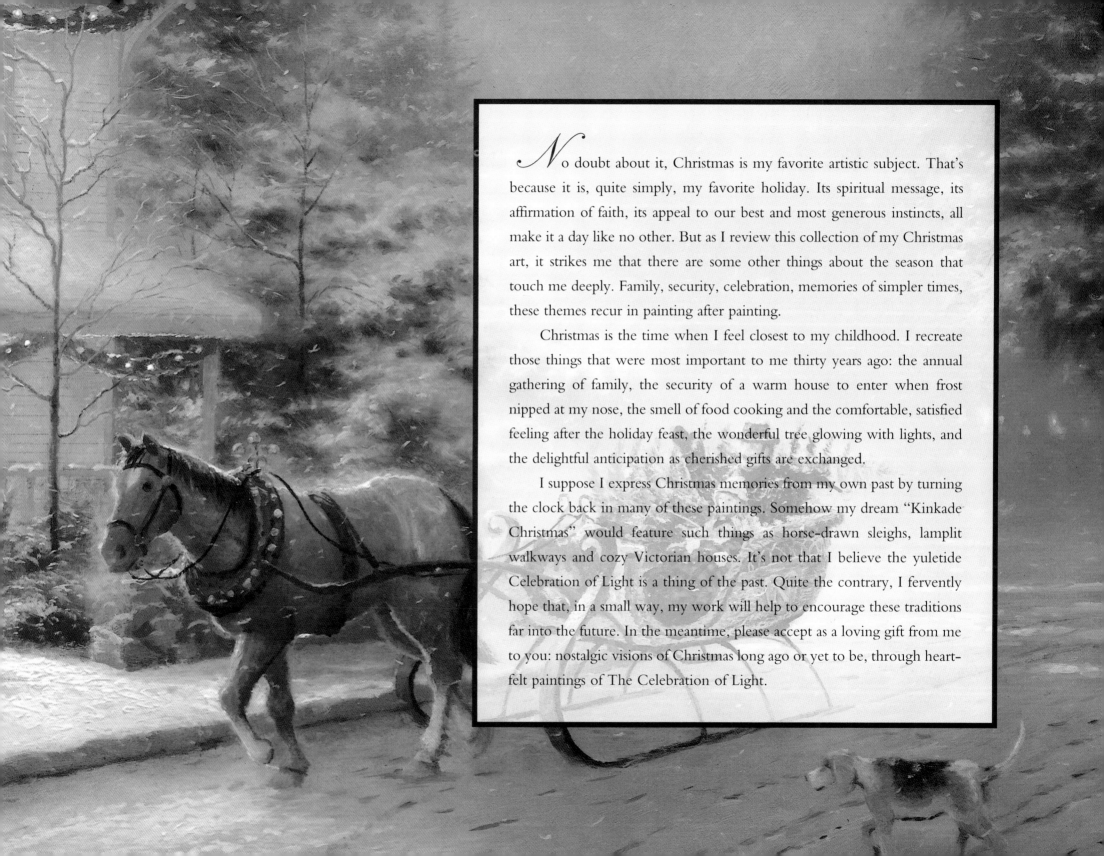

\mathcal{N}o doubt about it, Christmas is my favorite artistic subject. That's because it is, quite simply, my favorite holiday. Its spiritual message, its affirmation of faith, its appeal to our best and most generous instincts, all make it a day like no other. But as I review this collection of my Christmas art, it strikes me that there are some other things about the season that touch me deeply. Family, security, celebration, memories of simpler times, these themes recur in painting after painting.

Christmas is the time when I feel closest to my childhood. I recreate those things that were most important to me thirty years ago: the annual gathering of family, the security of a warm house to enter when frost nipped at my nose, the smell of food cooking and the comfortable, satisfied feeling after the holiday feast, the wonderful tree glowing with lights, and the delightful anticipation as cherished gifts are exchanged.

I suppose I express Christmas memories from my own past by turning the clock back in many of these paintings. Somehow my dream "Kinkade Christmas" would feature such things as horse-drawn sleighs, lamplit walkways and cozy Victorian houses. It's not that I believe the yuletide Celebration of Light is a thing of the past. Quite the contrary, I fervently hope that, in a small way, my work will help to encourage these traditions far into the future. In the meantime, please accept as a loving gift from me to you: nostalgic visions of Christmas long ago or yet to be, through heart-felt paintings of The Celebration of Light.

Christmas Eve

One of the great pleasures of Christmas is that each holiday is new, fresh, joyous. And yet each is also a reminder of Christmases past, a connection to our best memories of home and family. That's just the way the paintings in my Christmas Cottage series work. This series, which has become one of my most popular, is planned as an annual event that will extend from 1990 through the turn of the century, Lord willing! Each year's addition stands on its own, and yet each adds to my growing portrayal of the joys of a favorite season. Like its companion pieces, *Christmas Eve* features a small address placard in the right foreground bearing the release year 1991 as if it were the address of the cottage.

 Christmas Eve is plain, simple, and an expression of my ongoing love affair with the Christmas season. This wonderful old stone cottage allows me to express the lights, mood, and magic of the most wonderful season of the year. As is so often true in my paintings, the tiny "N" adorning the sign beside the door is a tribute to Nanette, my wife.

Oil on canvas, 24 x 30 in.

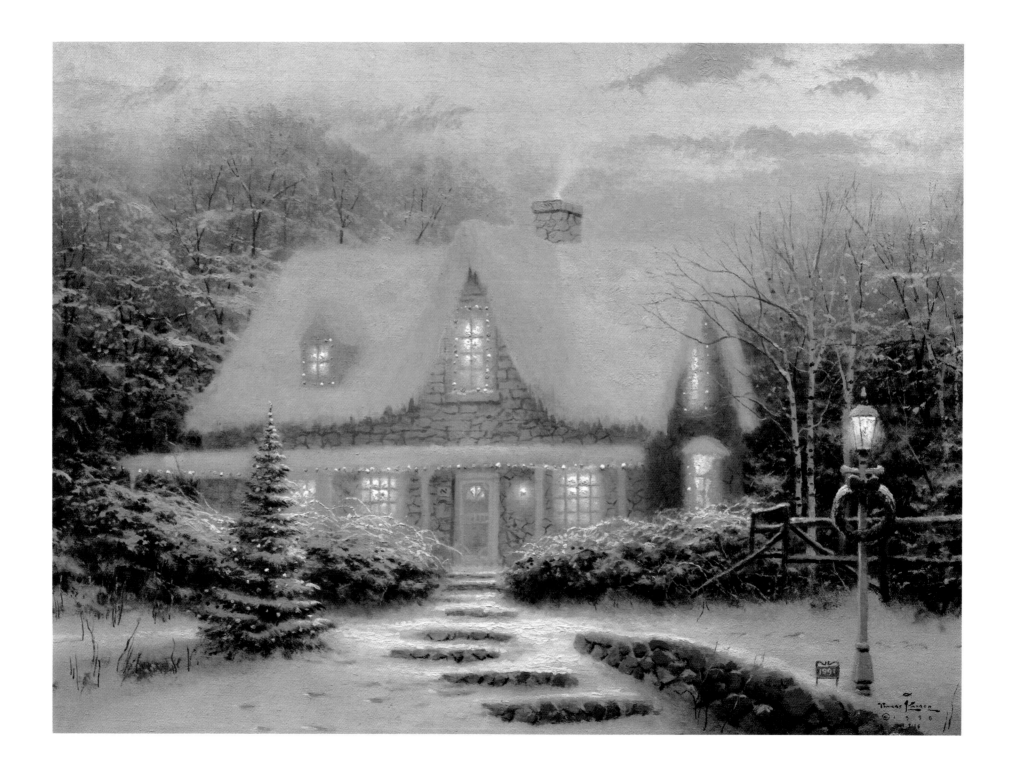

Silent Night

In this, the third of my annual Christmas releases, I painted a theme I find particularly satisfying: the peaceful reverence of a moonlit Christmas Eve. In fact, this is the first moonlit cottage I've ever put into print. I was so taken with the simple message of the classic Christmas carol "Silent Night," with its beautiful images of sleeping villages and the coming of the Christ child, that I decided to give this annual Christmas release the same title and to evoke a bit of the song's mood. What could be more enchanting than a full moon on Christmas Eve with the stars beside the moon shining down on a sleeping, snow-covered village?

I hope this painting will remind each of us of the message of hope and peace that is the true meaning of Christmas as illustrated in the Savior's birth.

Oil on canvas, 12 x 16 in.

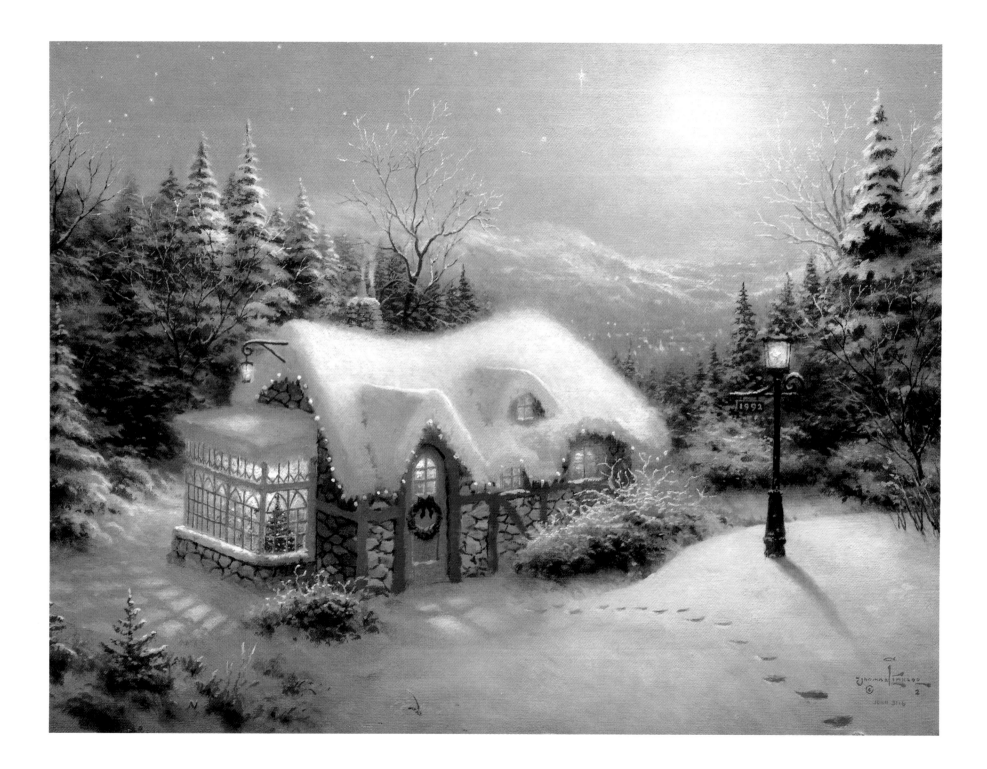

Stonehearth Hutch

One of the things I enjoy about the great Renaissance painters is the fact that they had a language of symbols to work with—a broad vocabulary of visual cues their audience was sure to understand.

That's one reason I'm drawn to Christmas as a subject for my art—the symbols of the season speak very clearly to us all. I've incorporated some of them—wreath and tree—in *Stonehearth Hutch*, fourth in my Christmas Cottage series, to signal that the warm glow of this sunset heralds Christmas Eve.

I've also used more personal symbols to express the spirit of the season. The lone, rough-hewn stone cottage represents the rock of faith. Outside is only the solitude of the woods—with no carriage track or footprint to hint at human comfort. But inside is a golden light, suggesting the hope of Christmas. Fires burn in each hearth, promising abundant food; their smoke rises heavenward. The odd little path, winding and slippery, leads to the cottage door.

My prayer is that *Stonehearth Hutch* will communicate to many, in a language as universal as Christmas wreaths, yet as deep as faith.

Oil on canvas, 12 x 16 in

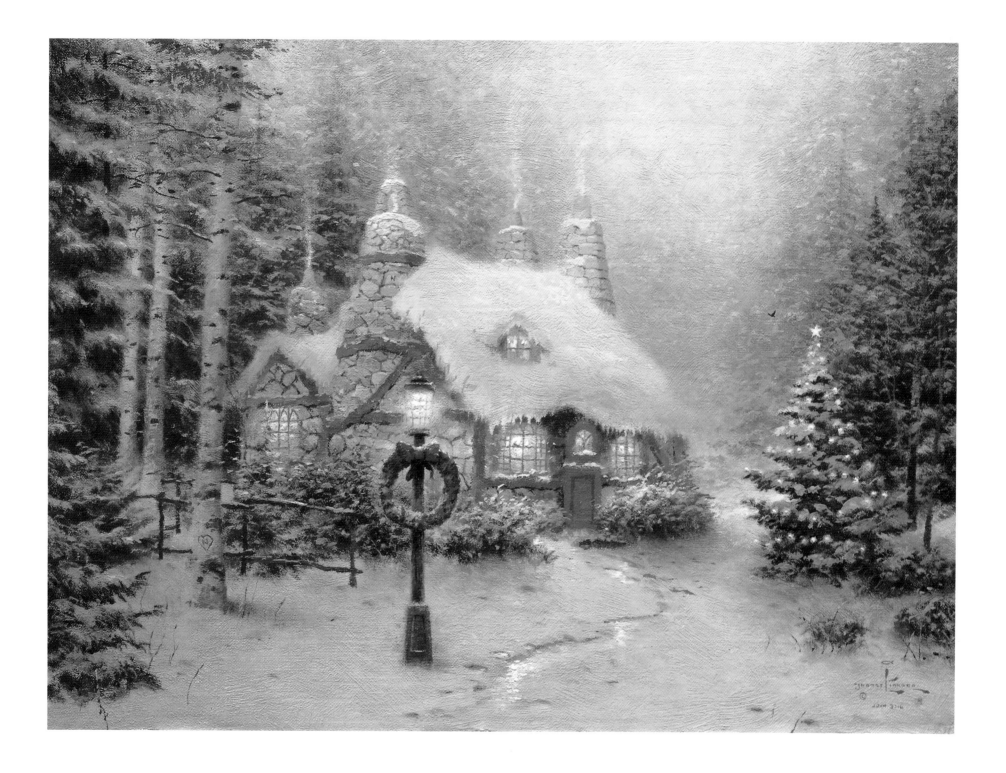

Christmas Tree Cottage

The time when Christmas memories really come flooding back is when I set up our fresh-cut pine tree. Nanette pulls out a carefully packed box, and the Kinkade family hangs the Christmas tree decorations. Each year, we add specially selected ornaments that commemorate our travels and our special times. So decorating the tree has become a treasured trip down Memory Lane.

Our Christmas tree reminds us of beloved family rituals, and our own precious memories of childhood. More than that, it connects us to a grand tradition of Christmas celebration that dates back hundreds of years. That's why I've chosen the Christmas tree as the theme of the fifth painting (and midpoint) in my decade-long Christmas Cottage series.

A stately evergreen dominates the scene; this glorious symbol of Christmas tradition is echoed in the rustic bentwood gate and relief-carved door of *Christmas Tree Cottage*.

And, when I think of the glory of Christmas, I also think of the radiant sunsets that set the snowy world aglow at that time of year. The luminous golden color of the sunset in *Christmas Tree Cottage* is a vibrant reminder that the glory of the season truly comes from God alone.

Oil on canvas, 12 x 16 in.

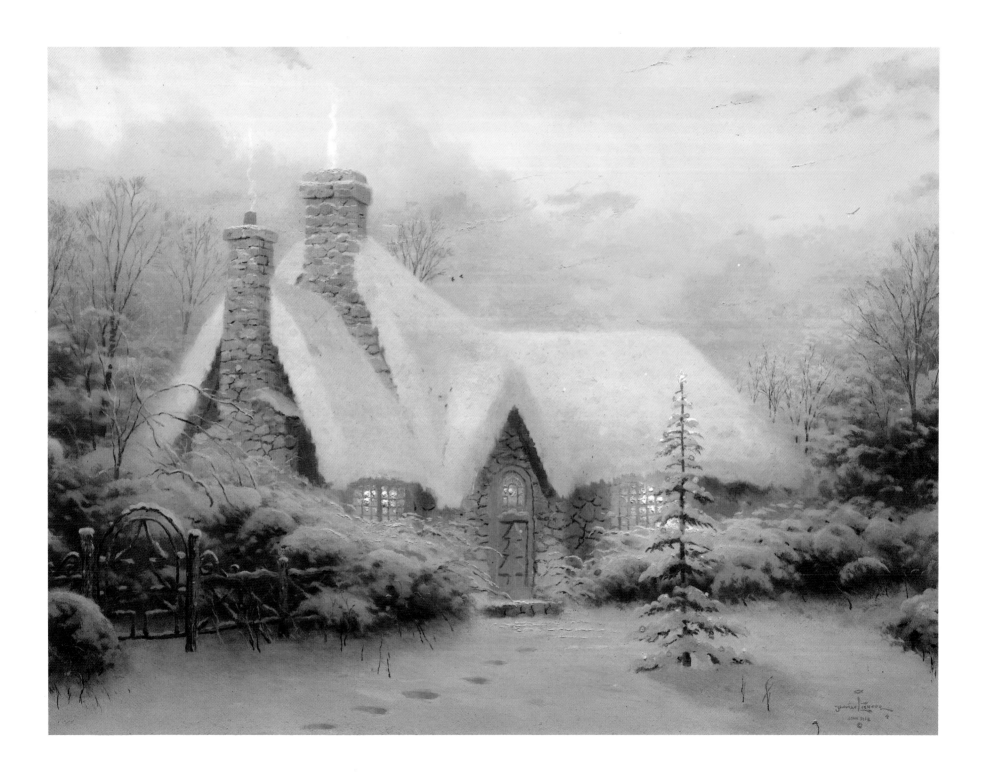

Home for the Holidays

I don't know if anyone truly experiences Christmas the way we all picture it. Somehow I think Christmas, like childhood, is a magical blend of reality and imagination. Christmas has always supplied me with a wealth of inspiration. I was fortunate enough to grow up in a small town where Christmas still meant caroling and sleigh rides and snowmen. Those childhood Christmas memories seem to blend and intermingle as the years go by, so that when I paint nostalgic recreations of Christmas past, I can never be sure where experience ends and fantasy begins!

Home For the Holidays is an example of memory and imagination blending together to create an idyllic vision. Who hasn't daydreamed about taking a frosty sleigh ride to visit friends for a bit of Christmas Eve cheer? Presents will be exchanged, prayers offered, and perhaps a mug of steaming punch will send you on your way.

By the way, my daughter Merritt is a wonderful model for paintings like this. In tribute to her efforts, her name adorns the mailbox to the right of the sleigh.

Oil on canvas, 16 x 20 in.

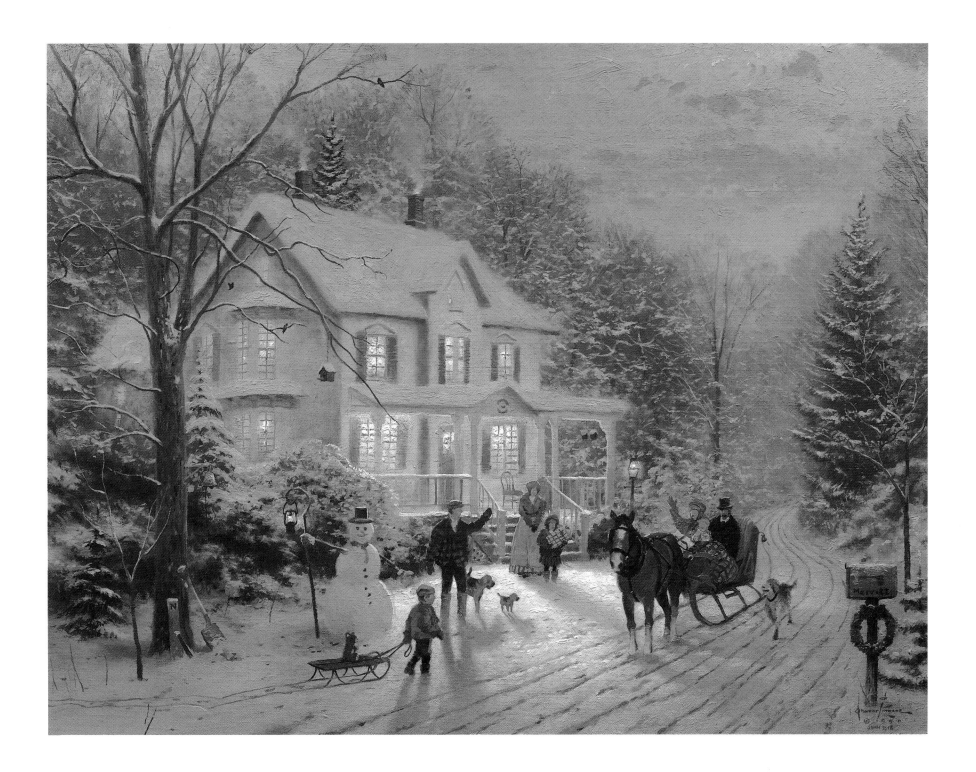

Evening Carolers

This painting celebrates one of the most universal Christmas traditions: the singing of joyous Christmas carols. There's nothing that lifts the spirit like joining in song with those you love on a crisp December evening.

I painted the house portion of this painting directly from a beautiful house in the Cotswold district of England. I knew that its special dignity and warmth made it the perfect setting for some sort of celebration, but at the time I wasn't sure just what.

When I returned home an inspiration hit me. I decided to introduce a Christmas theme and added the figures of the carolers. The fact that this painting was created in two separate countries is appropriate. After all, Christmas caroling is one tradition that is truly international in scope.

Oil on canvas, 8 x 10 in.

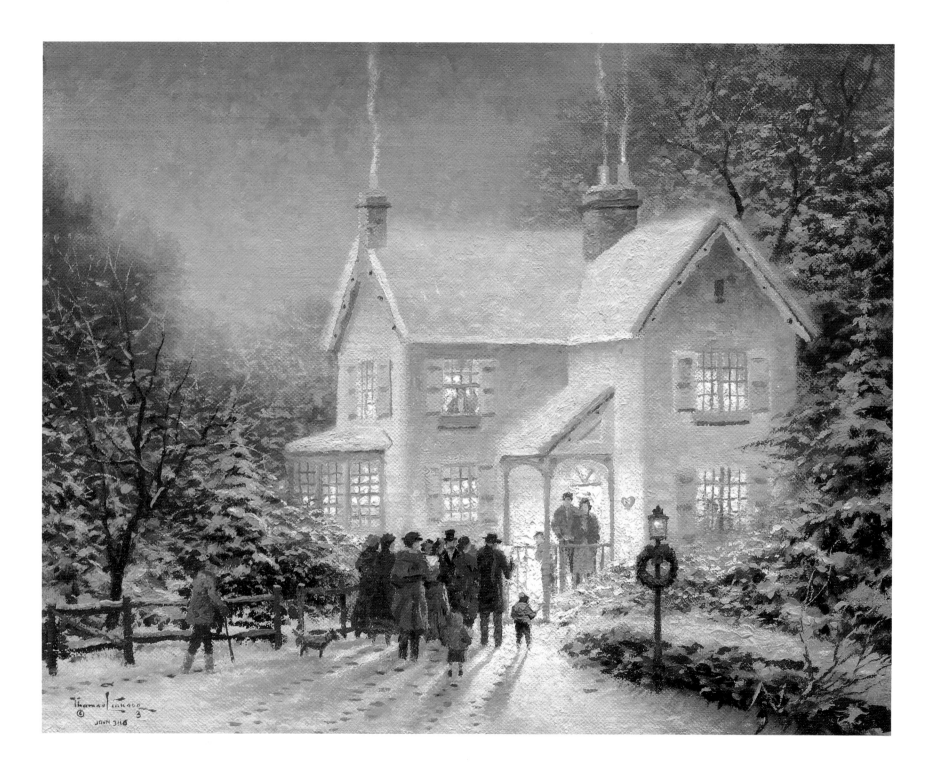

Christmas at the Courthouse

Perhaps the Christmas present I'd like most would be a time machine. I seem to have a powerful urge to celebrate this wonderful holiday with my great grandparents or perhaps even with Charles Dickens in Victorian London.

Christmas at the Courthouse displays the nostalgic charm I find in the spirited Christmas celebrations of a more innocent era. The street, crowded with shoppers and celebrants and lined with wonderful vintage cars, is as festive as a brilliantly lit Christmas tree. There is a joy to the bustling crowds, and a warm camaraderie among the friends who stop on the street to talk and share holiday plans. Snow transforms the familiar courthouse and town center into something wondrous and strange. It is nature's Christmas decoration; I can hardly imagine the holiday season without the festive addition of snow.

In a way, I do have a time machine—my art. Paintings like *Christmas at the Courthouse* let me create—and then enjoy—rich, imaginative worlds that preserve the very best of the past.

Oil on canvas, 24 x 36 in.

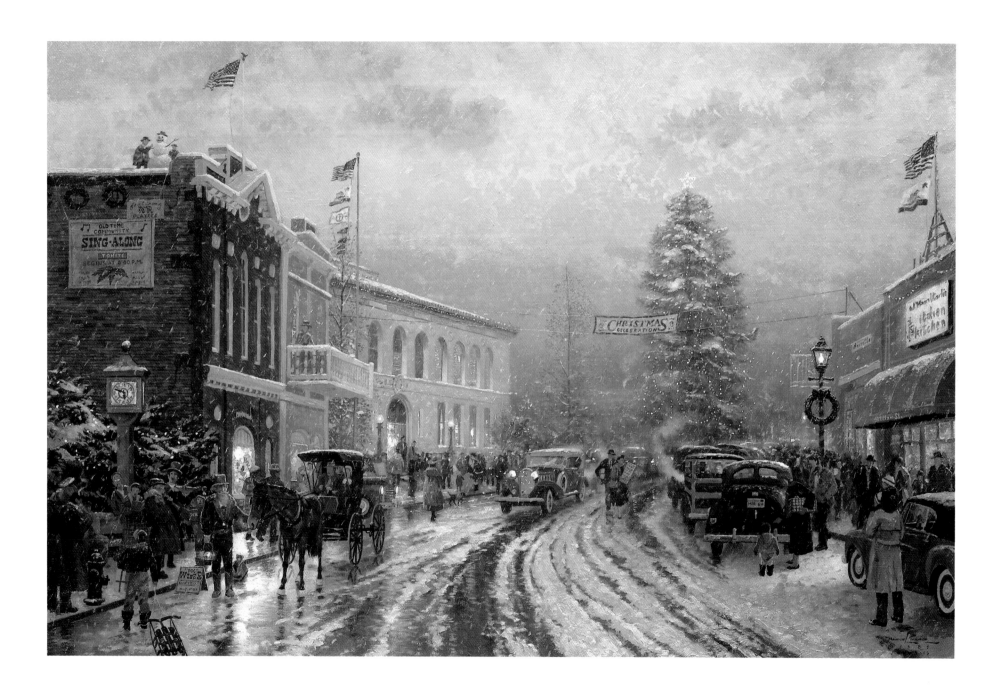

St. Nicholas Circle

I began to work on this painting in Norman Rockwell's great studio near Arlington, Vermont. I was captivated by the charming New England architecture; many of the little gems in surrounding towns made their way into *St. Nicholas Circle*.

This is nothing less than my dream Christmas village—in this one idyllic spot time stands still, and it's Christmas all year round. The heart of town is the skating pond and Christmas tree; the church and town hall, the shops and homes circle the pond like wreaths. Horse-drawn sleighs are the only form of transportation; the little lanes have fanciful holiday names, lights and bows deck the trees, and snowmen stand vigil on the hillside. Is there anything more enchanting than the thought of Christmas all year round?

Oil on canvas, 16 x 20 in.

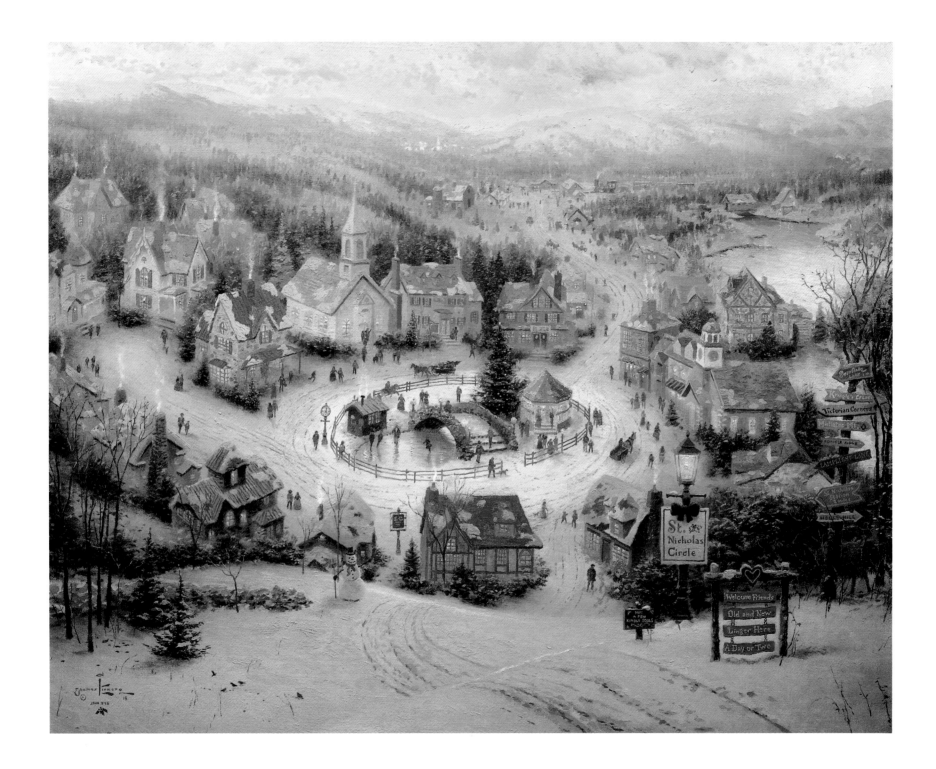

Christmas Memories

Recently, I set myself a challenge: to convey the spirit of Christmas without relying on the time-honored visual device of snow. After all, as I was growing up, my own California Christmases were never white.

In *Christmas Memories*, the first painting in my new series that celebrates the joyous festivity of an earlier and more gracious era, one of California's great historic houses—an imposing Victorian with a turret, gables, and a deep, wraparound porch—shows its best holiday face. Colorful lights spill out from the huge Christmas tree onto the surrounding bushes and shrubs, and tethered horses patiently await the close of the evening's merriment. I hope that even without snow, my *Christmas Memories* will capture the festive spirit of Christmas.

Oil on canvas, 16 x 20 in.

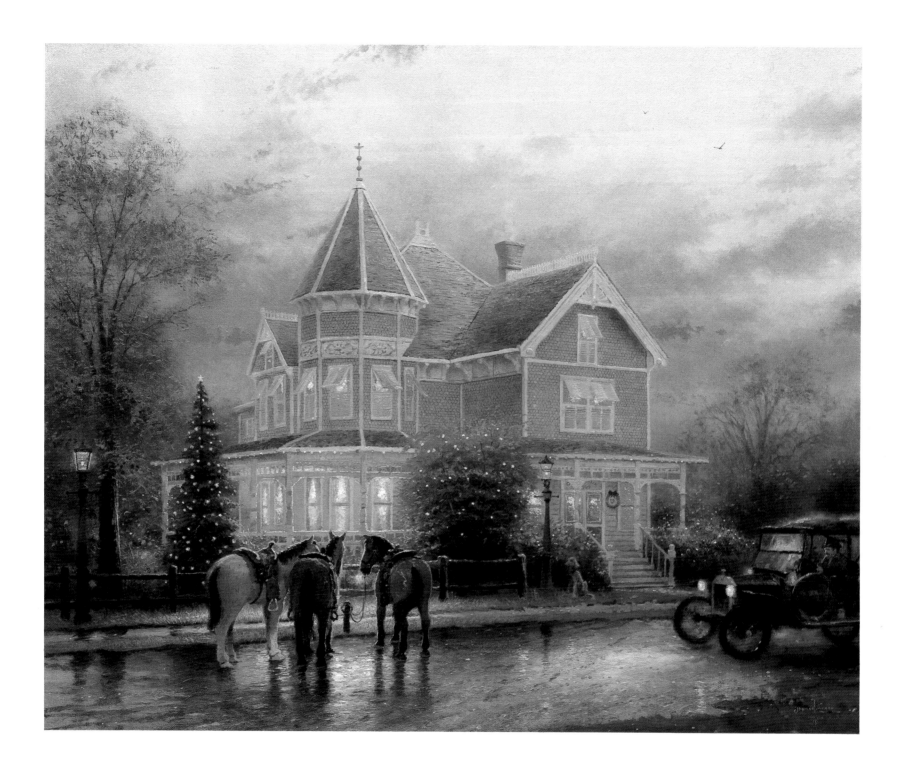

Victorian Christmas I

Some homes just beg to be painted! This stately old Victorian stands on a prominent street corner in my hometown. Since I was a young boy, I've been fascinated with the unusual asymmetrical design and carpenter's gothic touches, or "gingerbread" of the home.

I decided to turn back the clock to Christmas Eve around the turn of the century. I imagined the festivities surrounding a Christmas Eve open house, with guests coming and going and mischievous children frolicking in the snow. I pictured the beautiful old house all lit up for the occasion, with the glow from the windows cascading down the snowy hill.

Just for fun, I included some whimsical touches. For instance, the man smoking a pipe in the lower left hand corner is none other than Norman Rockwell. The nostalgic activities of the scene seemed something Rockwell would have enjoyed, so I couldn't resist including him!

Oil on canvas, 20 x 24 in.

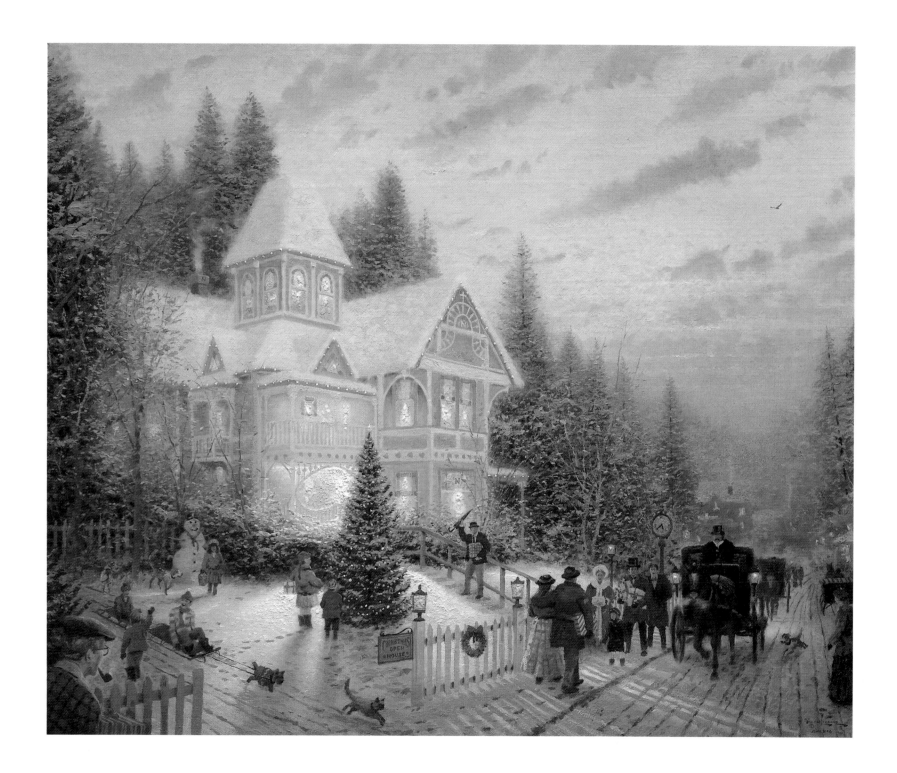

Victorian Christmas II

Christmas parties. I've been to some wonderfully festive affairs and I imagine you have, too. But today I'm inviting you to a Christmas party unlike any you have ever attended, because it takes place a hundred years ago!

The "party" is being held at a very stately Victorian mansion, which you might be able to locate in Placerville, the Northern California town where I grew up. But I welcome you to look for that grand historical house instead in my painting *Victorian Christmas II*. The festivities are in full swing as you arrive. Guests have tethered their horses or handed them over to the carriage house attendant. At the top of the stone walkway your hosts await to greet you while boisterous children slide gleefully on their sleds. Above it all, the grand house is ablaze with holiday lights.

In my paintings, I love turning back the clock to a simpler era. That's what my Victorian Christmas series is all about. It brings my favorite holiday and a glorious historical period alive on canvas.

Oil on canvas, 20 x 24 in.

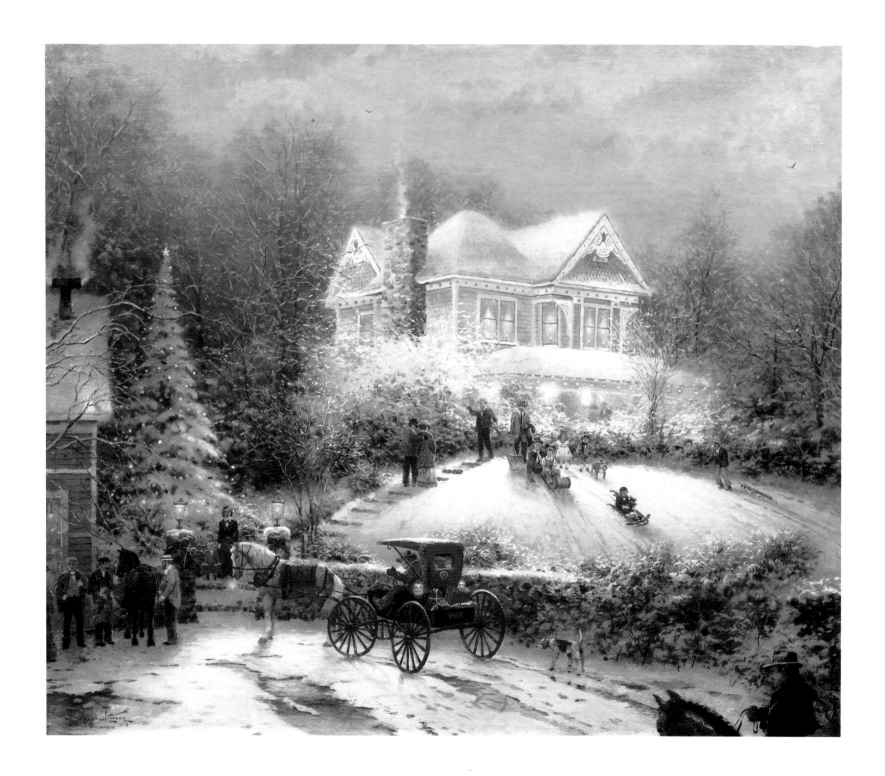

Victorian Christmas III

'Twas the night before Christmas and all through the house, a sweet spirit of celebration prevails.

In the upstairs bedroom, Mother tucks in her freckle-faced boy and baby daughter with talk of Santa, and sings favorite Christmas carols until they fall asleep. In the parlor, Father sets up a magnificent Douglas fir, hanging multicolored popcorn balls and treasured heirloom ornaments; a wonderful lace angel sits atop the tree. In the kitchen, a goose is ready for the roasting, and fruitcakes fill the cupboard with their special fragrance. And hidden in the recesses of the closet, under carefully folded clothes, is a pile of neatly wrapped presents.

I've saluted the festive spirit that surrounds holiday celebrations in earlier paintings. In *Victorian Christmas III*, I touch the quiet heart of the holiday itself. Flanked by stately evergreens, and shrouded by new-fallen snow, this golden house is aglow with the spirit of Christmas.

The silence that graces this lovely Victorian home is the same profound peace that once enfolded a babe in Bethlehem.

Oil on canvas, 20 x 24 in.

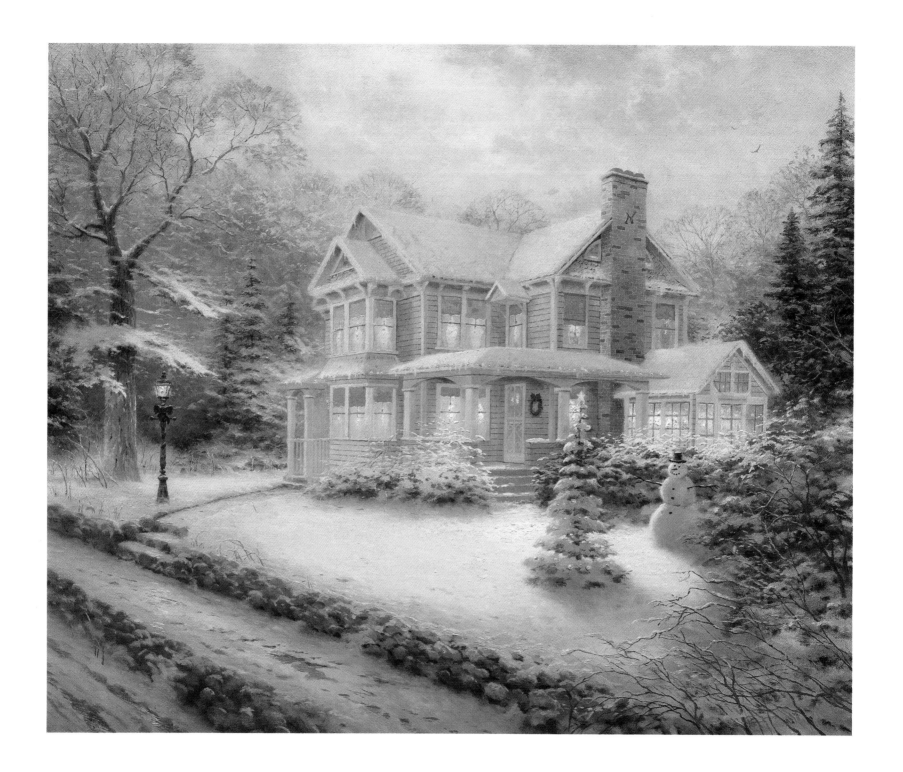

Bringing Home the Christmas Tree

This nostalgic vision of Christmas past completes one of my favorite collections. *Victorian Christmas IV: Bringing Home the Christmas Tree* is filled with my personal memories of Christmases in Placerville, but I think it touches a magic chord in all of us.

I have concentrated on the family here, which, after all, is at the heart of some of our warmest holiday memories. Here, as the early evening grows dark, Father is returning to the festooned house on a sled with his precious daughter. Together—guided by his wise advice and her bubbly enthusiasm—they have chosen the perfect Christmas tree to bring home. The memory-rich pine aroma fills the brisk air around their sled, and even a family dog, who followed along, knows that something very special is in the air.

In the meantime Mother, in her apron, has taught her son a thing or two about holiday baking (his chance to nibble a broken gingerbread leg and a loosened raisin button). They bring their latest kitchen creation—a hot apple pie made with the Placerville region's apples—outdoors to welcome the hungry adventurers. A fresh-cut Christmas tree, a hot apple pie, and the warmth of the whole family together as they prepare their home and hearts for Christmas—I don't think there could be more perfect pleasure on a frosty winter evening!

Oil on canvas, 20 x 24 in.

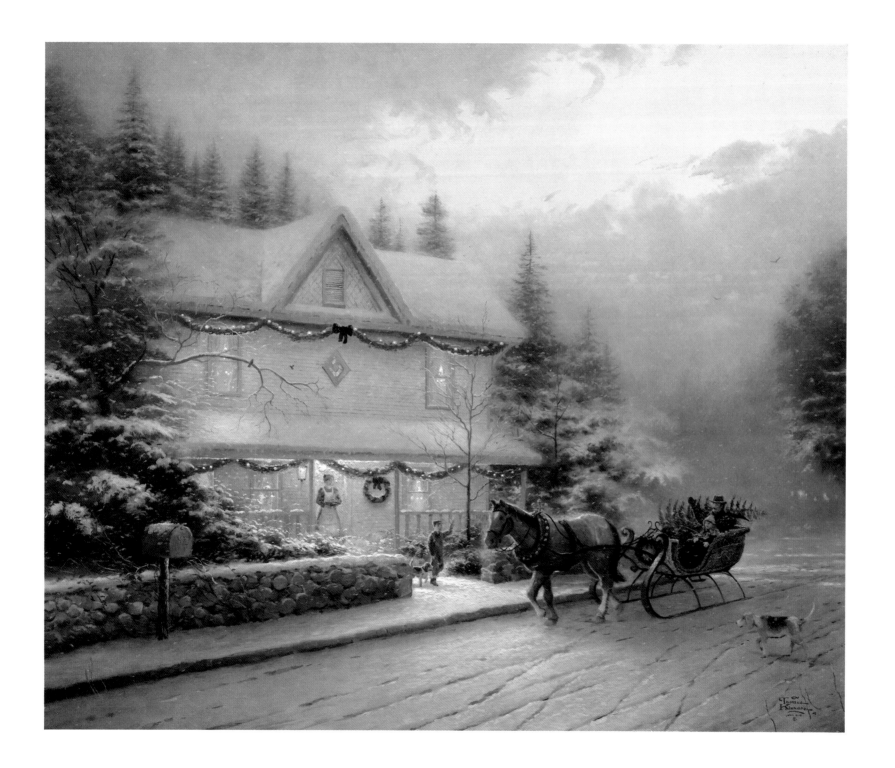

VILLA MONTALVO

Thomas Kinkade and the Plein-Air Tradition

by PHILIPPA REED

Unlike many artists working today, Thomas Kinkade has followed two very different creative paths with equal enthusiasm and success. On one hand, Kinkade is best known for his meticulously crafted and detailed paintings—of cityscapes, majestic scenes of nature, or intimate stone cottages in idyllic landscapes—done in a Romantic Realist vein. These works, although often based on reality, have been created with the express intention of maximizing their dramatic potential.

On the other hand, Kinkade has, since boyhood, been a proponent of the plein-air tradition in painting. Named after the French phrase *plein air*, it means, simply, "open-air," and refers to the practice of painting directly from nature, rather than

Venice Canal, *oil on canvas, 10 x 8 in.*

using sketches (or photographs) made in the outdoors as the basis for a finished painting that is made in the studio. Spontaneity rather than meticulous detail, and an economy of brushwork rather than a carefully worked surface, are its hallmarks, and, as the artist himself explains, "They suggest a scene in bold strokes." Generally small in scale—the largest of these works measures twelve by sixteen inches, giving them an almost jewel-like quality in spite of their spontaneity. "I just put in the landscape and that's it," Kinkade has said. "I start at the top, work from deep space to foreground, two hours at the most. That urgency forces you to work very concisely."

Kinkade enthusiastically embraced the idea of painting from nature as a boy, even before he knew anything of the plein-air tradition, and before he encountered his two most important mentors, the

Opposite: Wisteria Arbor, *oil on canvas, 9 x 12 in.*

artists Charles Bell and Glenn Wessels, both of whom encouraged him to paint and sketch in the outdoors. And although he has painted in this fashion for years—and sold a good number of these works—it is only recently that Kinkade has made reproductions of them available to the same wide market that now buys his romantic studio paintings. In doing so, he demonstrates his mastery of an approach to painting that had a profound effect on European and American art.

Around 1830, the Barbizon school of painting, so named for the small town near Paris that was the center of the movement, pioneered the painting of landscape for its own sake. This was certainly not the first time that this genre had been an important subject for artists, but landscape was traditionally seen as a backdrop for human activity; nature was always secondary to man. The seventeenth-century French painter Claude Lorrain had produced romanticized and idealized landscapes in which human figures, usually of classical or biblical origin, were of minor importance—but they were there nonetheless. In the same era in Holland, Jan van Goyen and Aelbert Cuyp were painting romanticized landscapes of their own—but adding majestic sailing ships or placid cows to "legitimize" the scene.

Luxembourg Gardens, oil on canvas, 8 x 10 in.

It wasn't until the 1820s in England that artists—notably John Constable, with his tranquil scenes of the countryside—began to make the landscape a valid subject on its own. "The landscape painter must walk in the field with an humble mind," said Constable. All these artists—particularly Constable—influenced the Barbizon painters, as did the English painter J.M.W. Turner, whose wildly romantic, atmospheric landscapes were the direct result of careful observation of nature, yet were almost invariably painted in the studio. The Barbizon artists—among them, Camille Corot, Charles-François Daubigny, François Millet, and Théodore Rousseau—embraced the novel notion that painting the landscape for its own sake was a worthy goal.

The Barbizon painters in turn were to influence the development, in the 1870s, of French Impressionism, the movement, made famous by artists such as Claude Monet and Auguste Renoir, that attempted to capture fleeting effects of light and weather on landscapes both rural and urban. The Impressionist palette of colors, unlike that of the Barbizon painters, was known for its explosion of color (made possible by the developments in the quality and affordability of certain pigments) and its subject

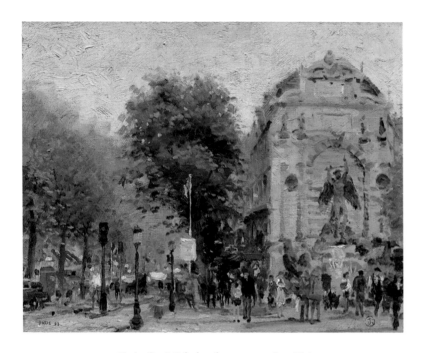

Paris, St. Michel, *oil on canvas, 9 x 12 in.*

San Francisco, Alcatraz, *oil on canvas, 12 x 16 in.*

matter was distinguished by its often festive depictions of modern life. The French Impressionists in turn influenced an entire generation of their American contemporaries, most notably William Merritt Chase, Childe Hassam, and Mary Cassatt—whose work was a reaction to the "academic" art, with its historical subject matter and stiff portraits, that had been very much in fashion after the Civil War.

This tradition of plein-air painting would, at the end of the nineteenth century, influence an entire group of artists—among them Alson Clark, Guy Rose, and Elmer and Marion Wachtel—who were working in California between 1890 and 1940. Once nearly forgotten, the works of these California plein-air artists are now highly admired. Their poetic depictions of the terrain and vegetation of both northern and southern California incorporate the broken brush strokes and intense colors of their French Impressionist predecessors. But, as Ruth Lily Westphal wrote in her book *Plein Air Painters of California: The Southland*, "Philosophically, they were closer to the traditions of America's nineteenth-century landscape painters, particularly those of the the Hudson River School, than to the French Impressionists. Many were deeply religious and felt their work to be a spiritual mission to interpret God's natural beauty…They believed that God manifested himself in nature and in man, and that the world was fundamentally a harmonious place ruled by the design and purpose of the Deity."

Biarritz, oil on canvas, 8 x 10 in.

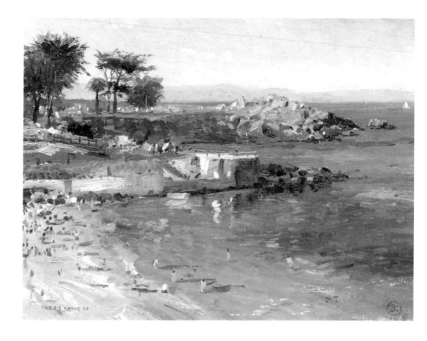

Pacific Grove, oil on canvas, 9 x 12 in.

No wonder Kinkade would feel an affinity for the work of the California plein-air painters. After all, he grew up idolizing the Hudson River School painters, such as Albert Bierstadt, Thomas Cole, and Frederick Church, who, as James Biddle said in his preface to John Howat's *The Hudson River and Its Painters*, regarded the landscape "as a direct manifestation of God. These men attempted to record what they saw as accurately as possible…They approached nature with reverence and portrayed it with the detailed care of a naturalist."

But Kinkade was also fascinated by the aspect of adventure that characterized so many paintings of this era. Artists such as Bierstadt and Thomas Moran traveled to the relatively uncharted areas of the American West and Southwest, and presented their findings to an amazed and enthralled public; the painter Thomas Hill later depicted scenes of Yosemite National Park that would inspire Kinkade to become an artist. Kinkade's boyhood ramblings among the hills of his native Placerville, and his exuberant adventures in "hoisting," the word he and fellow artist James Gurney invented to describe their sketching journeys, reveal an innate sympathy for similar artistic wanderings. "Artists of the past would make amazing sacrifices to capture a subject," he notes with obvious admiration.

As an adult, Kinkade describes with great relish his quest for ever more spectacular natural vistas, no matter how remote the terrain or unforgiving the climate. He talks of having to mix his watercolors with rubbing alcohol instead of water to keep them from freezing in the

frigid Alaskan wilderness, or of painting under an umbrella to escape a broiling tropical sun. Kinkade's plein-air adventures often take him to less rugged locations, such as England's Cotswolds, or the beaches of France, but his wanderlust is reflected in the variety of his subject matter. "I especially love to travel to places where the culture is many centuries old," Kinkade has said. "In California, any structure that's a hundred years old is considered a historical site. In Europe and other places, anything that recent is little more than a nuisance, interfering with one's enjoyment of the real antiquities. I like old things that have the mark of history on them; they're incredibly rich with human dreams."

Enamored as he is of the natural landscape, Kinkade is also a keen observer of urban scenery. In *Venice Canal*, the eerie light of a rainstorm illuminates the facades of buildings while it gives the sky a pale brightness that is reflected in the greenish glow of the water of the canal. In his Parisian scene *Luxembourg Gardens*, the monochromatic palette of buildings, sky, and ground is a foil for the emphatic punctuation marks of color that define the passing pedestrians as well as the pink blossoms on the trees. *Paris, St. Michel* captures just a fragment of building and trees,

Puerto Vallarta Beach, *oil on canvas, 9 x 12 in.*

yet manages to convey a clear sense of the city's grand, tree-lined boulevards. *San Francisco, Alcatraz* does not really focus on the infamous former prison island; instead, it gives equal weight to the historic sailing vessels docked in the foreground. And in *Bloomsbury Cafe*, Kinkade depicts the exterior of one of the city's many pubs in an array of colors—browns, greens, and golds—that imply an almost autumnal air of nostalgia.

Kinkade's plein-air paintings also include scenes of well-known resort areas—which in fact were a favorite subject of the French Impressionists. *Biarritz* conveys a clear sense of the evolution of time in this fabled northern French beach town. While many of the buildings in the scene seem to fade into the distance, Kinkade deliberately contrasts the substantial Gothic church at the upper right with the newer, smaller, and tourist-mobbed seafood restaurants below, emphasizing the seemingly haphazard layering of old and new that characterizes so many European cities and towns.

Pacific Grove offers an idyllic view of a Northern California beach. Its shallow, clear green water deepens to blue, violet, and ultimately a

blue-gray, while bathers on the shore and the lanterns of a Chinese festival, are rendered as a profusion of brightly colored dots. Two rock outcroppings define the background of the picture, creating a room-like sense of enclosure around the beach. Another seaside scene, *Puerto Vallarta Beach*, is even more economical in its presentation of sand, rock, vegetation, and bathers. Beyond the white, sun-bleached beach, a cluster of thatched umbrellas called palapas sits at the foot of a hill covered with luxuriant greenery that partially obscures a tile-roofed villa. The mountains beyond seem almost to blend with the blue-green of the ocean. In their handling of color and brush-work, these paintings bring to mind some of the outdoor scenes of John Singer Sargent—who, it should be noted, is another member of Kinkade's personal pantheon of great artists. Sargent is also an inspiration in that he, too, managed to move easily between plein-air and studio work.

The painting called *Wisteria Arbor* is an anomaly among this group; its focus is narrow and its scale intimate. In it, a gracefully

Bloomsbury Cafe, *oil on canvas, 12 x 9 in.*

columned pergola is lushly draped with blooming wisteria vines, the sharp, pale green of their new growth deepening to a much darker shade below. There is no sweeping vista to be seen here, no large-scale composition, just a fragment of a building nearly consumed by vegetation—the triumph of the natural over the man-made world.

The contrast between Kinkade's plein-air paintings and his studio works is indicative of his versatility. The "romantic" paintings, as he calls them, are loaded with detail, are meticulously crafted, and often employ man-made light—usually lamplight—to create a focal point that helps to draw the viewer into the world of the painting. In Kinkade's plein-air paintings, however, there are no such carefully placed points of entry; these compositions are more open, and they are illuminated by the more general, ever-changing light of the sun. Therefore, they seem more "perishable" somehow than their studio counterparts—and that is precisely Kinkade's point. He explains, "A great artist once told me, 'When you work in a studio, you paint; when you work outdoors, it paints.' Nature tells you what to do."

Index of Works